G000244623

# TETBURY
# & DISTRICT
## THROUGH TIME
Lynne Cleaver

AMBERLEY PUBLISHING

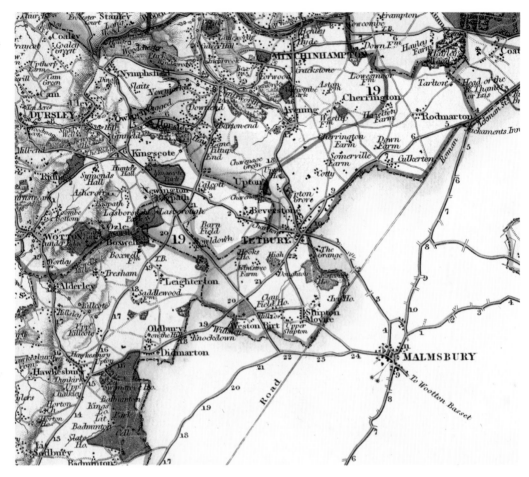

Greenwood's map of Gloucestershire, 1823.

*Dedicated to a loving father who died just before this publication was finished,*
*David John Boulter, 5/1/1930–28/7/2011.*

First published 2011

Amberley Publishing
The Hill, Stroud
Gloucestershire, GL5 4EP

www.amberley-books.com

Copyright © Lynne Cleaver, 2011

The right of Lynne Cleaver to be identified as the
Author of this work has been asserted in accordance
with the Copyrights, Designs and Patents Act 1988.

ISBN 978 1 84868 932 9

All rights reserved. No part of this book may be
reprinted or reproduced or utilised in any form
or by any electronic, mechanical or other means,
now known or hereafter invented, including
photocopying and recording, or in any information
storage or retrieval system, without the permission
in writing from the Publishers.

British Library Cataloguing in Publication Data.
A catalogue record for this book is available from
the British Library.

Typeset in 9.5pt on 12pt Celeste.
Typesetting by Amberley Publishing.
Printed in the UK.

# Introduction

When deciding the areas to include in this volume of photographs based in and around Tetbury I was faced with a problem – draw a 5-mile radius around the town and you include parishes such as Malmesbury, which is a subject in its own right. I eventually decided to focus on the area that formed the Tetbury Union created from the 1834 Poor Law Amendment Act. This comprised the parishes of Tetbury, Ashley, Long Newnton (both of which were in Wiltshire at one time), Beverston, Kingscote, Newington Bagpath, Ozleworth, Didmarton, Oldbury on the Hill, Lasborough, Westonbirt, Boxwell, Shipton Moyne, and Cherington. In 1893, Avening was separated from the Stroud Union and added to the Tetbury Union to form Tetbury Rural District.

The main trades in Tetbury were those associated with wool, with the market for these goods being not just the local valleys around Tetbury but Kidderminster, Andover and Leicester. This prosperous trade resulted in the development of the Tetbury that we are so familiar with today, with many of the buildings redeveloped in newer, more modern styles to reflect the fortunes of the tradesmen. With the decline of this trade, the livelihood of the townspeople diminished with more people chasing after the few remaining jobs. You can understand their anger and worry when the enterprising farmers started using threshing machines in the 1830s. During the time when a man could be hung or transported for stealing a loaf of bread to feed his hungry family, work was vitally important. Before the creation of the Unions in 1834 the poor were the responsibility of the Church and would be given 'outdoor relief' in the form of money, food or clothing as appropriate, thereby enabling them to stay in their own homes. Those considered as the 'undeserving poor' would be dealt with harshly. The Poor Law Amendment Act 1834 created Unions from groups of parishes across the country to be managed by a Board of Guardians. Outdoor relief was no longer an option – now the able bodied poor would be sent to the workhouse which was meant to act as a deterrent to the 'idle poor' from living off the parish.

Some of these parishes comprised of only a few houses and visiting them in the twenty-first century it is hard to imagine that anyone living there could be in need of poor relief. The reader must bear in mind that the outlying areas were agricultural and that the work of the labourers was dependent on the seasons just as the Tetbury men were dependent on the woollen trade. Bad harvest equalled bad financial return. Some of our agricultural labouring ancestors moved around annually, 'signing on' at the Tetbury Mop fair. Just look at the places of birth of the children on any of the Victorian censuses and you will be able to track this movement.

In his book on rural economy (1789), William Marshall describes the Cotswold farmers as intelligent and respectable. The workers, he noted, were numerous and their wages remarkably low, and servants' wages were also low. The farms were mostly large, between 200 and 1,000 acres each. However, the buildings were without regularity or plan, and the farmhouses stood mostly in the villages, even some in towns. This may explain how the census lists some Tetbury men as farmers when they were living on roads such as Long Street in the centre of the town with no agricultural land on the doorstep.

Population in the small villages has remained static with sometimes less than 100 inhabitants. Very little new development has been allowed to take place preserving tiny pockets of exclusivity, but also havens of peace from the bustle of twenty-first-century living. There are some beautiful and remote areas within a remarkably short distance of Tetbury. The two parishes not following this population trend are Tetbury and Avening. Tetbury continues to grow and develop to meet the needs of an increasing population whether it is welcomed or not. Avening on the other hand, is half its original size of just under two hundred years ago. Its population was at its peak in the period 1820 to 1881, having a rapid decline of 50 per cent by 1891, followed by a slow decline to the 1960s. This can no doubt be attributed to the closure of the three mills that had been established around the Aven stream.

Yet again, in compiling this book I have been on a fascinating journey of discovery. I hope that you too feel inspired to follow the lanes and footpaths of this tiny corner of Gloucestershire to discover for yourself the beauty and history in our midst.

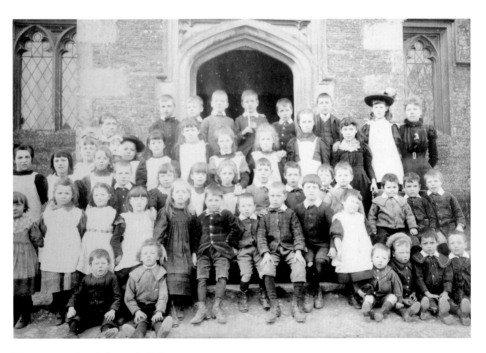

Beverston school class of 1898.

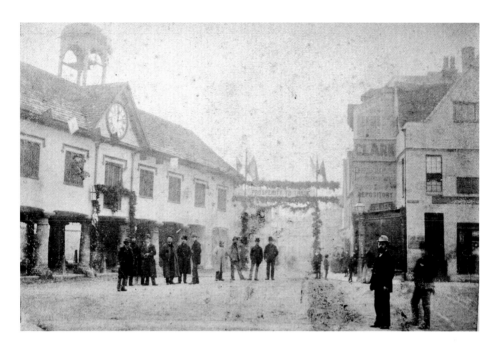

**Church Street, Tetbury**

In this old photograph, probably dating from *c.* 1889, a banner stretches across from the Market Hall to Church Street proclaiming 'Prosperity to Trade'. This was to celebrate the opening of the long awaited Kemble to Tetbury branch line (see page 40). It was one of many such banners across the town proclaiming 'Success to our Railway', 'Prosperity to Tetbury' and 'May Agriculture Flourish'. Today, flags and bunting stretch across the streets to celebrate high days and holidays, such as the recent Royal Wedding of Prince William and Catherine Middleton, and the Woolsack Races.

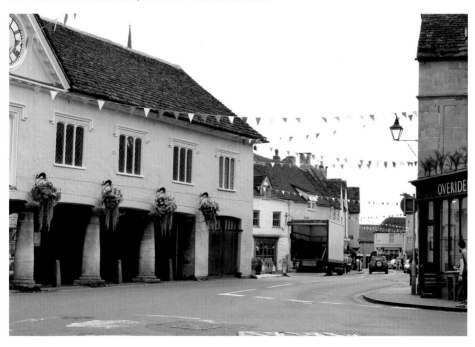

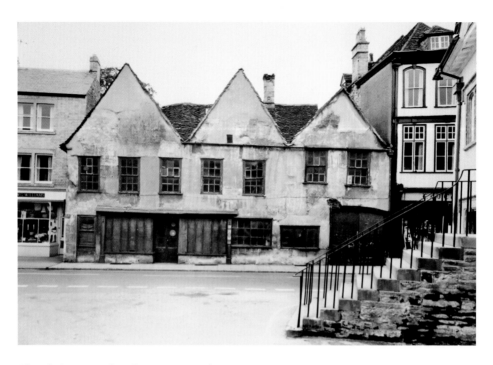

**Church Street – The Three Cups, Tetbury**

The Three Cups was a coaching inn on Church Street – coaches left here daily for Oxford and Bristol. In the 1850s, it closed its doors as an inn and became the premises for a blacksmith and ironmonger, probably Henry Simpkins, later William Sealy and eventually the Witchell family. This old photograph shows the building shortly before its demolition in 1973. Today, the rebuilt block reflects the outline of the old, and houses a range of shops. The archway to the yard at the rear of the premises, Trooper's Court, is so named after Trooper Witchell, a conscientious objector in the war; the name was given to him in irony.

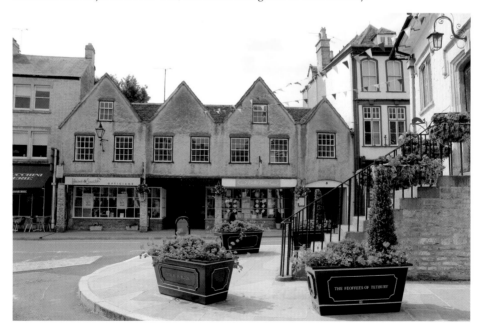

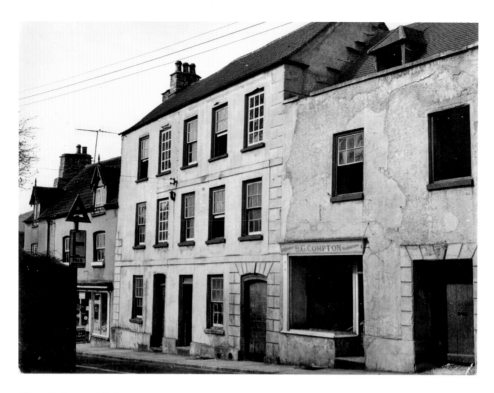

### Church Street, Tetbury

At the other end of Church Street there was Compton's hairdressers, shown here in 1968, with what looks like no glass in the window. Beyond the hairdressers was a house, at one time occupied by a branch of the Warn family, and then a sweet shop, just visible in the photograph. Note the 1960s road sign.

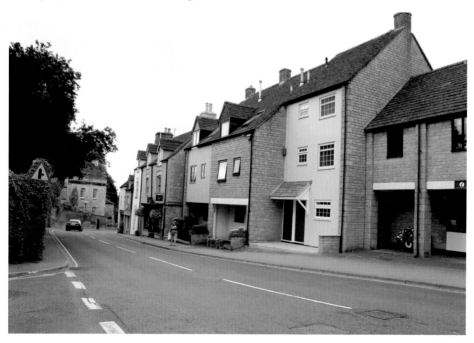

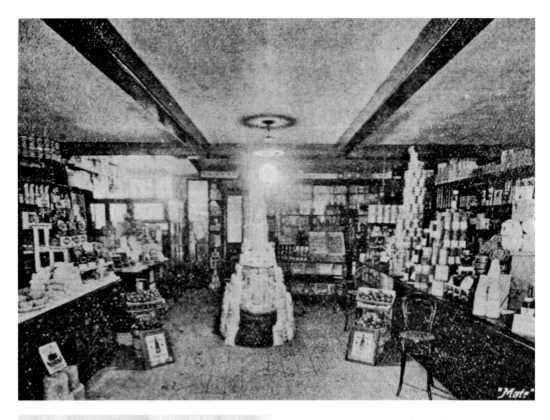

## CHURCH STREET, TETBURY.

### ESTABLISHED 1850.

*Intending Visitors to this beautiful Cotswold District — should send for our —*

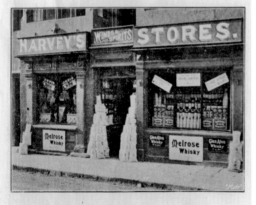

### = STORE PRICE LIST, =

*which we shall have great pleasure in forwarding post free upon application.*

**Proprietor : E. J. HARVEY.** ————

Church Street – Harvey's, Tetbury

Edwin John Harvey was running Harvey's Stores on Church Street between the years 1901 and 1920. International Stores had taken it over by 1923. Prior to Harvey it had been run by Frederick George, who had taken over from Charles Banks. In these two old photographs dating from 1908, the goods for sale can be seen piled up in impressive towers.

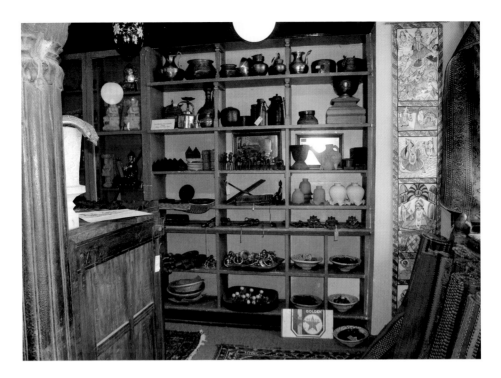

**Church Street – Harvey's Interior, Tetbury**

Mrs Bristow ran the shop as 'Patches' before handing over to her husband who now runs the shop as 'Artique', specialising in antiques from the East. The modern internal shots show Mr Bristow amidst his exotic collection of wares. The shelves used for the display of these wares are the shelves that previous generations used to display food as seen in the older interior shot opposite.

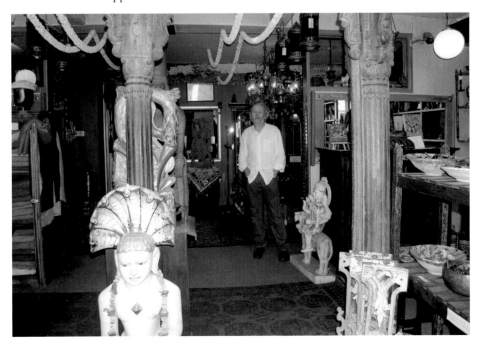

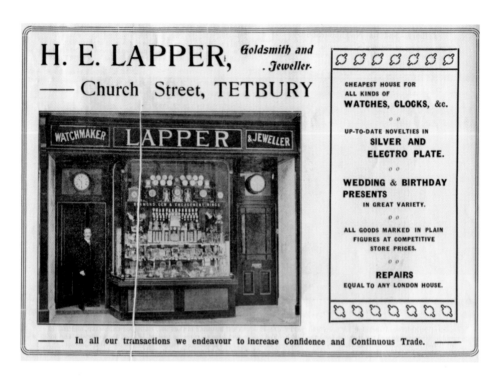

H. E. LAPPER, *Goldsmith and Jeweller.*

—— Church Street, TETBURY

WATCHMAKER LAPPER &JEWELLER

CHEAPEST HOUSE FOR
ALL KINDS OF
**WATCHES, CLOCKS, &c.**

o o

UP-TO-DATE NOVELTIES IN
**SILVER AND
ELECTRO PLATE.**

o o

**WEDDING & BIRTHDAY
PRESENTS**
IN GREAT VARIETY.

o o

ALL GOODS MARKED IN PLAIN
FIGURES AT COMPETITIVE
STORE PRICES.

o o

**REPAIRS**
EQUAL TO ANY LONDON HOUSE.

—— In all our transactions we endeavour to increase Confidence and Continuous Trade. ——

**Church Street – Lapper's, Tetbury**

Harry Edward Lapper worked in Tetbury at the Church Street premises shown above between 1901 and 1910. He had moved on to Dursley by 1911 and the premises that are now part of the Blue Zucchini Brassiere were taken over by Mr Montgomery. A few doors up the road, a current jeweller, Fraser & Brown, offers all the traditional services offered by those in earlier times, which until recently was run by Norah Brooks & Daughters.

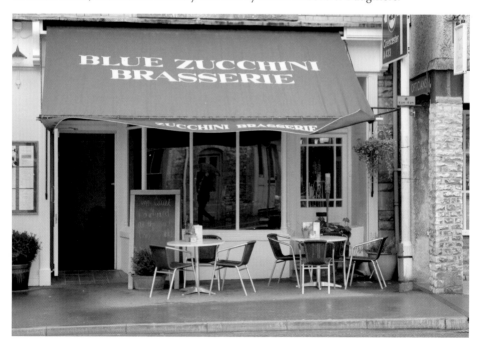

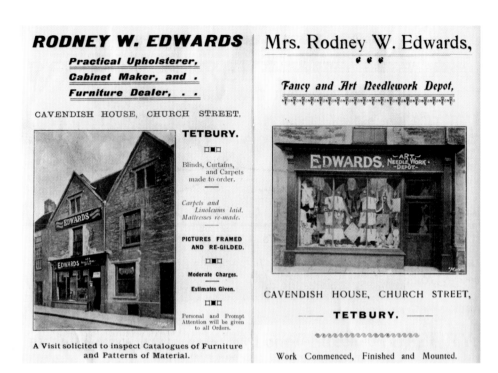

## RODNEY W. EDWARDS

**Practical Upholsterer,**

**Cabinet Maker, and .**

**Furniture Dealer, . .**

CAVENDISH HOUSE, CHURCH STREET,

**TETBURY.**

Blinds, Curtains, and Carpets made to order.

*Carpets and Linoleums laid. Mattresses re-made.*

**PICTURES FRAMED AND RE-GILDED.**

**Moderate Charges.**

**Estimates Given.**

Personal and Prompt Attention will be given to all Orders.

**A Visit solicited to inspect Catalogues of Furniture and Patterns of Material.**

## Mrs. Rodney W. Edwards,

*Fancy and Art Needlework Depot,*

CAVENDISH HOUSE, CHURCH STREET,

—— **TETBURY.** ——

Work Commenced, Finished and Mounted.

### Church Street – Edwards, Tetbury

Rodney William Edwards and new wife Sarah occupied Cavendish House, Church Street, in 1908, supplying blinds, curtains, carpets, and picture framing. Mr Edwards was an upholsterer, cabinet maker and furniture dealer while Mrs Edwards ran the fancy and art needlework depot. The family home was on Silver Street and this eventually became the business premises too. The shop unit now houses one of Tetbury's many antique shops, Jester Antiques, specialising in clocks, which is well established in the town.

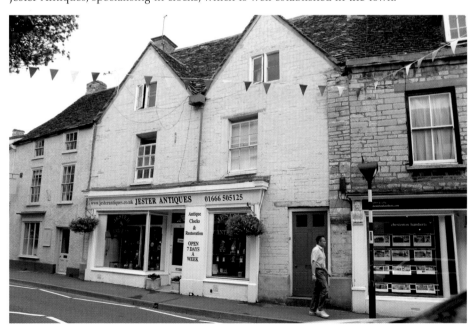

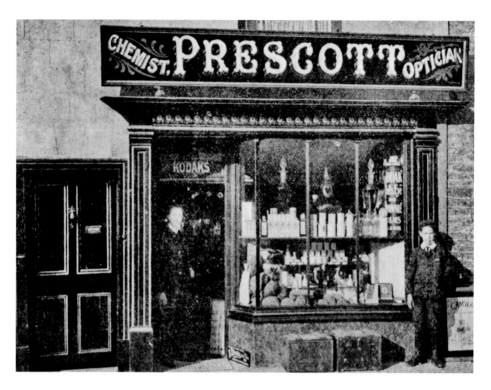

### Church Street – Prescott, Tetbury

The chemist business at 23 Church Street, run by John Prescott in this photograph of 1908, took over from Benjamin Walker after 1902. Walker's Chemist was in business in the 1880s up until he sold to John Prescott. Benjamin Walker was the father of Tetbury doctor Thomas Warburton Walker. The shop unit was Bell's Chemists, and now houses a branch of a vet's business, The George Veterinary Group, also supplying pet requisites.

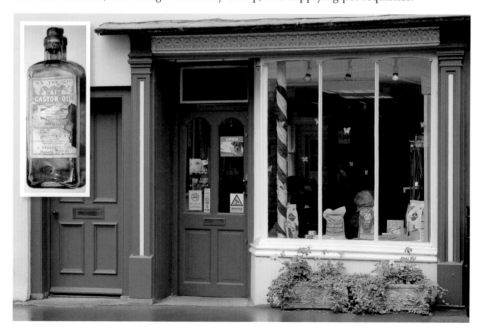

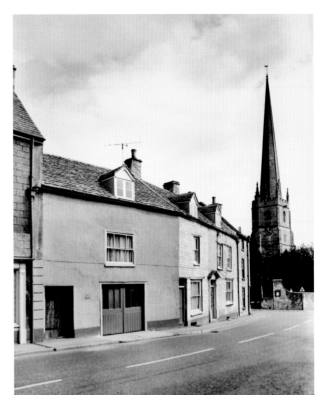

**Church Street, Tetbury**
The older of these two photographs, which were taken fifty or so years apart, are looking in opposite directions on Church Street, and show the terrace of houses. How little traffic there was in the 1960s! The houses have since been converted into shops selling bread, traditional toys and jewellery.

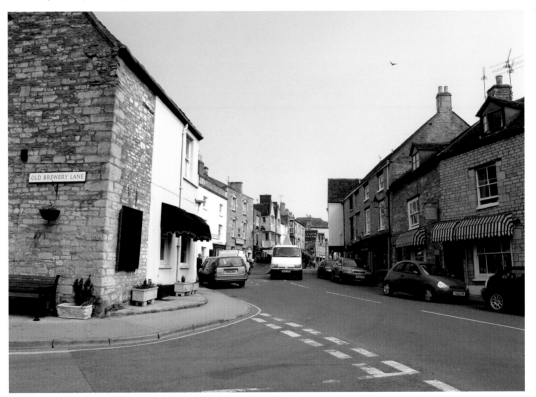

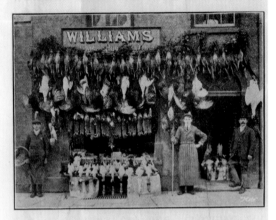

# J. Williams, ⚜ Fishmonger, . Poulterer, etc.

### Market Place, Tetbury.

□□□□□□□□□□

## WENHAM LAKE ICE ALWAYS IN STOCK.

## Good Supply of Fresh Fish daily.

**LICENSED DEALER IN GAME.**

□□□□□□□□

## COUNTRY ORDERS PROMPTLY ATTENDED TO.

**Tetbury Market Place – Williams**
Joseph Edgar Williams, fishmonger, poulterer, etc., was running his shop by 1894. A wide range of poultry and game, etc., can be seen in this advert from 1908. In the 1930s, MacFisheries replaced Mr Williams with the fishmonger's shop which was still trading in 1980. The shop unit now houses a charity shop.

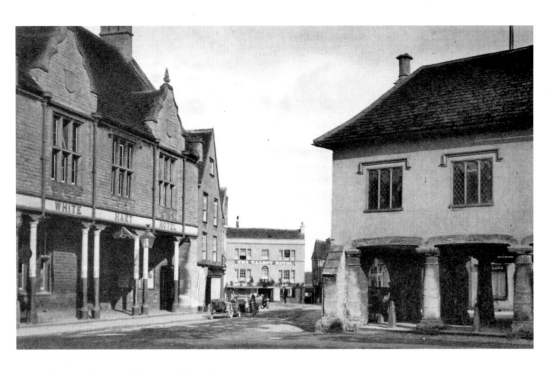

### Tetbury Market Place – White Hart

The White Hart has been on this site since before 1594, when it is mentioned in John Hexham's survey of the borough: 'Robert Hibert holdeth freelie one tenement being the signe of the White Harte'. During the mid-nineteenth century, the building was altered by Robert Holford, using his architect Lewis Vulliamy. Over the years, the inn has been used as a coaching inn (departures for Oxford and Bath), an assembly room, a cinema and the inland revenue office! During the 1960s, the then owner changed the name to the Snooty Fox; it was changed back during the 1970s and is now once again known as the Snooty Fox.

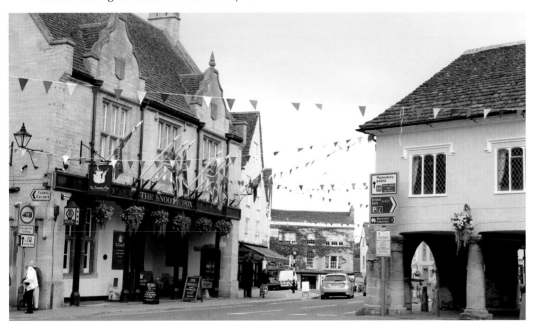

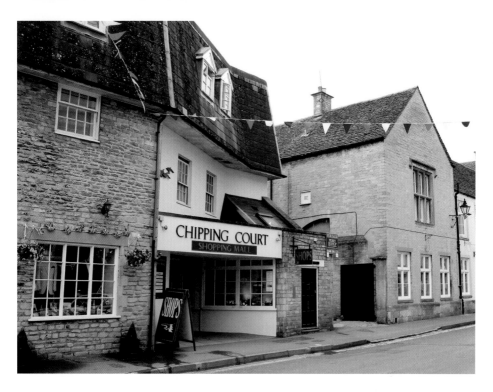

**Chipping Lane – White Hart Cinema, Tetbury**

The cinema at the White Hart was first opened by Mr Shaw Phillips in October 1920, 'under entirely NEW management', and was showing *East is East* starring Florence Turner. By 1930, Mr George Adams was the proprietor and was on duty on the afternoon in June 1931 when a fire broke out in the film projectionist's room. The projectionist, Francis Dorin, did his best to extinguish the flames but was unsuccessful in his attempts and suffered burns to his arms and face. Mr Adams managed to get all the audience out calmly and thus averted tragedy. There were about seventy in attendance, most of them children.

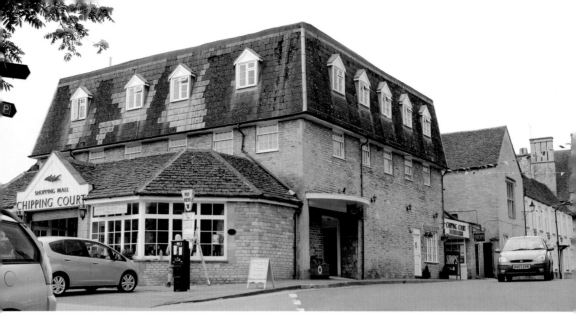

**Chipping Lane – White Hart Cinema, Tetbury**

The Tetbury fire crew attempted to put the fire out but were unsuccessful. This photograph shows the bystanders watching from a safe distance. The cinema was rebuilt and reopened in January 1932 with the film *A Warm Corner* starring Leslie Henson. During the 1960s, the cinema finally closed to be replaced firstly by an industrial unit, then a leisure centre, and after another fire, the current arcade of shops.

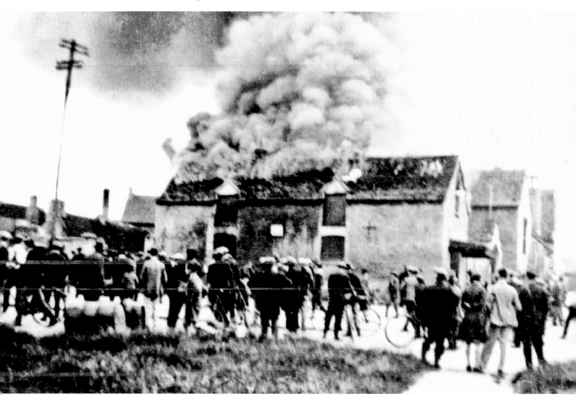

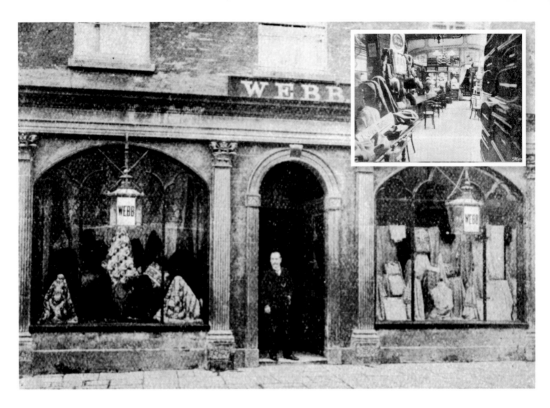

**Tetbury Market Place – Webb's**

By 1859, Thomas Webb from Longworth, Berkshire, had joined with Frederick Withers in a drapery business in Market Place. The partnership was dissolved in 1863 and the Webb family continued to run the shop. Later it was trading as G. T. Webb under the management of Mr Barker and Mr Solly, but their partnership was dissolved in 1925. The shop was still trading in the late 1930s. The current post office building was built in the 1960s.

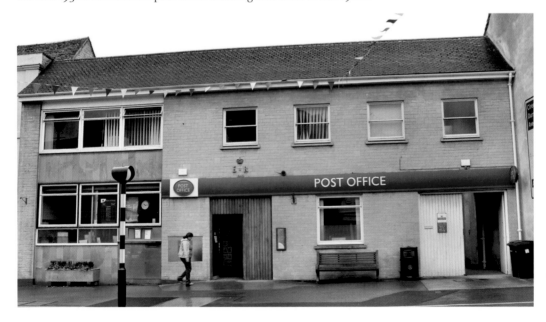

**Tetbury Market Place – Sattely**
Deacon's jewellers were founded in Swindon in 1848 and opened this branch in Tetbury in 1981. The old photograph shows the shop undergoing repair to its fascia whilst in ownership of George Sattely. He bought the property from George Pride in 1888 and ran his clock-making business from there until he died in 1922. His son Albert carried on the business, which included the contract to maintain the Market House clock. One earlier Tetbury clockmaker who had this task was John Pitt, between the years of 1816 and 1852.

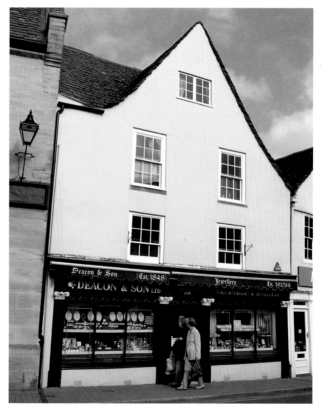

19

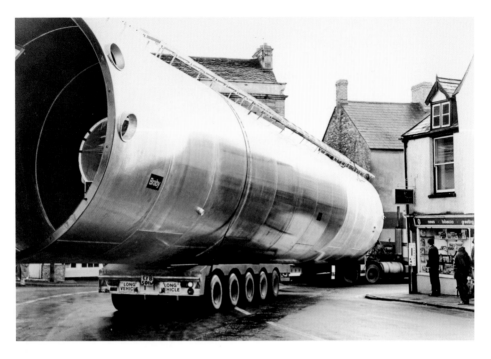

**Tetbury Market Place – Traffic Problems**
This incredible sight of a rather large lorry trying to get around the corner of Market Place and Silver Street highlights the problems the town faces with traffic. It is not only the volume of traffic coming into the town that causes problems but the sheer size of some vehicles. This lorry was part of the fleet belonging to a Wotton-under-Edge company, John Golding Heavy Haulage.

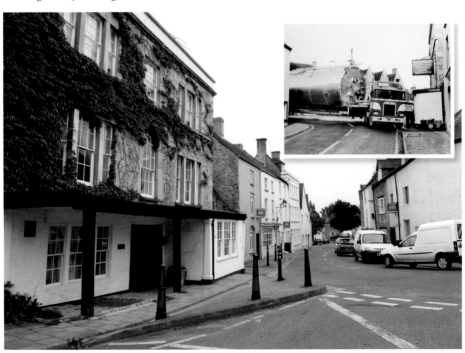

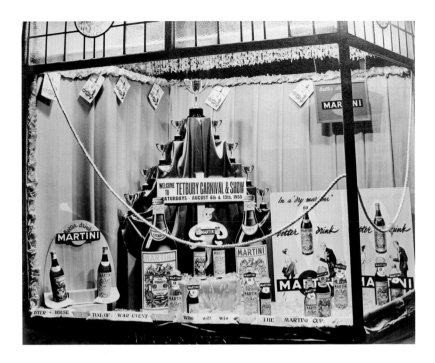

**Long Street – Fawkes, Tetbury**

This window display from August 1955 was in Fawkes Stores and showed assorted bottles of Martini and a range of trophies on the pyramid to the back of the display. The banner around the bottom read: 'inter house – tug of war event – who will win – The Martini Cup'. The surprise winners were the Royal Oak, who 'confounding the form book' beat the United Services Club team. The cup, given for the first time, was set to become an annual award. The late seventeenth-century building was partly rebuilt in the mid-twentieth century and has housed offices and a bank, but it is now Quayles, selling fine foods and delicatessen products.

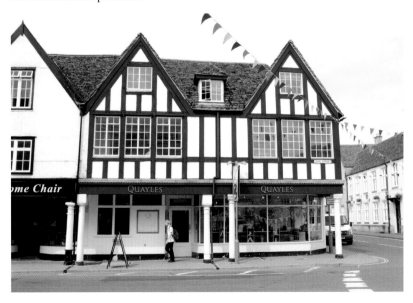

21

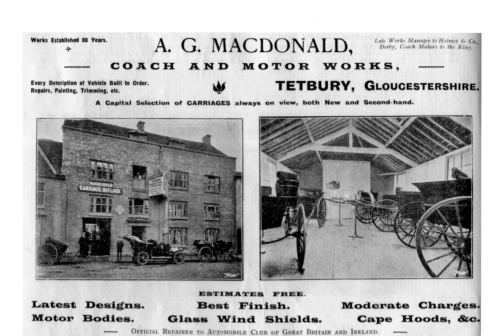

Works Established 88 Years.

**A. G. MACDONALD,**

*Late Works Manager to Holmes & Co., Derby, Coach Makers to the King.*

—— **COACH AND MOTOR WORKS,** ——

Every Description of Vehicle Built to Order.
Repairs, Painting, Trimming, etc.

**TETBURY, GLOUCESTERSHIRE.**

A Capital Selection of CARRIAGES always on view, both New and Second-hand.

ESTIMATES FREE.

**Latest Designs.** **Best Finish.** **Moderate Charges.**
**Motor Bodies.** **Glass Wind Shields.** **Cape Hoods, &c.**

—— OFFICIAL REPAIRER TO AUTOMOBILE CLUB OF GREAT BRITAIN AND IRELAND. ——

**INSPECTION PIT.** TYRES VULCANISED BY HARVEY FROST PROCESS. **MOTOR GARAGE**
MOTOR SPIRIT. LUBRICANTS. ETC.

### Long Street – MacDonald's, Tetbury

In this advert from 1908 Alfred Godfrey MacDonald is beginning to advertise motor works as well as coach building. Note the upstairs showroom. According to the advert, a coachbuilder had been trading for eighty-eight years. This may have been the business operated by James Sampson Coventry, and later James Sisum Brown. In 1923, the business was offering the complete build of a motor car using seasoned wood. The machinery used was of the 'best type which ensures the nicest accuracy in every detail of manufacture'. He would also 'prepare a special design and build you one'. I wonder if any of these hand built cars are still in existence today.

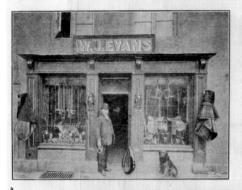
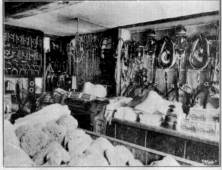

# W. J. EVANS, SADDLER AND ... HARNESS MAKER,

## LONG STREET, TETBURY.

**BLANKETS, RUGS, CLOTHING WHIPS, BITS, SPURS, STIRRUP LEATHERS,** and **BRUSHES** of every description.   **CHAMOIS LEATHERS, SPONGES,** etc.

REPAIRS NEATLY EXECUTED.                 PERSONAL ATTENTION GIVEN TO ALL ORDERS.

## Long Street – Evans', Tetbury

William John Evans opened his Tetbury shop on Long Street around 1900 on discharge from an army career spanning more than twenty years with the Royal Artillery in India. His training as a saddle maker was in Oldbury on the Hill where he was working as an apprentice saddler in 1871. In 1924/25, he was advertising 'hunting saddles a speciality'. No doubt, this specialism reflected the change of transport from horse and carriage to the motorised vehicle, and a decline in the demand for everyday harness and saddle.

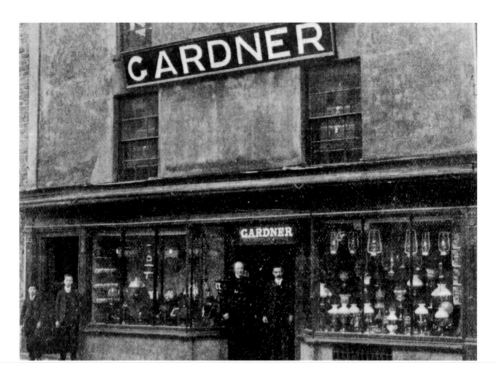

### Long Street – Gardner's, Tetbury

John Wilson Gardner was a manufacturing ironmonger, brazier, cutler, iron, zinc and tinplate worker, an agricultural implement agent, and at one time the secretary to Tetbury Cattle Market. His business was first listed on Long Street in 1870 and was originally Sealys, before they moved to Church Street (see page 6). After the death of Mr Gardner in 1912, the business was leased to Munday & Fowler (later Munday & Morris) in 1914, who continued the business well into the 1960s.

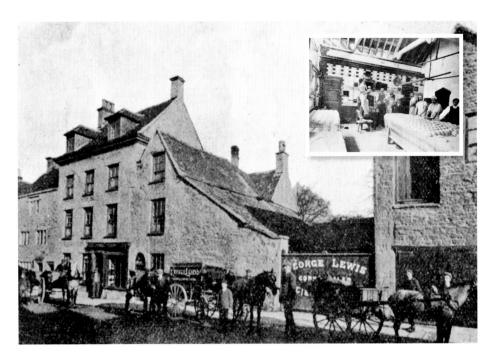

## Long Street – Lewis,' Tetbury

George Lewis' premises on Long Street are shown here in 1908. The Lewis family of 'bakers and meal men' were living and working on Long Street by the 1830s. Four generations and one hundred years later, in the 1930s, Alexander Hastings Lewis was a baker and corn dealer at 49 Long Street. The bakers' yard was built up with the shop unit that now houses cafés and antique shops.

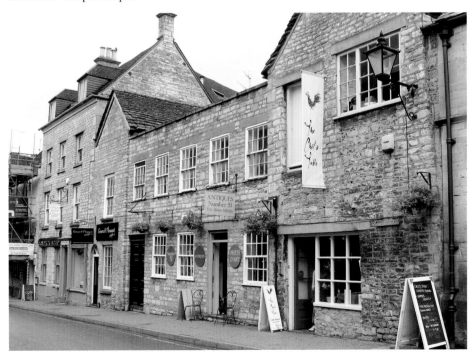

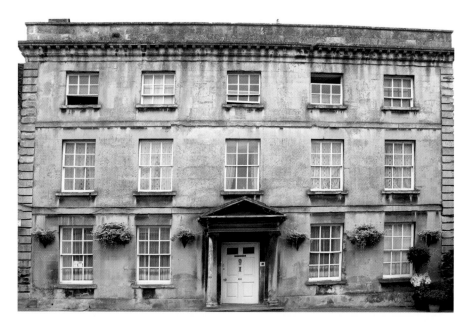

### Long Street – Old House, Tetbury

The Old House is an early seventeenth-century house, which was re-fronted in the eighteenth century to the Georgian façade we see today. In 1864, it was established as a Collegiate School run by John Welsh Keiller, a Scot who was resident in the town by the 1840s and worked at the National School. He ran a successful boarding school along with his wife, Elizabeth, offering the classics and French along with other lessons. After his death, Elizabeth put the school up for sale. The school was still advertising in 1910 as Tetbury Collegiate and High School for Boys and Girls. In the early twentieth century, Dr Brodie had his surgery here for a time.

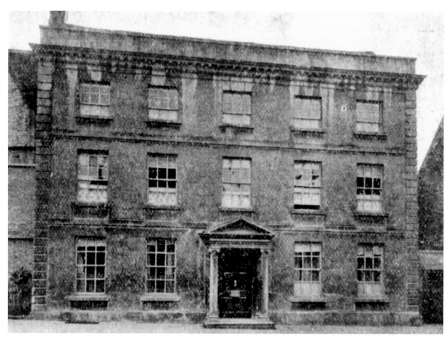

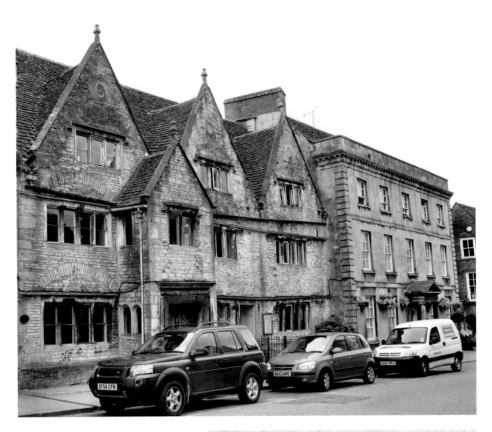

## Long Street – Porch House, Tetbury

Next to the Old House is Porch House, one of the buildings in Tetbury that is thought to date from the late sixteenth century and reputedly said to have been designed as a school but no records remain of this. Certainly, in the Victorian era Mr Keiller bought it as an extension of his Collegiate School next door. In his school log book he refers to his gardeners and some of the tutors employed by himself in less than satisfactory terms. Was Mr Keiller a hard task master and difficult to please, or did he possess a lack of judgement in employing capable staff? More recently, Porch House has been the Tetbury Urban and District council offices and antique shops.

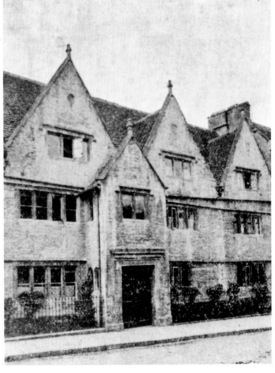

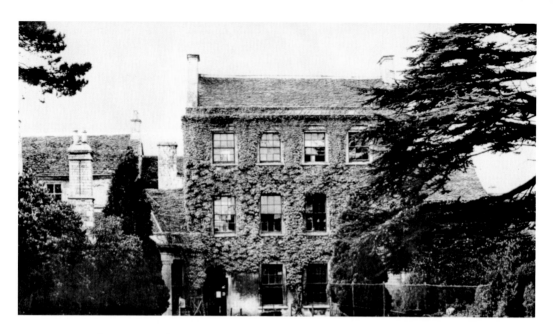

## Long Street – The Ferns, Tetbury

At the Ferns, on Long Street, the Grammar School was opened in 1921. Later, this too became a doctor's surgery, a role which it still fulfils today. Renamed Sir William Romney's school in 1952, the school was moved to a new site on the outskirts of the town in 1969. This old photograph shows the rear of the house.

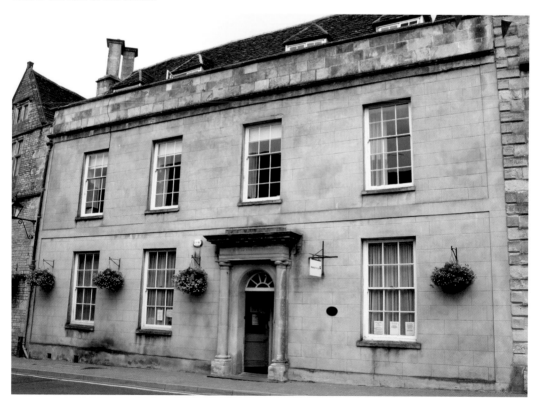

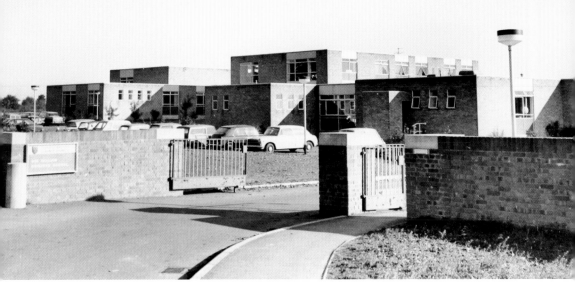

## Lowfield Road – Sir William Romney's, Tetbury

Shown here in the late 1960s is the newly built Sir William Romney's School on Lowfield Road. The building at the Ferns had over 400 pupils in attendance by the mid-1960s, and despite additional facilities added since it became a Comprehensive school in 1952, it was outgrowing the facilities and the move to a new purpose built school was planned. Also housing Tetbury Sports Centre, the site is used by the whole community.

## St Mary's Road, Tetbury

St Mary's Road was part of the new council development that took place in the 1960s. It comprised of mixed housing and flats with bungalows for the elderly. Now under the jurisdiction of a housing association, and private ownership, the wide open roads still remain light and airy. I cannot imagine developers today leaving such a wide expanse of grassy land undeveloped.

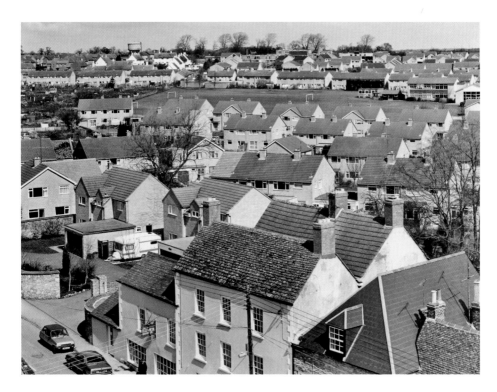

## Courtfield, Tetbury

This photograph, taken from the old brewery building, shows part of Hampton Street, Magdalen Road, the primary school playing fields and the Lowfield Estate. Courtfield was developed on three pieces of land called Court Field, which were used for both arable and pasture farming. It was developed in the 1960s and initially comprised twenty-seven homes, seen in the middle of the old photograph.

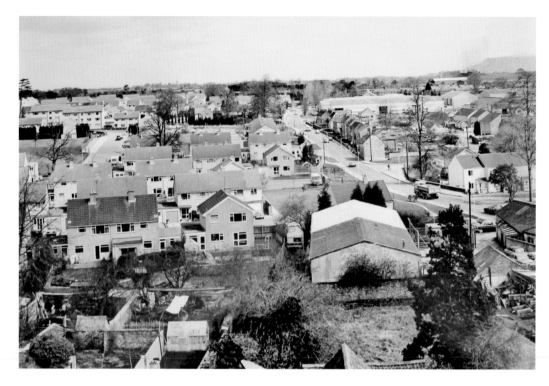

London Road – Pegler's, Tetbury

This 1970s view of Courtfield and London Road taken by Tetbury photographer Peter Harding, shows the top end of London Road and the warehouses which are now the site of a Tesco store. Pegler's garage workshops are to the front of the photograph. Albert Pegler started his garage in the 1930s, initially as a private hire company and then progressed to car repairs. Following a short spell as a franchised dealer for British Leyland, they gained the franchise for Ford and since 1970 they have been supplying and repairing Fords.

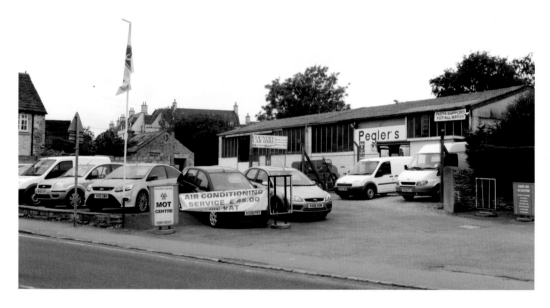

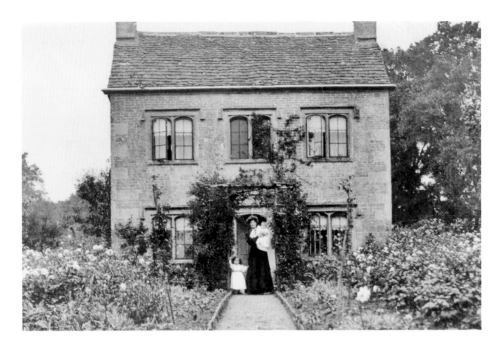

## London Road – Painton's, Tetbury

Frederick Painton's Nursery Gardens on London Road will be remembered by older residents of the town. He supplied the family shop on Church Street with locally grown produce. This photograph of the house with Jane Painton and her two children, Peter and Millicent, dates back to around 1913. The market gardens extensively surrounded the house until the property and land were sold for development and the Conygar estate was built – 'A Kent Living Design Development'. An advert in 1975 was offering 'low cost housing for the young family' with a three bedroom semi selling for £9,700. The old cottage stood on the site of the semi detached houses shown in the new photograph.

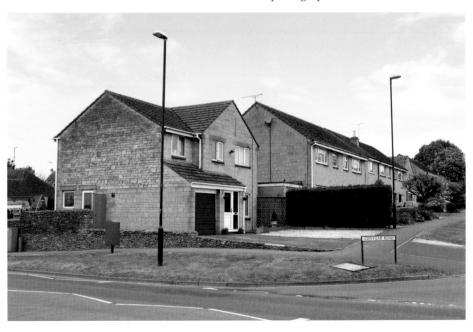

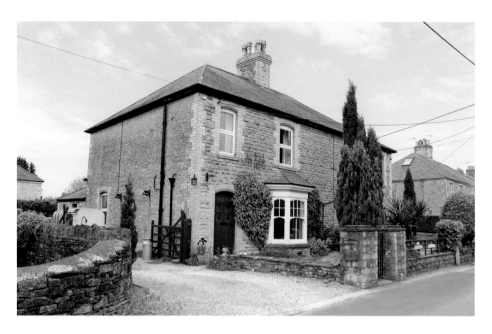

### Northfield Road, Tetbury

Northfield Road has been developed over the last 150 years following the line of the old field boundaries. This semi-detached house was part of the development that took place in the early twentieth century, and this old photograph shows Frederick Bathe (1900–68) tending his garden. Local farmer Ian Mitchel, Fred's employer, owned the house and allowed Fred and his mother to live there rent free all their lives. Fred was described as 'a kind and generous man' by all who knew him. Some may remember the small field to the left of the house where June Bishop kept her prize-winning sheep before two detached houses, keeping with the style of the existing houses, were built in the late 1990s.

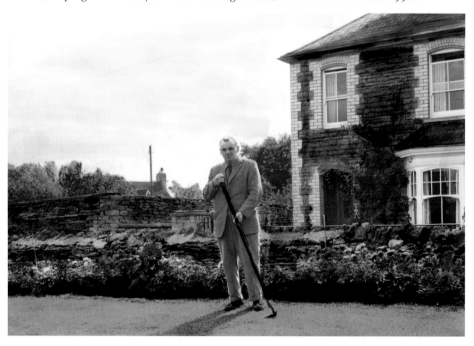

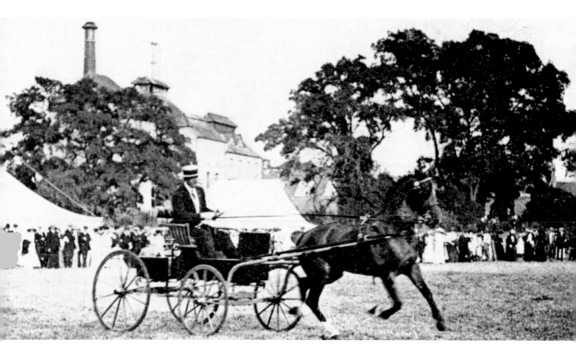

**New Church Street – Recreation Ground, Tetbury**
In this photograph from August 1911, Messers L. & P. Smith's famous chestnut pony, 'Perfect Wonder', comes second in the open driving competition. The old brewery buildings are quite clear in the background and these are now converted to apartments named Helena Court and Prince Court.

### New Church Street – Dolphins Hall, Tetbury

This photograph, taken from the Hampton Street brewery in the 1970s, shows Dolphins Hall with St Saviours church beyond. In 1954, a group of trustees comprising Maj.-Gen. George Paul St Clair CB GBE, DSO, Alexander Hastings Lewis JP, William Somers Llewellyn MA (vicar), Alfred George Munday, Augustus Albert Braine, Ethel Ann Rosa Butler, Ruth Morrison-Bell (who owned the Close) and Joan Adelaide Macintyre bought a plot of land from Mrs Elizabeth Clark, wife of William Mories Clark, owners of Coombe House, for £300. The money was given by the Tetbury Institute but it was to be another six years before Dolphins Hall was finally opened on 6 June 1960 by Miss Morrison Bell. The building in front is sheltered housing also called Coombe House, which was built in 1972.

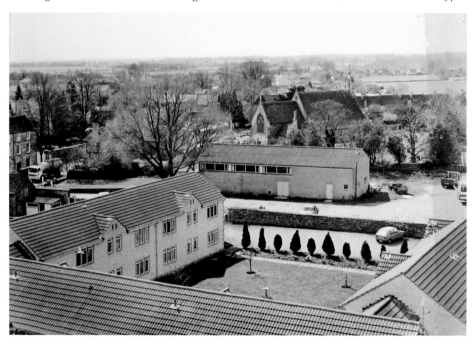

## Dolphins Amateur Dramatic Society, Tetbury

The first performance by Tetbury Amateur Dramatic Society was *The Pirates of Penzance* by Gilbert & Sullivan and here we see some of that original cast from April 1910. The new images are of the cast during rehearsals for their anniversary performance of the same operetta in 2010 and were taken by Jason Watt.

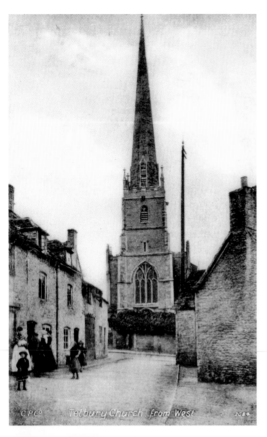

Harper Street, Tetbury

Harper Street was mentioned as early as 1398 as Hatters Street but by the early seventeenth century, it was known as Harper Street. It gradually gained a bad reputation, being the home of petty criminals. Although the cottages are described by Pevsner as 'artisan' rather than skilled craftsmen, most of the workers were in fact labourers. Sometimes several families were crowded into the small houses. To rid the street of its bad reputation they changed the name to West Street in the 1930s.

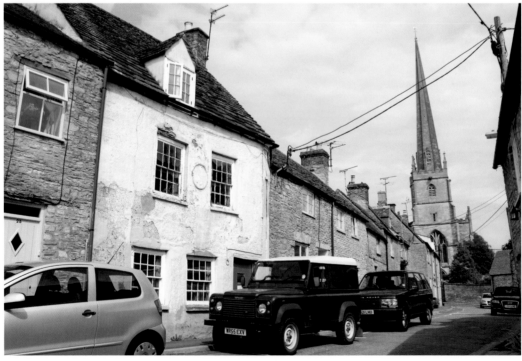

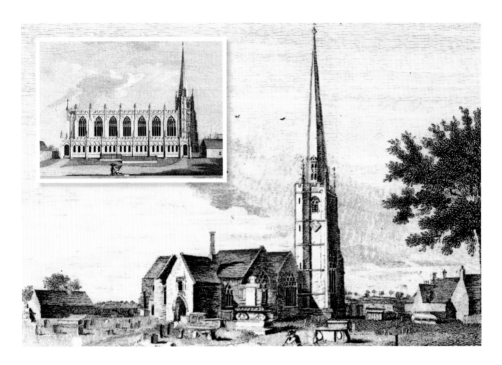

### St Mary the Virgin and St Mary Magdalen Church, Tetbury

St Mary the Virgin and St Mary Magdalen, known as St Mary's, has been rebuilt and remodelled over the centuries as have all our churches to reflect the popular taste of the period, and one would hope, to meet the changing needs of the parishioners. Here we see an engraving of the medieval church prior to the major rebuild of 1780, it being in a very bad state of repair, or as Rudder described it in his history of 1779, 'ruinous'! On the east wall engraved into the stone are the names of some men whom I like to think may have worked on the rebuilding.

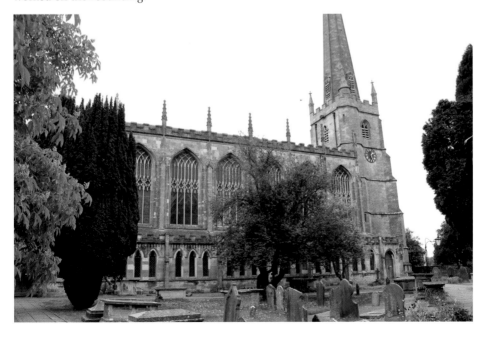

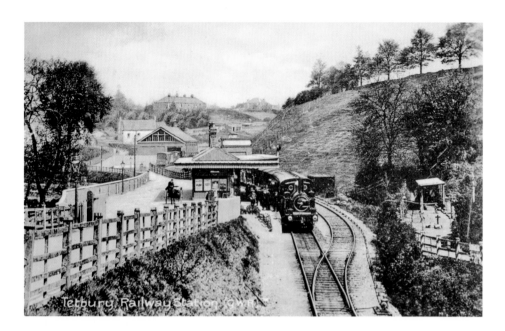

### Railway, Tetbury

The Tetbury Branch Line was opened on 2 December 1889 after a long and drawn out wait and many years of plans, meetings and discussions. The work was done by a Brighton company, J. Harrison & Son, who used not only their own labourers and staff but also local men. The intention was that in time the line would extend under the Wiltshire Bridge and onto the Severn Tunnel. The approach road seen in this photograph was described as 'a well constructed road, bounded by a substantial paling and entered by wooden gates supported by two massive iron pillars'. Now, the lane remains, making a pleasant walkway with railway sleepers put to decorative use as the only reminder of what was and what could have been.

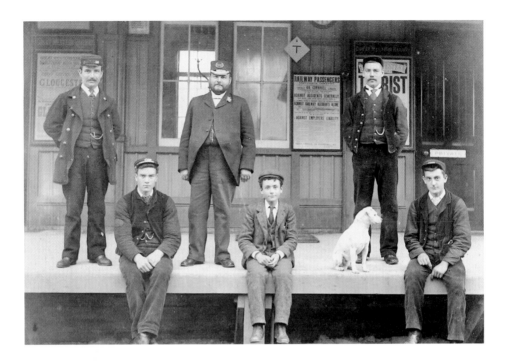

## Railway, Tetbury

The passenger station was originally constructed of wood so that it could be removed with ease and replaced with more substantial buildings when the extension of the line took place. As can be seen in the photograph below, the building was in fact condemned as unsafe in July 1914 and replaced, but not with the purpose of a station and line extension, but with pure and simple safety in mind. When stationmaster Henry Hawker took over in 1907, he reported the dilapidated state of the building and it took until 1916 before a new building was erected from red and blue bricks. The top photograph shows the staff of 1897 with stationmaster, Mr Boyd (back row, middle).

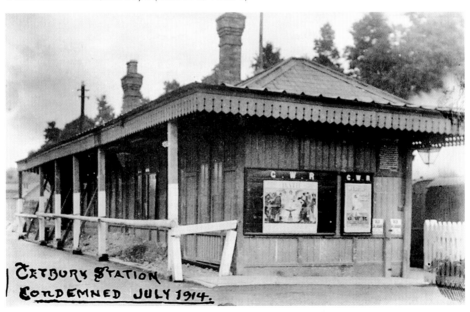

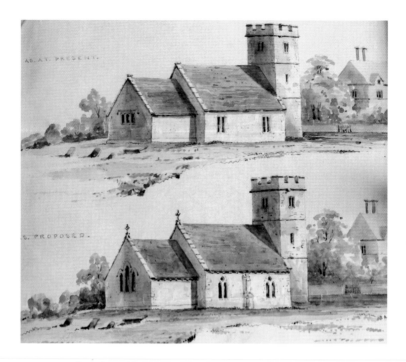

## St James Church, Ashley

Ashley was in the county of Wiltshire until 1930 when it was transferred to Gloucestershire. Never having had a population much over 100, when Tetbury Union was formed in 1834 there were just nineteen houses with just ninety-nine people. A single terrace of cottages was probably where the agricultural labourers of the Victorian era resided. Many of the homes today are converted from old barns and farm buildings but all preserve the mark of the farming origins of the village. These drawings of St James show the church prior to the alterations as envisaged by the Gloucester architect Frederick Sandham Waller in 1857. Rebuilding commenced in May 1859, with Francis Brown of Tetbury the builder; the total cost came to £557 8s 4d, all of which was paid for by donations.

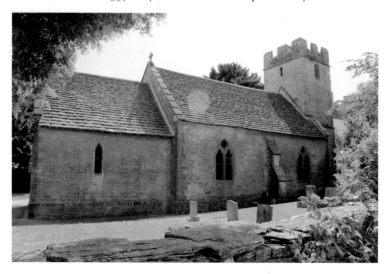

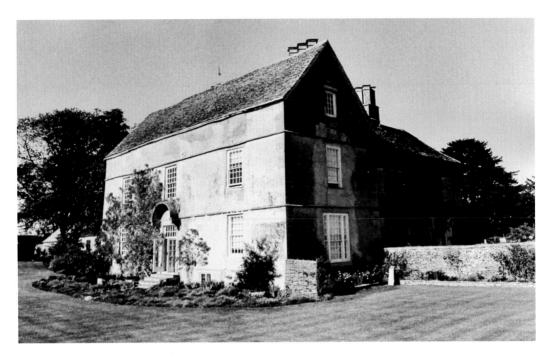

## Ashley Manor

Ashley Manor House, seen here in about 1985, has its origins in the fifteenth century and has been added to and altered over the centuries. At one time it was the property of the Estcourt family of Shipton Moyne, forming part of their large estate. The current owners have undertaken a large amount of restoration work.

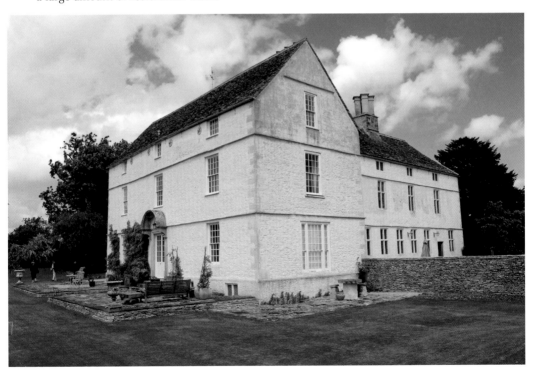

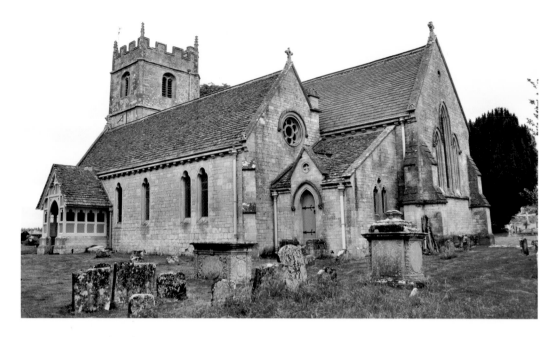

## Long Newnton Church

The seventeenth-century English antiquary and writer John Aubrey states in his book *North Wiltshire*, 'This village, long time ago, stood a little higher in the field, where they still plough up foundations of houses; the tradition is that it was burned, and then built here, whence it was called Newnton.' Again, it is an agricultural village and slightly larger than Ashley. The old print of Holy Trinity church shows it prior to the alterations and rebuilding of 1840–41, which saw the introduction of windows in the Early English style. In 1870, a north aisle was added. Long Newnton was also transferred to Gloucestershire from Wiltshire in 1930.

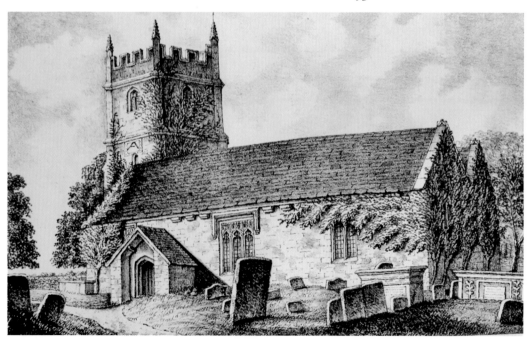

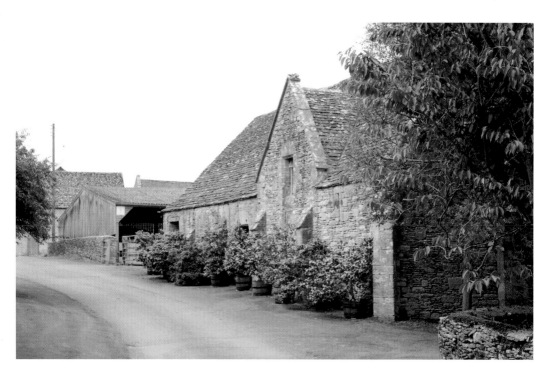

## Pilgrims Barn, Beverston

Pilgrims Barn dates from the fourteenth century and is one of the many listed buildings in the area. It was probably part of Castle Farm, some of which can be seen at the rear of the barn. There were two principal farms in Beverston – Castle Farm and Park Farm – and in the 1831 Swing Riots both farmers, William Robbins and Jacob Hayward, had their threshing machines smashed by the mob.

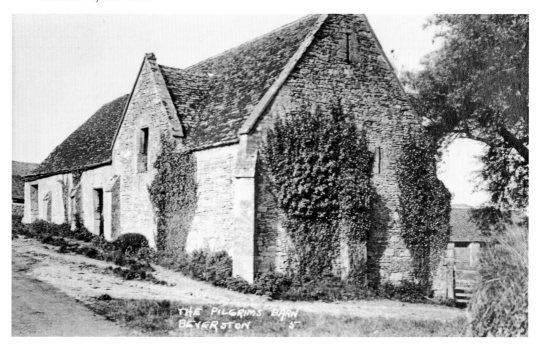

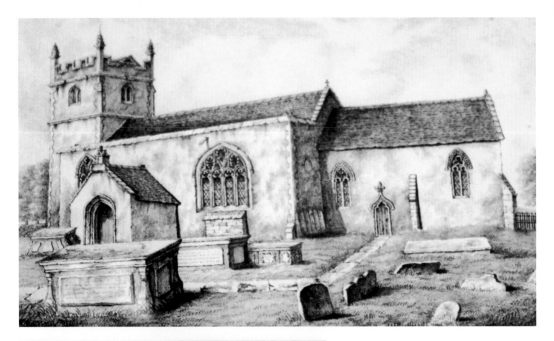

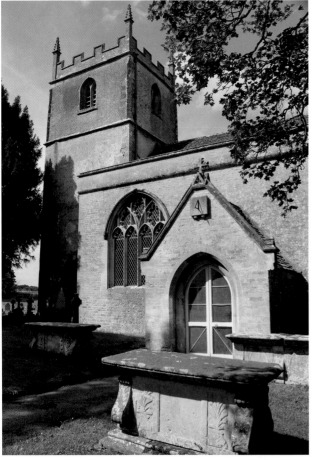

**St Mary's Church, Beverston**
The church of St Mary is situated next to the old castle. It has its origins in Saxon times but no evidence of this remains. Rebuilding took place in the 1840s by architect Lewis Vulliamy and Robert Stayner Holford of Westonbirt. The drawing is from 1843, just before these alterations took place. In the incumbents notebook from the 1890s it is recorded that these 'restorations were affected by an architect and builder wholly unacquainted with Church work and had consequently been done in very bad taste'. The very early parish registers mention the surnames Hathaway and Shakespeare, giving rise to rumour that William Shakespeare has connections with the village.

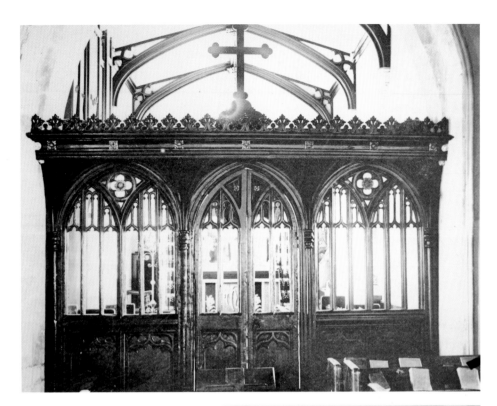

**St Mary's Church Interior, Beverston**

The sixteenth-century rood screen shown here, *c*. 1900, was thrown out in the alterations undertaken by Vulliamy, but was restored by Henry Frith in 1898–99. In his comments about the earlier restoration the incumbent records 'many valuable features in the church were destroyed, a fine oak screen was removed to the rectory garden, where it stood among the laurels built up as a summer house'. The lamp hangings, one of which can be seen here, were designed and made by blacksmith John Roberts, in the 1950s.

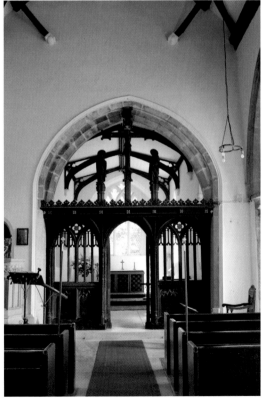

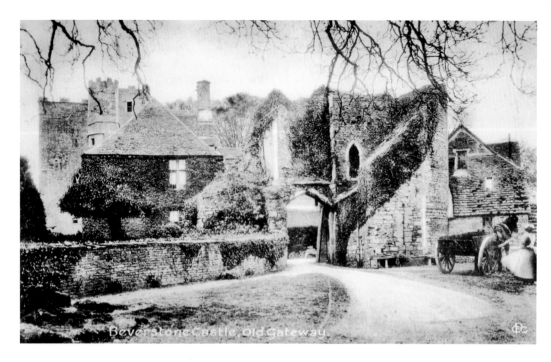

**Beverston Castle**

The gatehouse to the castle dates from the fourteenth century and at one time would have had guardhouses and lodging above. The new photograph, taken in summer 2010, shows little change from the old photograph which is dated 1910. The building to the right of the gatehouse has been replaced by a house, and the maid with horse and cart will of course have been replaced by more appropriate twenty-first-century transport!

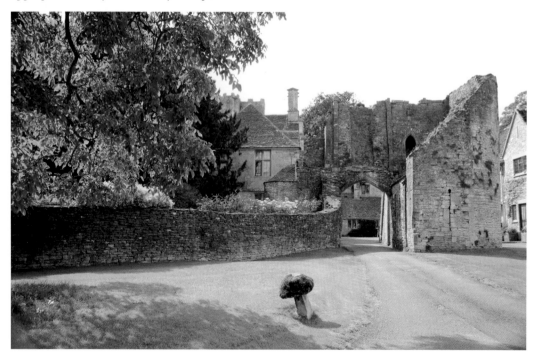

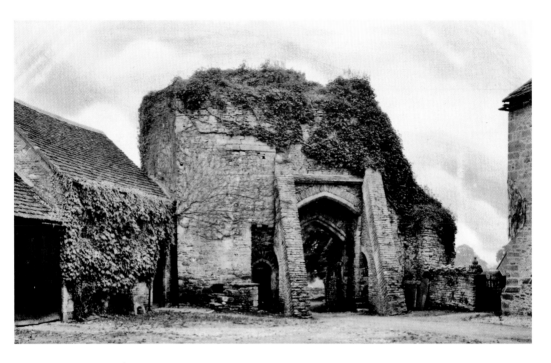

## Beverston Castle

The castle site dates from the eleventh century and has been subjected to various rebuilding activities, the most recent probably following a fire in 1691 when the house was burnt out, the last of three such occasions. The gatehouse viewed from the castle grounds offers views of the Cotswold countryside and would have offered a clear sighting of any approaching armies from the east. Much has been written about the castle's involvement in the Civil War, when it fell to the Parliamentarians. The tenant in 1895 was Mr James Garlick, who was described as 'a typical Gloucestershire farmer with his hearty greeting and genial hospitality'.

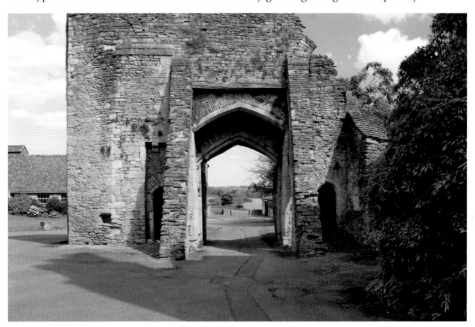

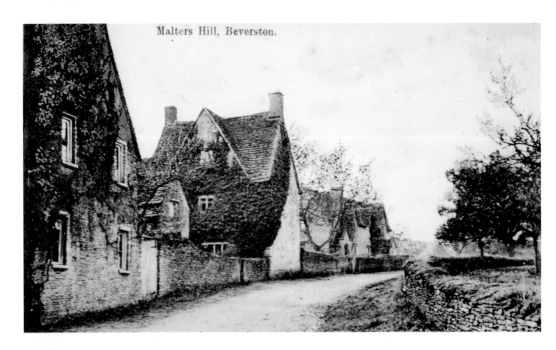

Malters Hill, Beverston.

### Malters Hill, Beverston

In the 1890s, the cottages on Malters Hill housed a builder, Daniel Lewis (he was in his eighties and his son, Joseph, was classed as a carpenter, undertaker and sexton), and a wheelwright, Arthur Maller and family. Other cottages housed an engineer and farm labourers. The first cottage in the lane is probably the oldest dating from the seventeenth century; the terrace further up the lane may date to when Holford bought the estate and commissioned building by architect Vulliamy in the 1850s. I wonder if the postcard company got the name of the lane correct – should it have been Maller's Hill with the wheelwright and family living there?

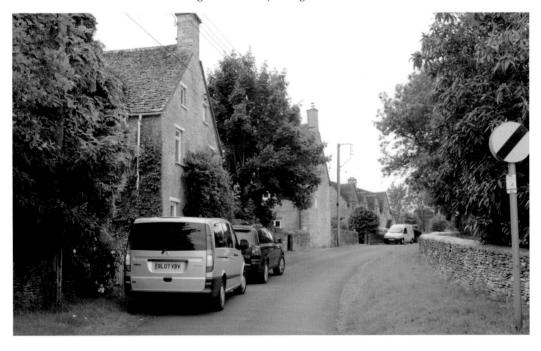

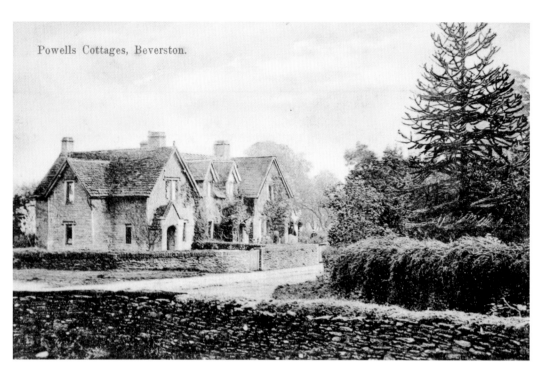

Powells Cottages, Beverston.

## Powell's Cottages, Beverston

Powell's Cottages on the main Tetbury to Dursley road were built in the style which seems to be the favoured design of Vulliamy. Compare with the cottages he built at Westonbirt in the same era (see page 79).

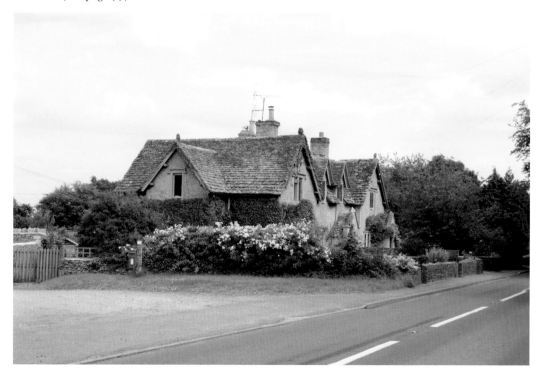

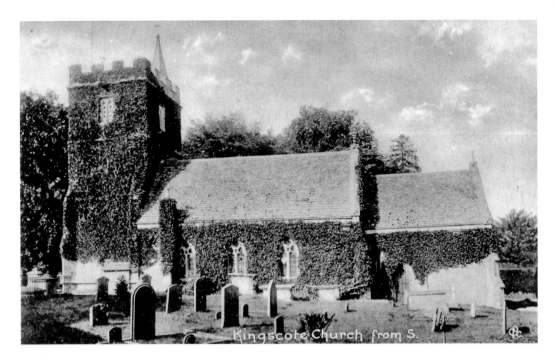

## St John the Baptist Church, Kingscote

The origin of the church of St John the Baptist is unknown, but remains of a skeleton and coffin were found during alterations in 1849 which are thought to date from the twelfth century and may be the remains of Aldeva FitzArthur, wife of the founder of the King[s]cote family. Major refurbishment and restoration in the 1850s by architect S. S. Teulon saw the current windows added. Edward Jenner, the famous physician, pioneer of smallpox vaccination and the father of immunology, married Catherine Kingscote here in 1788.

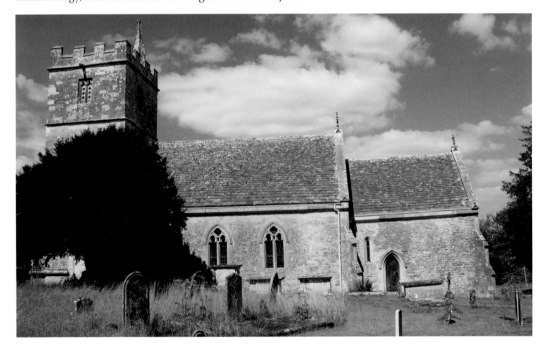

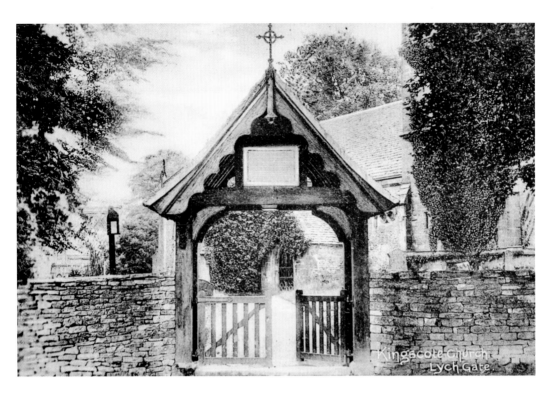

### Lychgate and War Memorial, Kingscote

This lychgate was still reasonably new when photographed for the Cotswold Publishing Company in 1910 having only been erected in 1901. The war memorial to the left of the gate was built on a plot of land given by Nigel Kingscote in memory of the twelve men of Kingscote and Newington Bagpath who gave their lives in the Great War. The official dedication took place in May 1921 and the Revd S. Rudge officiated.

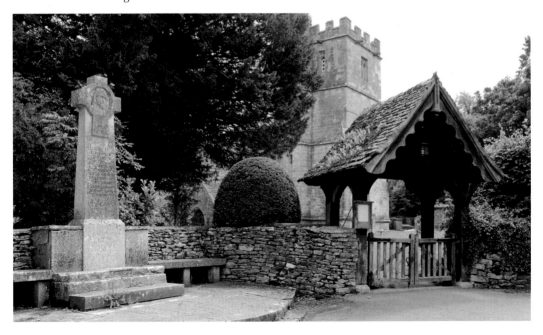

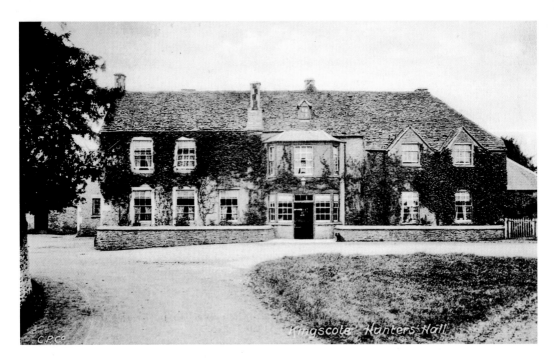

## Hunters Hall, Kingscote

According to the owner's website for Hunters Hall, currently hotel and pub chain Old English Inns, the earliest record of the hall was in 1604 and has held an unbroken license for 400 years. There was a house, inn, stables and smith's shop here originally. In its favourable position along the main road it served the many London carriers which supported the cloth-making trade based at Stroud and Dursley. In June 1921 over 400 guests attended an open air dancing event held at the Hunters Hall Pleasure Gardens.

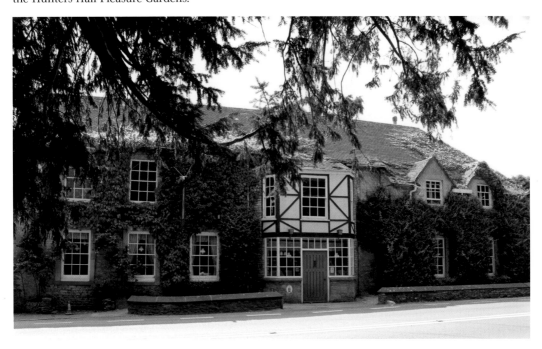

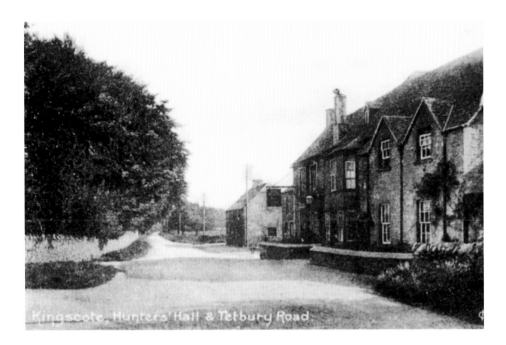

Kingscote, Hunters' Hall & Tetbury Road

### Hunters Hall, Kingscote

This second view of the Hunters Hall shows the outbuildings to the left of the main inn. Workshops here may have housed a blacksmith. The large hedge on the left now surrounds the Matara Centre which has at its centre Kingscote Park House, once the home of Catherine Kingscote, bride of Edward Jenner, as mentioned on page 52. The new photograph shows one of the original fireplaces – if you look carefully you can see a photograph to the left of the fire which shows an old gentleman sitting by the very fireplace, with another photograph taken in the 1970s of a young lad sitting in the very same place.

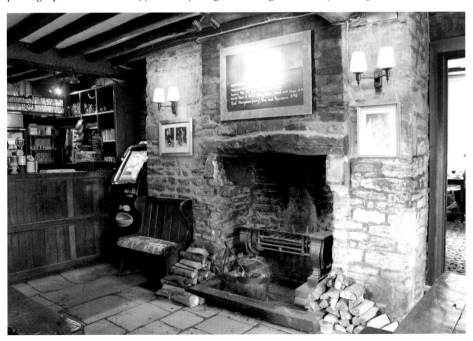

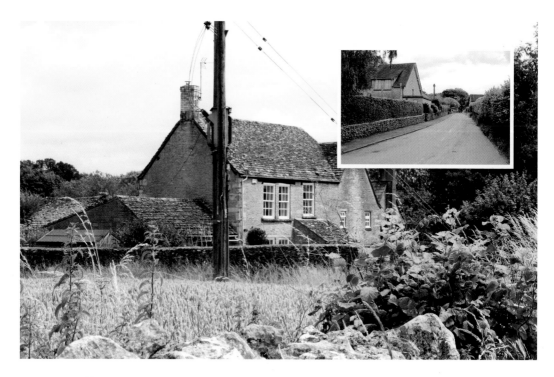

### Post Office, Kingscote

Once a thriving shop, the post office would have been the central point of many villagers' day-to-day lives. Nowadays, sadly, the village post office is becoming a thing of the past and here in Kingscote it is no different. They managed to keep a post office open until 2010, when it sadly closed on the retirement of the postmaster, with no one willing to take on the role. The inset image shows the property that housed the most recent post office; both this and the old post office are hidden behind hedges. Former postmasters have been Thomas Bruton (1908), William Richings (1923) and Mrs Lafford (1939).

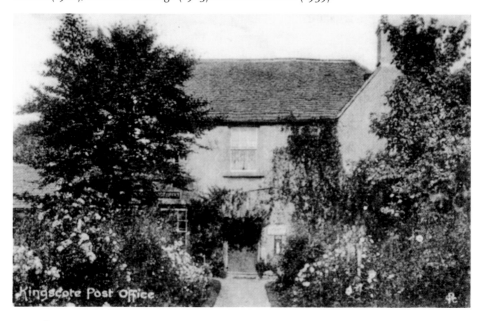

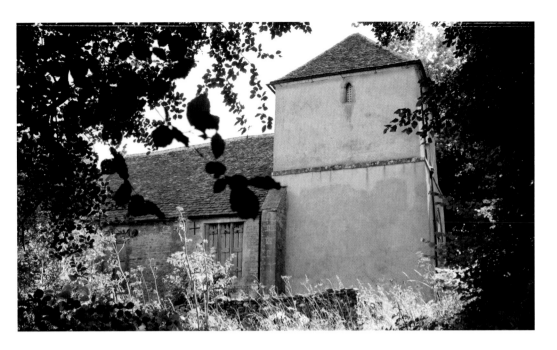

## St Bartholomew's Church, Newington Bagpath

In his memoirs, Parson Cornwall, who lived at Ashcroft House from 1827 until his death in 1872, described Bagpath as in a spiritually dark state. He describes how the services at the twelth-century church, St Bartholemew's, were scant – one a month if lucky – and that a large congregation was eight! Situated at the top of a hill, apparently in the middle of nowhere, it was made redundant as a place of worship in 1977. The community wanted to keep the building and not have it demolished. As protection against vandalism it was boarded up by 1979. In 1992, it was noted by English Heritage as a building at risk and now in private ownership it is rumoured to be awaiting conversion into a dwelling.

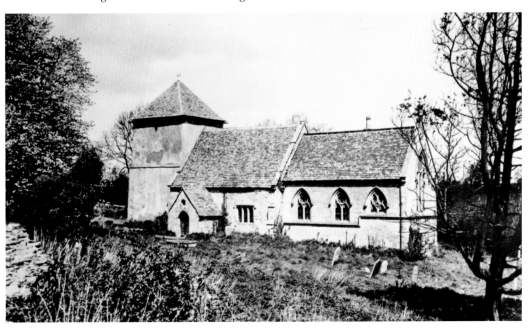

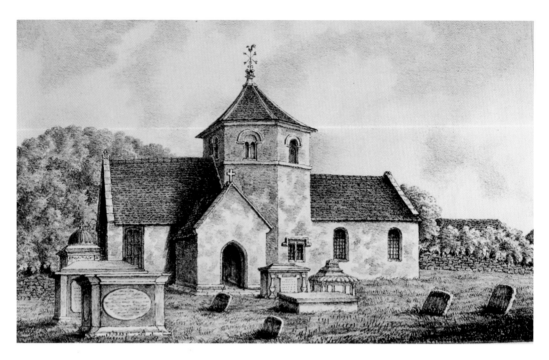

### St Nicholas' Church, Ozleworth

St Nicholas' church dates back to the twelfth century, with the lower section of the irregular hexagonal tower being the oldest part. It is thought to be one of the only two in England with such a tower, the other also being in Gloucestershire. Revd W. H. Lowder, an amateur architect, restored the church in the 1870s, extending the nave as can be seen in the new photograph, at a cost of £850. His brother, Revd Charles F. Lowder, was responsible for the building of St Saviours in Tetbury.

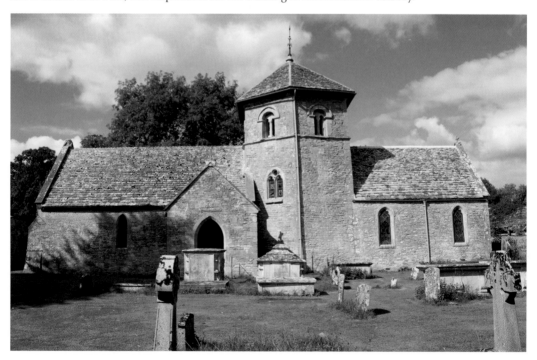

**St Nicholas' Church Interior, Ozleworth**
The Norman arch, visible in all three images, still gives testimony to the very early foundation of the building. The drawing from 1843 shows box pews and a coat of arms both of which are long gone. The postcard from around 1910 shows an interior where very little changed with maybe the exception of the addition of electric lighting. These interior furnishings were changed by Lowder as part of his alterations to the church.

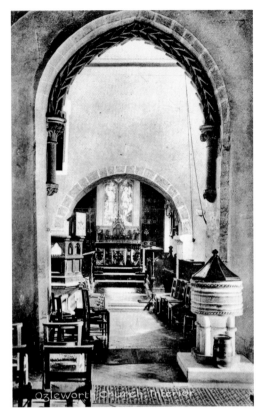

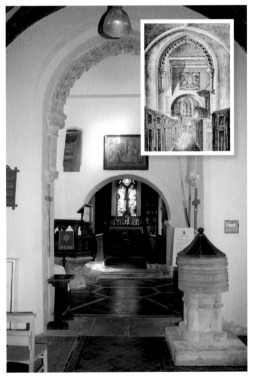

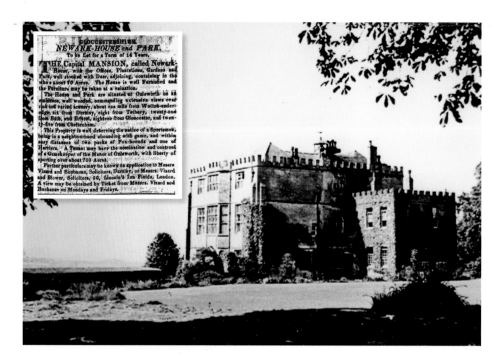

## Newark Park, Ozleworth

Originally a hunting lodge built in the mid-sixteenth century for Sir Nicholas Poyntz, Newark Park has been extended over the centuries to make it the magnificent house it is today. In the safe hands of the National Trust since 1949 it has been lovingly restored under the care of Robert Parsons (1920–2000) and Michael Claydon. For many years the house was let out to tenants. The advert from 1821 describes a 'capital mansion, called Newark House, with the offices, plantations, gardens and Park, well stocked with deer'. The neighbourhood was 'abounding with game', with two packs of fox hounds and one of harriers within easy distance.

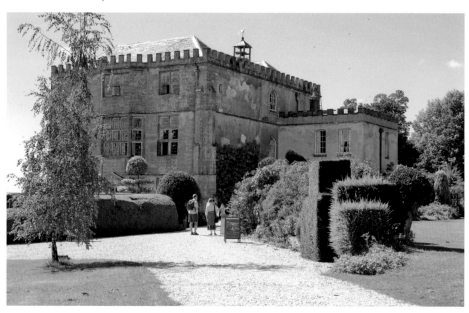

**Newark Park, Ozleworth**

This view of the south front from the gardens suggests that from the Gothic Porch there may be a view – and what a view! The front was remodelled by James Wyatt in the last decade of the eighteenth century, no doubt with this view of the Ozleworth Valley in mind for the then owner, Revd Lewis Clutterbuck. Paths weave through the gardens which were landscaped at the same time.

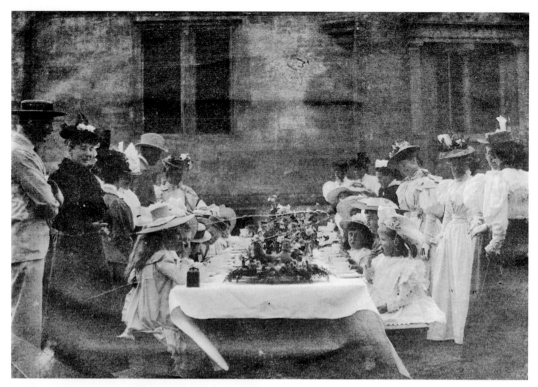

### Newark Park, Ozleworth

In 1893, an occasion on the lawn shows an unknown group of people, possibly a children's party. This photograph was found in the archives of Newark Park. The new photograph shows the detail of the magnificent Gothic Porch.

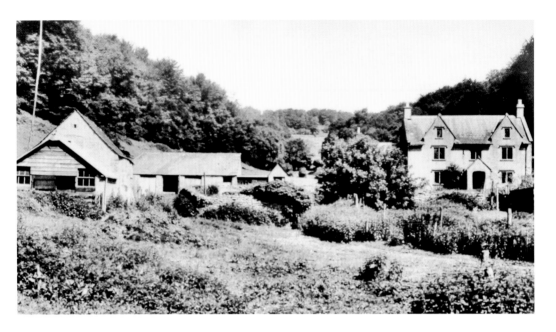

### Bulk Farm, Ozleworth

In 1947, Bulk Farm was for sale by auction as part of the Ozleworth Park Estate. The property came with just over 40 acres. Nestled at the bottom of a valley accessed by a narrow lane, life must be very peaceful and quiet. With it's origins in the eighteenth century, the cottage was enlarged in the ninteenth century and was at one time a school. By 1906, the children were attending Wotton-under-Edge and Bagpath schools. A chauffeur, Albert Watson, was living there in 1911, presumably employed by the family at Ozleworth Park.

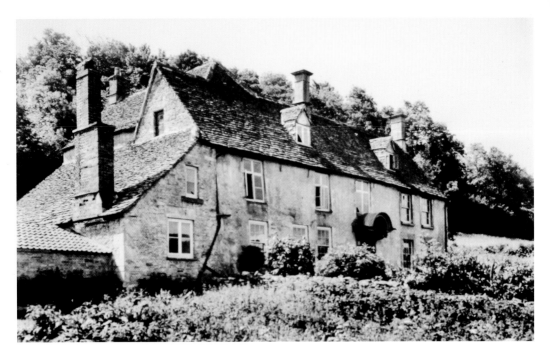

### Howells Farm, Ozleworth

Also sold as part of the Ozleworth Park estate along with Bulk Farm, Holwell Farm was just over 58 acres. The farm house is seventeenth century and was in more recent times the home of the late author Bruce Chatwin, who bought the property in 1966. It makes a distinctive sight with its red rendered walls, as it nestles on the gently sloping hillside, set amongst the woodlands of Ozleworth Bottom.

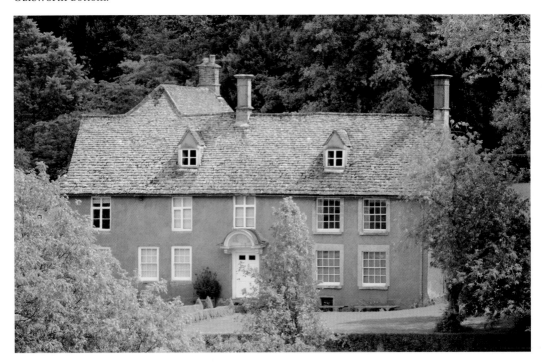

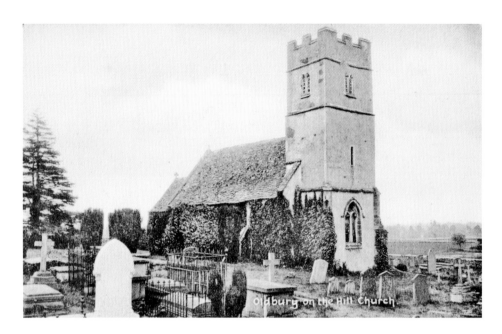

### St Arilda's Church, Oldbury on the Hill

The church of St Arilda in Oldbury on the Hill is another neglected treasure – on my visit one hot sunny day the churchyard was very overgrown. It was reached on foot via an old grassy track and you can imagine villagers walking up to the morning service along this very route. It is interesting that there are only two churches dedicated to St Arilda, both in Gloucestershire, the other being Oldbury on Severn. Since 1995, the church has been in the hands of the Churches Conservation Trust. The inset photograph is looking towards Manor Farm, which dates from the late seventeenth century.

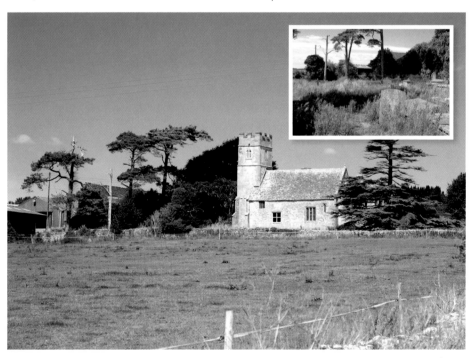

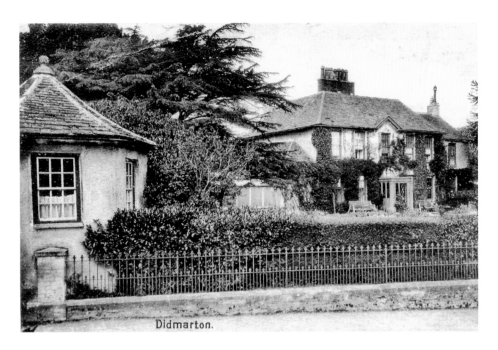

Didmarton.

## Kingsmead House, Didmarton

Kingsmead House is a fine mid-eighteenth-century house pictured here in the first decade of the twentieth century, and now hidden behind hedging and mature trees. The gazebo on the left of the postcard is octagonal and dates from the same period as the house, although it was looking a bit neglected when I visited. At one time the house was the home of Lord and Lady Westmorland, but other residents over the years include a JP, a high ranking army officer, and a retired yeoman, Edmund Rich, from the Tetbury family.

### Chapel Walk, Didmarton

Chapel Walk, so named because it led to the Congregational Chapel some metres beyond this image, is beautifully restored with the unsightly telephone wires removed, presumably underground. The very end house was at one time the manse for the minister and later became the schoolmaster's house. The one next to it was at one time a clockmakers, H. Yorke. Mr Sparrow, also a resident of Chapel Walk, began his bus service to Tetbury from here with the garage and petrol pumps at the junction with The Street.

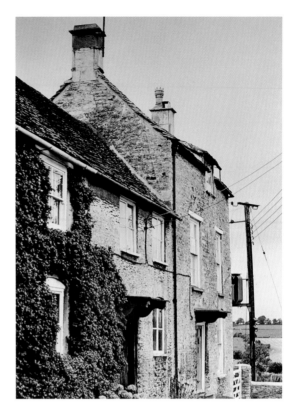

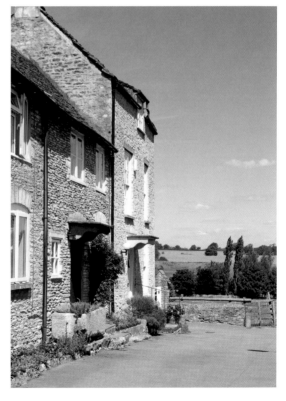

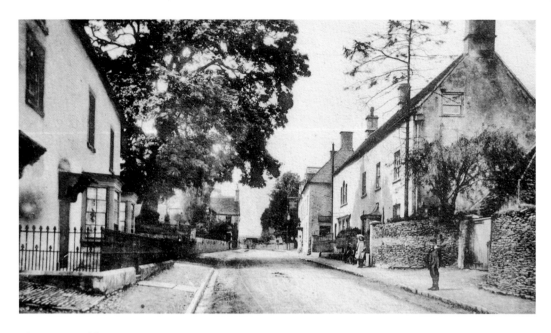

### The Street, Didmarton

Didmarton was at one time much smaller than nearby Oldbury on the Hill, but gradually became the greater developed settlement, perhaps because of the main Bath to Cirencester road that runs through it, called The Street. The furthest building on the right, the Kings Arms, is the only remaining public house in the village and was built in the seventeenth century. At one time it was a coaching inn that was rented from the owners, the Beauforts, for the princely sum of 6*d* a year. The house on the left is Didmarton House.

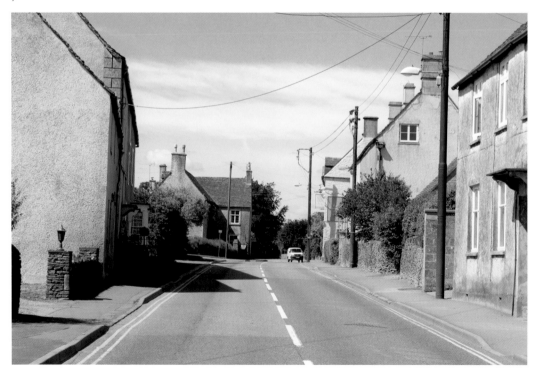

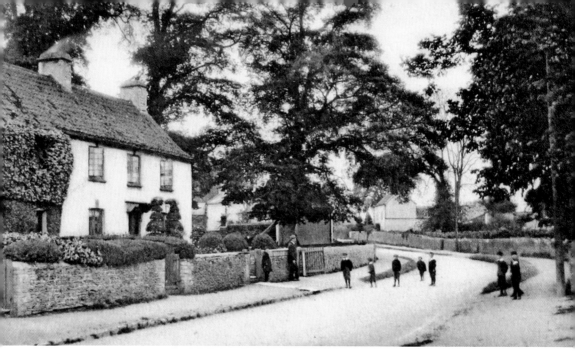

### The Street – Box Bush Cottage, Didmarton

Number 47, The Street, or Box Bush Cottage, the name of which becomes apparent if you look carefully, is shown here in the early part of the twentieth century. The arch created by the artfully clipped topiary is worthy of note and is well over 100 years old. To the right is the junction to St Arild's Road, a cul-de-sac of twentieth-century housing; at the time of this postcard it was undeveloped. Townsend's Farm is just visible at the top of the road.

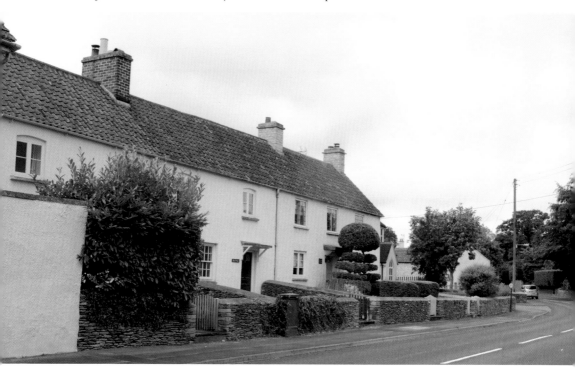

## Didmarton

This old view of Didmarton shows some of the more substantial houses with mounted riders on the lane in front. The new view is from Oldbury on the Hill looking towards Didmarton and shows the back of St Arild's Road. The horses posed beautifully after running up and down the field in front of the camera a few times and constantly checking to make sure I was watching them!

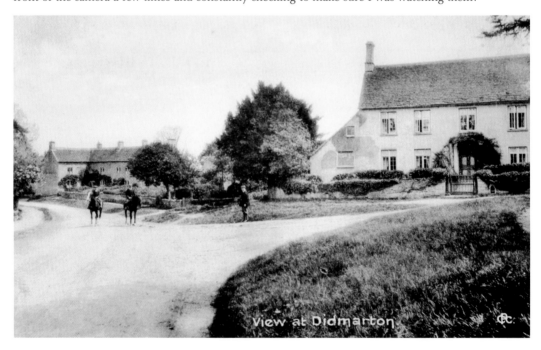

View at Didmarton

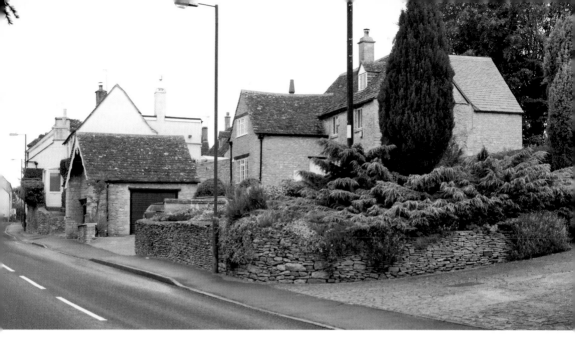

**The Street, Didmarton**

By the 1980s, the stone-built hut in front of these cottages had been converted to a garage with part of the boundary wall removed to give access. The sheep grazing the verge on the left of the old photograph shows how very quiet this road used to be.

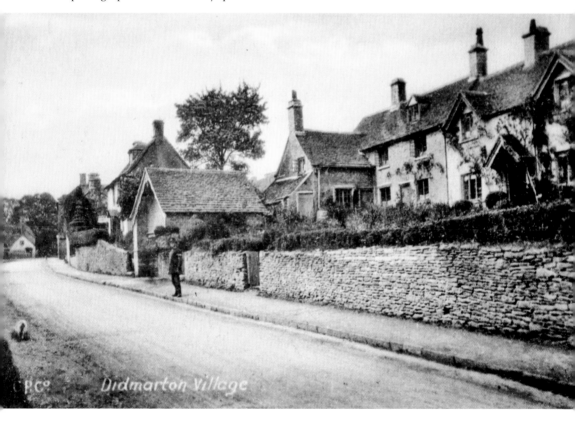

Didmarton Village

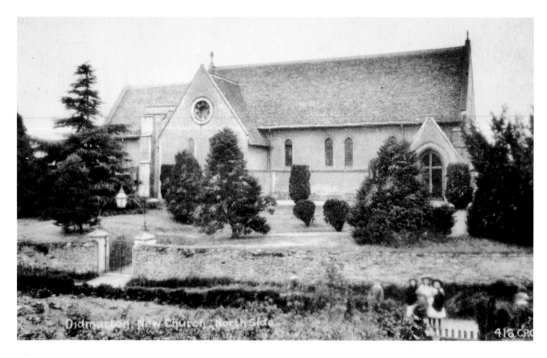

### St Michael's Church, Didmarton

The church of St Michael's was built in 1871–72 with Mr Francis Brown of Tetbury as the contractor, to the plans by T. H. Wyatt who was president of the Royal Institute of British Architects during this time. This church was to replace St Arilda in Oldbury and St Lawrence in Didmarton. To save any unnecessary division between worshippers of each parish it was built with half of the building each side of the parish boundary! In 1997, the building was converted into a house and worship transferred back to the old parish church of St Lawrence.

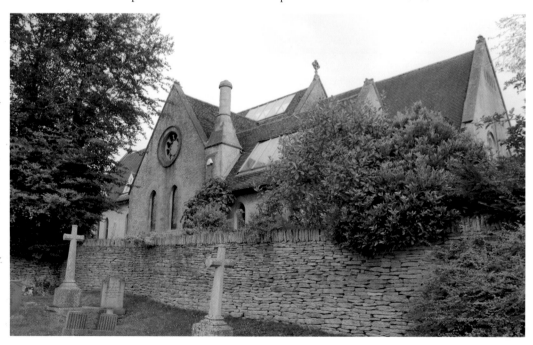

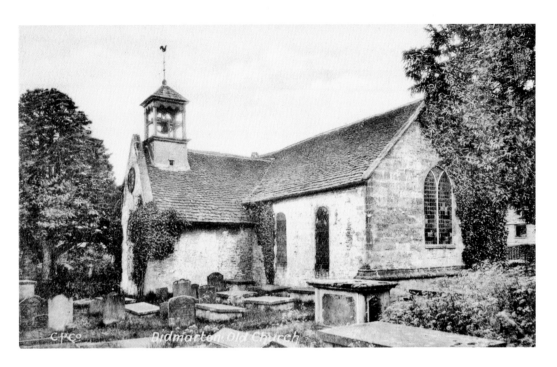

## St Lawrence's Church, Didmarton

The church of St Lawrence remained undeveloped due to the newly built St Michael's and was used as a mortuary chapel. Passing into the hands of the Redundant Churches Fund in 1981, the building was restored by a Painswick company, Gerrish Brothers. In 1992, it was passed back to the Diocese and with the addition of electricity was reopened for public worship. As can be seen from the interior photograph it retains its Georgian charm, which may have been removed had the Victorians not decided to build a new church instead.

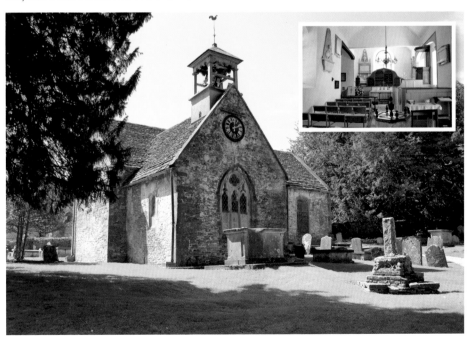

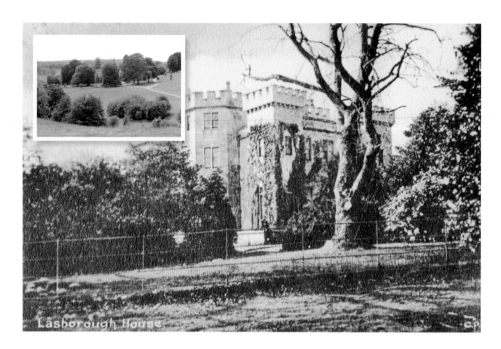

## Manor and Park, Lasborough

Lasborough Manor seen in the new photograph was built in the early seventeenth century for Sir Thomas Estcourt. Altered over the years with a large bulk of the house being demolished in 1862 by R. S. Holford, what we see today is only a small portion of the original building. The old image is of Lasborough Park in about 1910. At this time, according to the 1911 census, the family of seven had twelve live-in servants. This house was built in 1797 for Edmund Estcourt, the then current owner of the manor. At this point the manor, shown in the new photograph, became used as a farmhouse. It sits beside the church of St Mary which was used as the church setting in the popular TV drama *Larkrise to Candleford*.

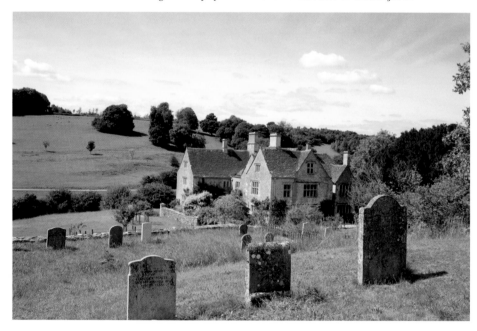

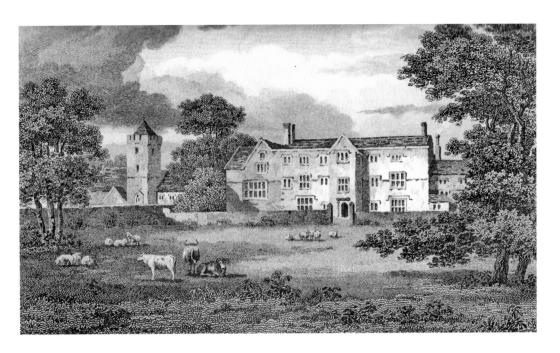

### Westonbirt House Pre-1813

The original house at Westonbirt, as illustrated in the print from 1813, was built in the late sixteenth century. Ownership at this time is un-established, but by the 1630s it had passed into the hands of the Crewe family. Within twenty-five years, John Crew had died leaving an only daughter, Sarah, who married into the Holford family some years later. Up until the demolition of this building in 1818, it was used as a farmhouse. The house was rebuilt on a slightly different site within five years, but this building was short-lived when Robert Stanyer Holford planned a grander house more in keeping with his millionaire status.

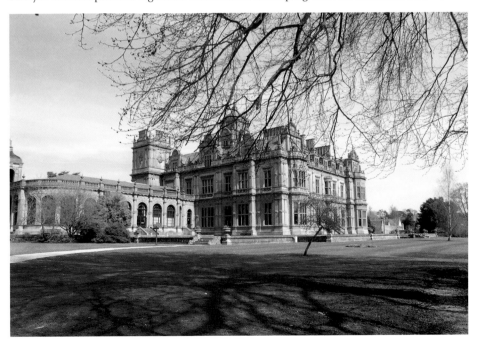

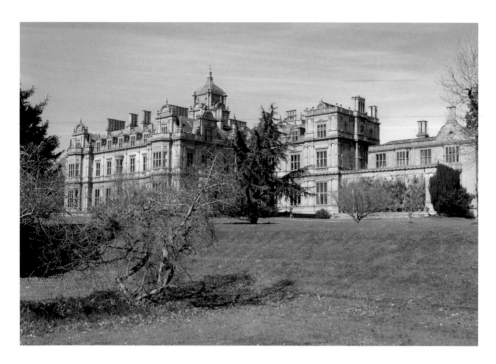

## Westonbirt House

Employing architect Lewis Vulliamy, the current house was constructed on the site of the former house and is the most important surviving domestic work of the architect. In 1863, the house built a few years earlier was pulled down and over the next eleven years the current house was built. Unfortunately, Lewis Vulliamy died before the work was completed. The working relationship between Holford and Vulliamy may have been slightly stressful; the brunt of Vulliamy's frustration at constant changes to the plans were being taken out on the poor clerk of works, Clement Thomas. The view shown here is of the south-east front.

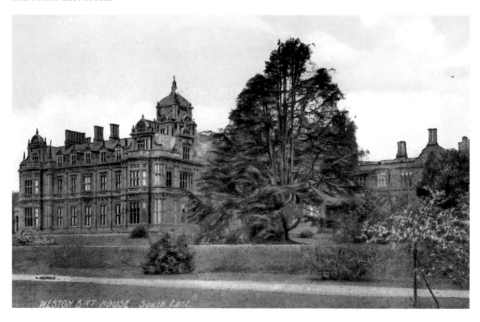

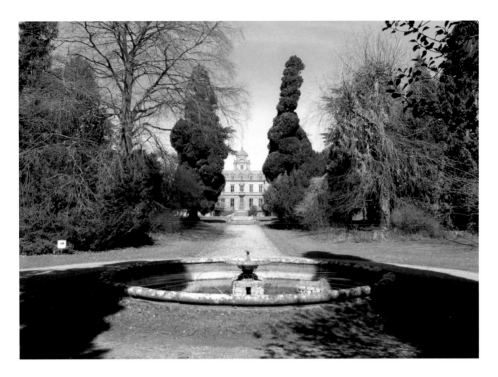

**Westonbirt House and Fountain Pond**

Many of the gardens are those that were laid out by Robert Holford in the 1840s, when he had first inherited the estate from his father. This photograph shows the Fountain Pond looking up towards the front of the house. Note the two gardeners next to the two evergreen trees, and compare with how tall these trees are today. The Holford Trust is gradually restoring as many features as their limited funds allow.

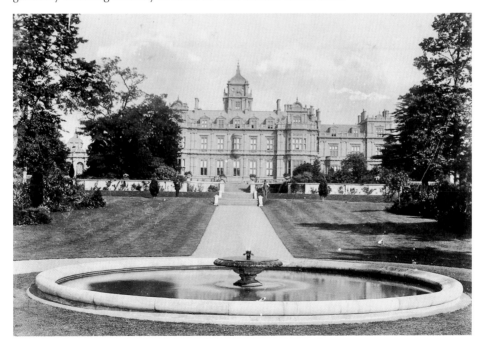

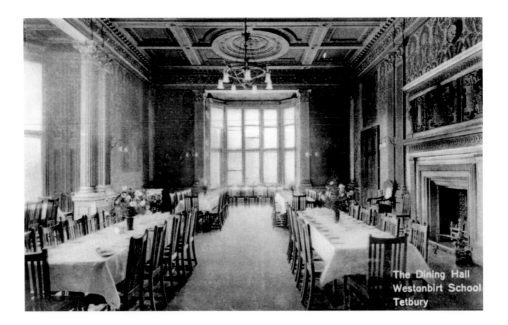

The Dining Hall
Westonbirt School
Tetbury

## School Dining Hall, Westonbirt

Not many homes as grand as Westonbirt stay in private ownership with rising costs of running such an estate, and when the 4th Earl of Morley inherited from his uncle George Lindsay Holford in 1926, he sold the property. In 1927, *The Times* reported on the sale to the Revd Percy Warrington (The Martyrs' Memorial and Church of England Trust), founder of Stowe School and Canford School, with the intention of creating a girls' school. This he did and Westonbirt School admitted its first pupils the following year. Restoration of the actual building continues both inside and outside, as can be seen in these photographs of the dining hall.

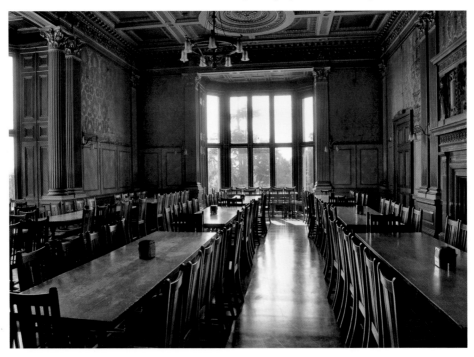

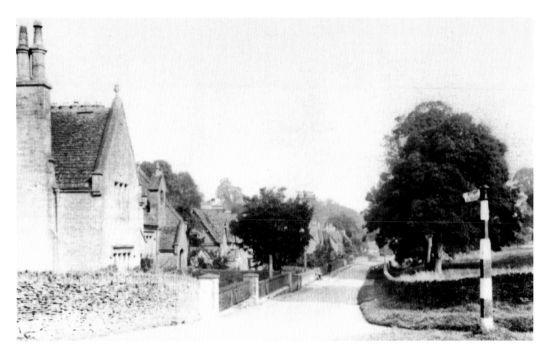

## Westonbirt Village

When George Holford inherited the house at Westonbirt and began his programme of improvements and the enlargement of the estate, he also redeveloped the farm buildings and cottages, the latter on a new site. The original site was closer to the church of St Katherine and is now a golf course. Here we see the cottages in the 1930s.

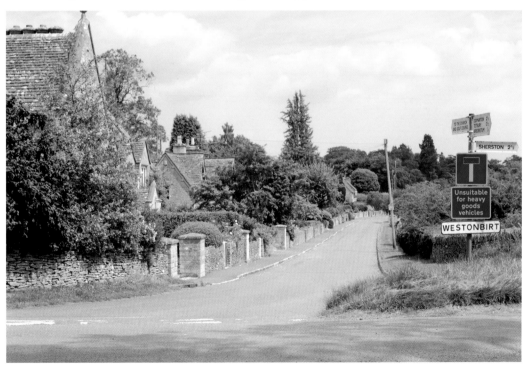

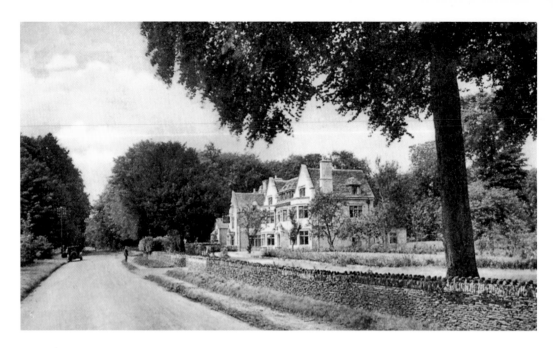

### Hare and Hounds, Westonbirt

The Hare and Hounds Hotel was built, or rather rebuilt, for George Holford by Vulliamy in 1854. Earlier references show it as a coaching inn on the main road between Bath and Cirencester. It was extended in 1928 by building a twenty-five-bedroom hotel on to the original inn. Landlords over the years have been Thomas Johnson, John Wells, John Neall and James Southgate. Banks, the local blacksmith family, had their forge by the inn for many years.

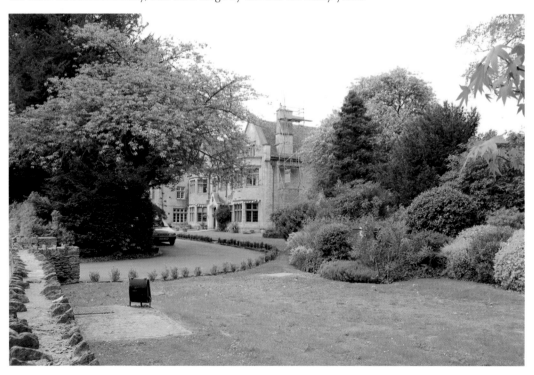

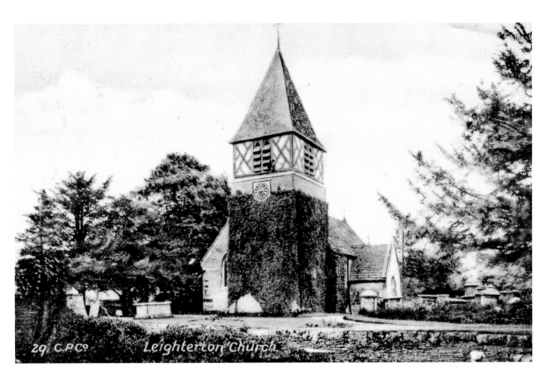

Leighterton Church

### St Andrew's Church, Leighterton

St Andrew's church dates from
the thirteenth century, with major
restoration taking place in 1876. The
timber-framed belfry was added by the
architects of this restoration, Waller &
Son of Gloucester, at a cost of £1,530.
Atkyns in his history of Gloucestershire
[1803] describes an 'octangular turret,
terminating in a point'.

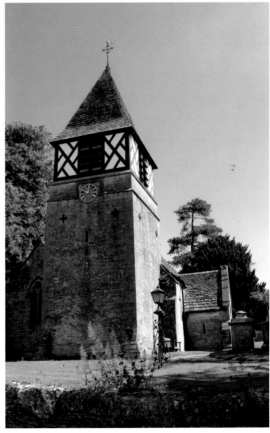

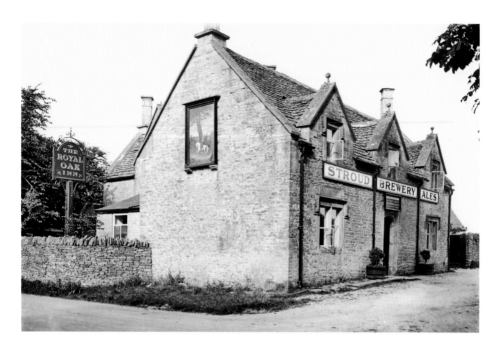

### Royal Oak, Leighterton

The Royal Oak is a nineteenth-century building probably built on the site of an earlier property, rumoured to be built with stones from the rectory at Boxwell. In January 1894 Esau King, a labourer from nearby Tresham, visited the Royal Oak Inn after attending the church service at St Andrews with his friend Caleb Evans. At about 10 p.m. they left for the walk home. Esau went on ahead and by the time Caleb caught up with him he had already fallen and was lying in the road. Caleb tried to get him home for several hours but finally gave up. Esau was found dead on the road the following morning. At the inquest it was stated death was due to exposure to the cold and Caleb was severely reprimanded for leaving his friend in this inhumane fashion.

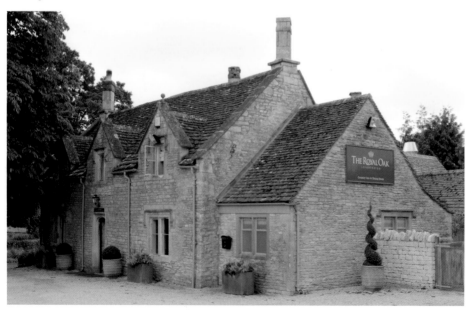

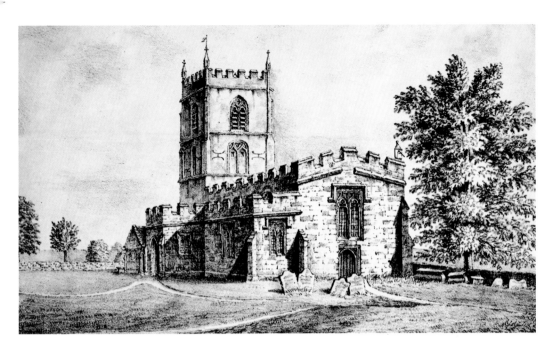

### St John's Church, Shipton Moyne

St John's church dates to the medieval period and was rebuilt in the 1860s by T. H. Wyatt for the Estcourt family. As can be seen from the modern photograph, the rebuild looks nothing like the earlier structure, which is another drawing from the 1840s. Wyatt moved the tower from the central position to the corner. The name of Shipton, as recorded in the Domesday Survey, comes from the sheep farming in the area, with Moyne added on a couple of centuries later when the Moyne family owned the Manor.

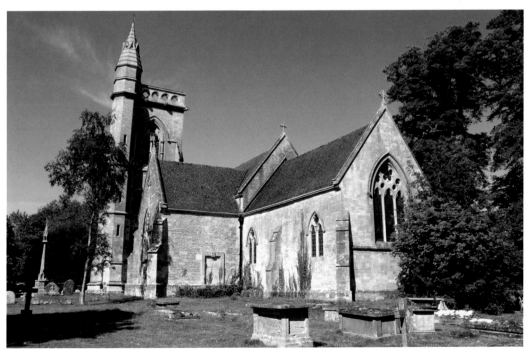

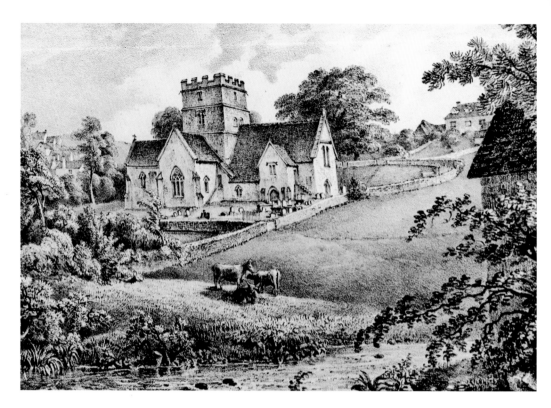

### Church of the Holy Cross, Avening

The Church of the Holy Cross is a Norman church which was restored by John Micklethwaite between 1902–06 following an earlier restoration in the 1880s. Much of the original Norman part has been preserved, as a reminder of those countless thousands offering their worship to God over the centuries. According to local legend, on the day the church was consecrated in the eleventh century, Matilda, Queen of England gave a feast of a boar's head for the builders and pig's face day is still celebrated in the village today.

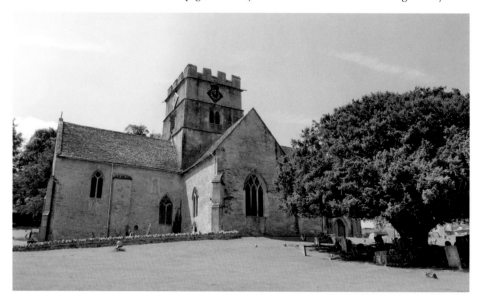

**Church of the Holy Cross Interior, Avening**

Inside there is a lovely atmosphere, embracing the modern whilst upkeeping the old, preserving centuries of tradition. The placing of some of the old Norman sculptures in the wall (see inset image) reminds you of those who have gone before, those who laboured long and hard to create a thing of beauty well before some of our modern tools were at our disposal.

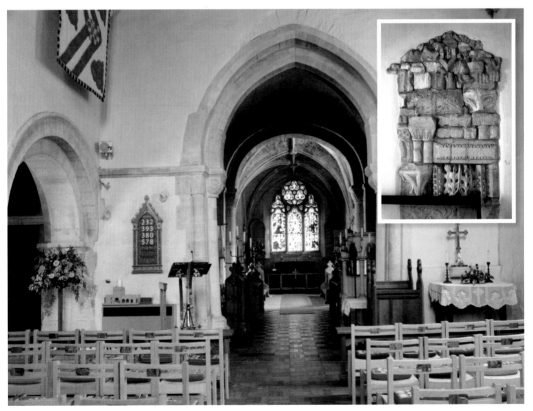

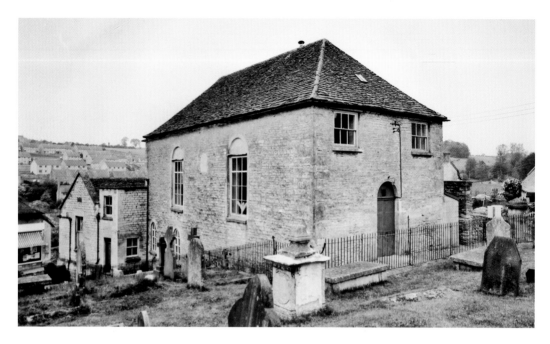

## Baptist Chapel, Avening

Opened for occasional worship in 1805 and enlarged less than twenty years later, the chapel building still stands but permission was granted to convert it to flats in 2000. When Samuel Rudder wrote his history of the county in 1779, there were three non-conformist meeting houses licensed in Avening but this chapel was built for members of the Shortwood Baptists living in Avening as a more convenient location in which to worship. By 1819, they wanted their own permanent place of worship which resulted in the enlarging of the chapel building. The congregation grew but then declined until in the 1970s there were just ten members.

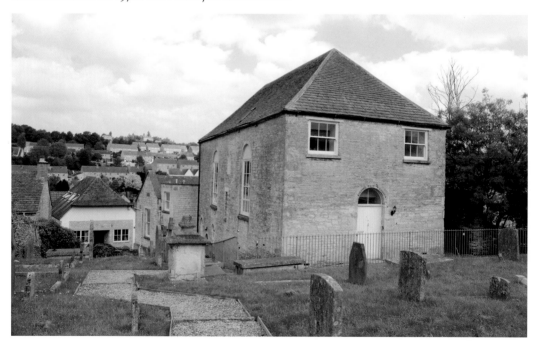

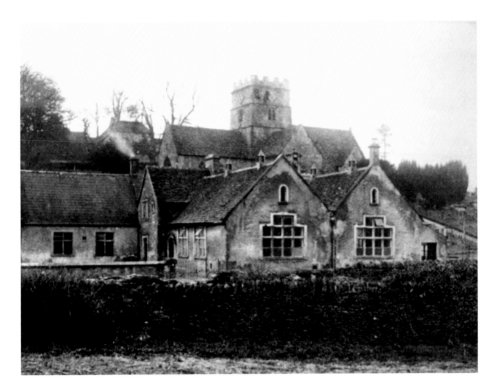

## Avening School

Avening school was built around 1842 as a National School and took in children already attending two charity schools in the village. Evening classes were also held and in 1894 the building was extended to accommodate the expanding roll. By 1910, this stood at 110 children in attendance and Alfred Morris was the headmaster. Today there are four classes catering for ages five to eleven, and a good range of thriving afterschool clubs.

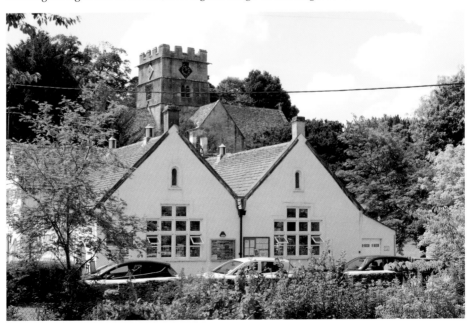

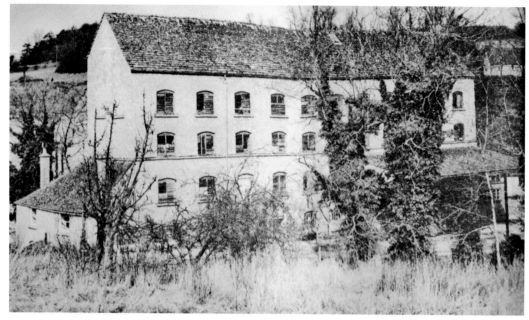

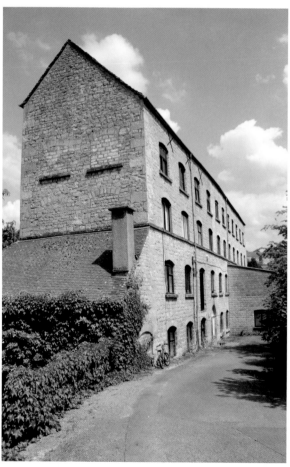

## Avening Mills

In 1826, William Cobbett describes the valley running down from Avening to Nailsworth thus: 'of a great many factories, steam engines as well as water mills, but that the drying racks were all empty, trade at a low causing a great many to be thrown upon the parish'. This imposing building, built along the stream which runs through the village, was built in the early nineteenth century. It has been a cloth mill, silk mill and corn mill, and in the 1980s a paper mill. Surrounded now by Sandford Leaze, a housing development of the 1970s, it still stands proud on the landscape as a reminder of the past.

### Woodstock Lane, Avening

The junction of the Nailsworth road and Woodstock Lane is shown here in 1956, where the horse and cart were still in use to collect and deliver milk. The trees hide much of these nineteenth-century cottages today, offering privacy with the increase in traffic along the main Tetbury to Nailsworth road.

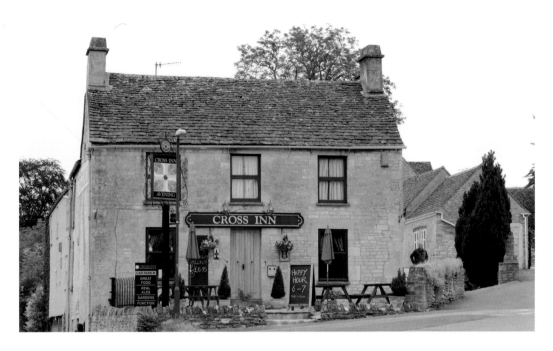

## Cross Inn, Avening

The sixteenth-century Cross Inn stands at the junction of two roads – one leading down the valley and the other up the steep hillside. In modern times, businesses have to diversify to keep going and none have done more so than this inn. Offering a good restaurant, skittles and good ale was not enough for the needs of the community so the pub landlord took over the role of village shopkeeper when the post office and village shop closed its doors in 2010. Glyn Crosthwaite converted a garage at the pub to offer newspapers and a basic food store.

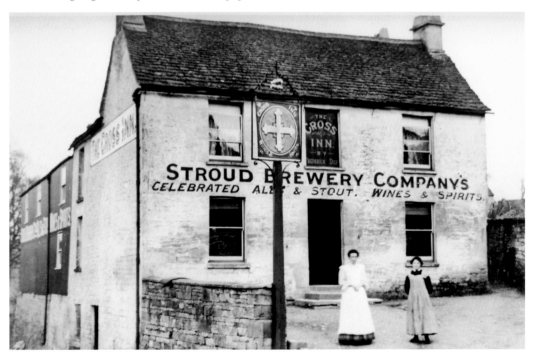

## Avening View

In the old photograph you can clearly see the Tetbury road climbing up the steep hill side on its way out of Avening. The new image, taken from Hampton Hill looking across to Tetbury Hill, shows the trees that now line the road making it blend into the landscape.

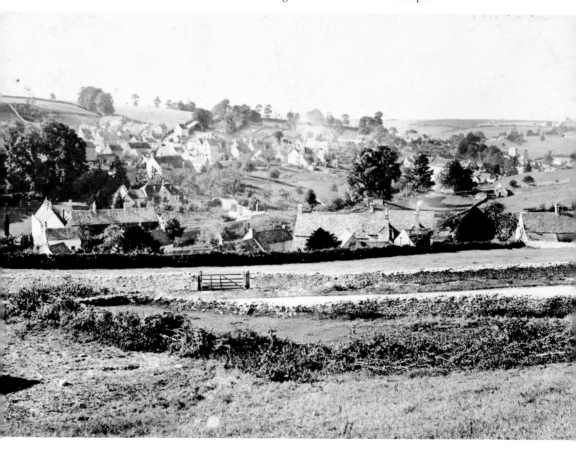

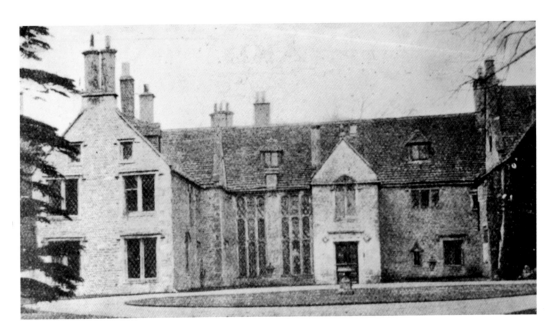

### Chavenage House, Avening

Chavenage House is Elizabethan in style, built on the site of a medieval building by Edward Stephens when he purchased the property in the sixteenth century. During the Civil War, Cromwell's troops stayed here whilst trying to capture Royalists at nearby Beverston. A popular location for film and TV productions, it has also been used in the TV drama *Lark Rise to Candleford*. George Thomas was the butler from the 1920s and spent two-thirds of his life in service at Chavenage. He recalled a time of many servants, parties and weekly dinner parties. In the days of the train, Mrs Lowsley-Williams would keep the trains waiting at Tetbury if she was running late instructing: 'Ask them, please, to hold up the train, Thomas!'

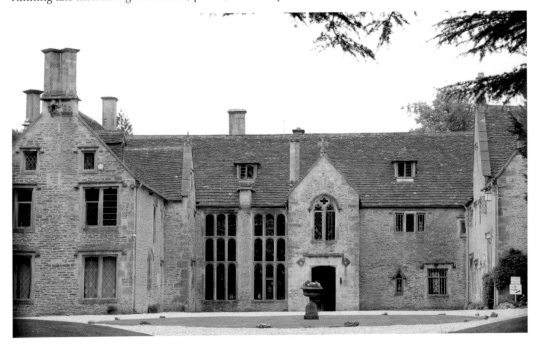

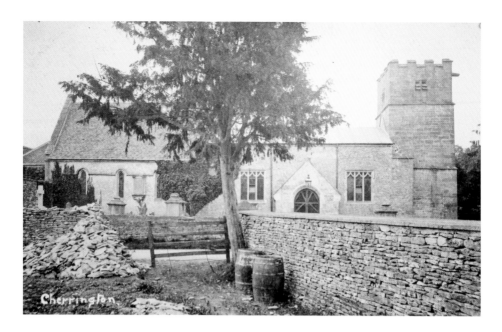

### St Nicholas' Church, Cherington

The Norman church of St Nicholas is now part of a united benefice with Avening, but relations between the two churches haven't always been so sweet. In December 1831, three 'Gloucestershire Bumkins by way of a lark' [quoted from the *Bristol Mercury* transported one of the four hundred weight bells to Avening church. A reward of 10 guineas was offered, and a policeman called from London to help the search, but it was not until July that the Avening churchwardens told those of neighbouring Cherington that the bell was in their belfry! The three men were sentenced to death but due consideration would be given to their previous good character. I certainly hope that they didn't meet their end all because of a 'lark'.

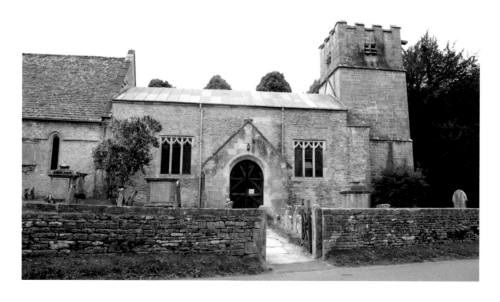

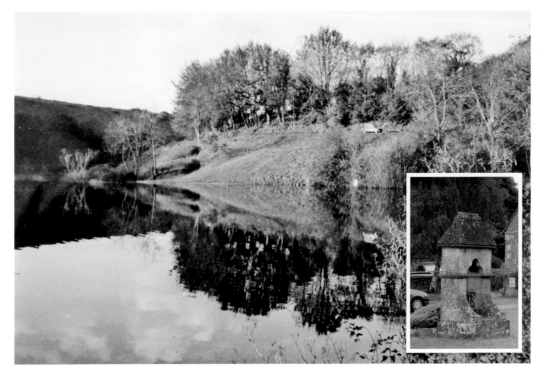

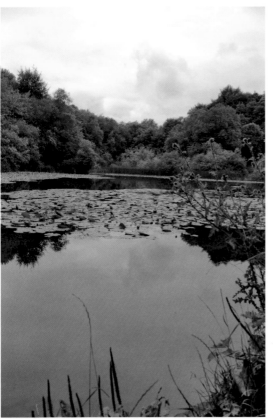

## Cherington Lake

Cherington Lake seen here in the 1970s, gathers water from the Avening stream and for many years provided water for the village by means of the village pump shown in the inset photograph. Originally dug out in the mid-eighteenth century, it now offers a place of recreation for fishermen and walkers. In the 1970s, the Tetbury Dolphin Angling Club rented the fishing rights, and in 2000 a Carp Syndicate held these. At one time boating and swimming took place as well as picnicking.

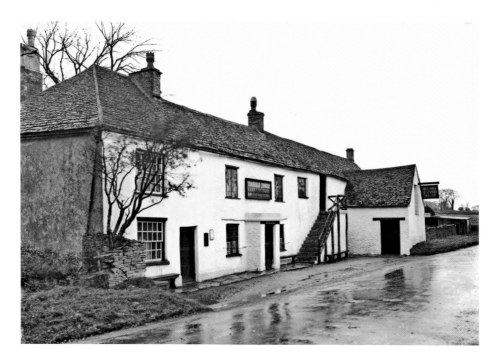

### Cherington Trouble House

The Trouble House Inn was built by a carpenter, John Reeve before 1757 possibly on the site of an earlier building and it has at some times had the name of Wagon and Horses. After the Swing Riots of the 1830s, when the mob descended on the inn the name stuck. In 1938 the delightfully titled book *Mr Prune on Cotswold* relates of an Aladdin's Cave full of very rare Bristol glass – 'rows and rows of it, glass walking sticks, if you please, glass bells, and glass wine decanters shaped like fat pigs...all of them gleaming in...ruby-red, deep Bristol blue, and gleaming amethyst'.

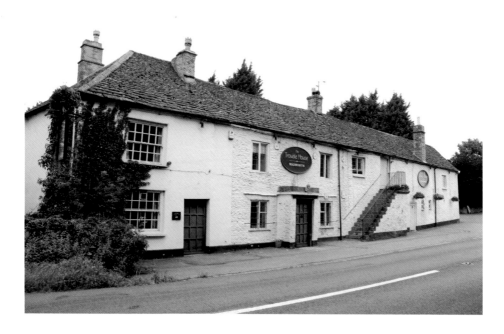

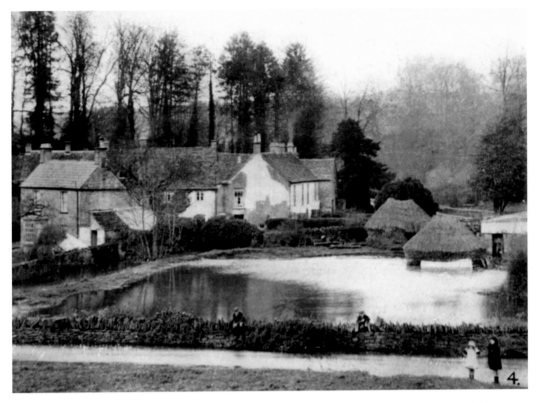

Photographed for the *Cheltenham Chronicle* and *Gloucestershire Graphic* in January 1926, the Aven stream was in flood and rickyards were submerged.

# Acknowledgements

Thanks to the following people and organisations for use of their material in this book. Bristol and Gloucestershire Archaeological Society Record Series Vol. 5, Bigland's Gloucestershire Collection Part 3; Cheltenham Family and Local History Library; the late George Love Dafnis (Bath in Time); Gloucestershire Archives; History of Tetbury Society; Jason Watt; John Peters; Lori Attridge, Grimsby, Ontario, Canada; Michael Claydon; Nick Kingsley; the late P. D. Turner; Paul Best; the late Peter Harding; Stuart Hilliker; Aileen Charteris.

Thanks to my husband, Nigel, for tirelessly proof reading and for the support and encouragement he gives to me.

I have made every effort to contact copyright holders.

at **RO** ... **US**

...tivities
...nt Café
...& Deli
**Gift & Card Shops**
**Countryside Information**

Pony Trekking

Land Rover Tours

Archery

Safaris on Foot

Biking

Camp & Caravan Park
T: 01479 812800

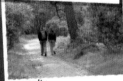
Family Activities

Gorge Walking

Walking

Speak to us **01479 812345**
Email us info@rothie.net
Book Online **www.rothiemurchus.net**

Special acknowledgements go to all our sponsors, without whom this book would not have been possible.

see pages:

| | |
|---|---|
| **Alvie Estate** | 12 & 271 |
| **Balmoral Estate** | 88, 208, 271 |
| **Cairngorm Mountain** | 216, 265 |
| **Dalfaber Golf & Country Club** | 36 & 263 |
| **Forestry Commission** | 220 & 247 |
| **Highland Wildlife Park** | 218, 251 |
| **Hilton Coylumbridge Hotel** | 50, 267 |
| **Ian Turner - Remax** | 273 |
| **Laggan Wolf Trax** | 18 & 255 |
| **Landmark Adventure Park** | 4 & 32 |
| **Pine Bank Chalets** | 269 |
| **Rothiemurchus Estate** | 1,24, 46, 200, 128, 228 |
| **Speyside Heather** | 230, 259 |
| **The Lost Gallery** | 66, 253 |
| **Walk Deeside Ltd** | 271 |
| **Waltzing Waters** | 236 ,257 |
| **Wild and Art** | 54, 247 |

**Published By**
Ice Publishing
Ossian Apartment
Kincraig
Inverness-shire
PH21 1QD
tel (01540) 651 419
icep@btopenworld.com

*Compiled by*: Tony Brown
*Editorial*: Tom Ramage

**Photography**
*As credited on pictures
otherwise pictures by:
Ynot - Ice Publishing
Cover Picture: Ynot

**Printed By:**
Buxton Press
www.buxtonpress.co.uk

First Published: April 2008
ISBN 978-1-900916-19-6

©Spot On Cairngorms National Park
Where to Go. Ice Publishing.

The publishers (Ice publishing) have taken all reasonable measures to ensure the accuracy of the information contained in this publication. The information has been supplied by either each organisation listed or from information that is publicly available. Information may vary after the date of this publication going to print. The publishers (Ice Publishing) cannot accept any responsibility or liability for errors in or omissions from any information given or from any consequences arising therefrom.

*Cairngorms National Park*
*'Where to Go'*
*is dedicated to the loving*
*memory of*
*LYNN*
1946 - 2007

*Footnote:*

Putting this book together, I spent months visiting every corner of the Cairngorms National Park, and I was staggered to learn just how much there is to see and do in the park's boundary - frankly, anyone who can't get an interest fix here should take up brass rubbing with a blunt nail!

There is something here for everyone no matter what age: teenagers Becky and Sam Mccash from Dundee can confirm this - while they are out exploring one of the adventure parks, mum Nikki is content to chill in one of the many leisure centres. So don't delay, get here today!

A special thanks goes to everyone who supplied information for this book, your support helped enormously.

Finally a very special mention goes to all those who have had to put up with me while I was compiling this book: Bruce, Cara, and Brac, my sister Anita, Johnny and Tom, the MacDonald family, the Capuano duo, the Turner clan and Mary Cowie. Thanks to you all.

Tony Brown

www.landmarkpark.co.uk

*Lots of great attractions for everyone*

fun discovery and adventure

**ROPEWORXS ***
An amazing aerial
challenge (min height 1.5m)

**SKYDIVE ***
Climb and jump...what could
be easier? (min height 1.5m,
weight limit 19 stones)

**Unbelievable VALUE**
Season Tickets allow you to visit as often as you like
for only £8 extra on the day rate per person.

- Wildwatercoaster *
- Microworld
- Climbing Wall *
- Tree Top Trail
- Steampowered Sawmill *
- Clydesdale Horse *
- Fire Tower
- Ant City Playground
- Forest Activity *
- Maze
- Red Squirrel Trail and feeding area

**Landmark**
FOREST ADVENTURE PARK

*"Scotland does have a theme park it can be
proud of ... it's fantastic ... Check it out"*
Donald Macleod, Daily Mirror

CARRBRIDGE, INVERNESS-SHIRE  0800 731 3446
Shop, Restaurant & Snack Bar - Open all year (except * open Easter - late October)

# Cairngorms National Park
# Where to Go

## Contents

# Introduction

## Where to Go in the Cairngorms National Park

**Key to symbols used through out the book**

 Gardens

 Wheelchair Access

 Take care water feature

 Restaurant or Cafe

 Toilets

 Take care steep banks

 Parking at, or nearby

 Shop

 Good picnic site

 Be responsible, forest fire risk

 Minimum age restrictions

 Good view point

The Cairngorms National Park has an endless array of delights and it doesn't matter the time of day or year - whether you want to be indoors or out, actor or spectator, spender or spendthrift, you will certainly find something for you and yours in this magic corner of the world.

The Park's as varied as it is vast, covering some 1467 sq miles from the east at Dinnet, south to Glenshee, on to Dalwhinnie and up to Grantown-on-Spey.

You are gloriously spoilt for choice here, with galleries, castles, museums, whisky distilleries, wildlife visitor centres galore, all fashioned into a landscape steeped in history, tradition and folklore - not to mention the very latest star television status (don't miss a trip through the "Monarch of the Glen" country made world famous by the favourite up-date of Compton Mackenzie's classic novel).

 **Possible risk of falling masonry**

 **Closed to the public**

The evocative Cairngorm mountain range with its evergreen forests, its fabled heather-clad moors, scintillating lochs and snow-capped peaks has inspired a wonderfully rich Highland culture.

*Your highland heritage
trail starts here!*

# Towns & Villages in the Park

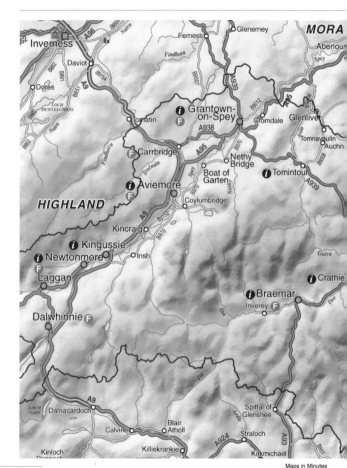

Maps in Minutes

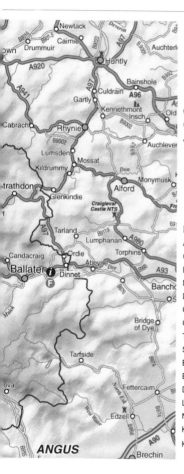

*ℹ* Tourist Information Offices

*🅖* Fuel Stations

— Park Boundary

## DISTANCE BETWEEN VILLAGES

Aviemore to Carrbridge - 6 Miles
Carrbridge to Boat of Garten 4 miles
Boat of Garten to Nethy Bridge - 4 miles
Nethy Bridge to Dulnain Bridge - 3 miles
Dulnain Bridge to Grantown - 3 miles
Grantown to Tomintoul - 14 miles
Glenlivet to Tomintoul 9 miles
Tomintoul to Strathdon - 18 miles
Strathdon to Ballater - 18 miles
Ballater to Braemar - 16 miles
Braemar to Dalwhinnie - 70 miles
Dalwhinnie to Laggan - 8 miles
Laggan to Newtonmore - 8 miles
Newtonmore to Kingussie - 3 miles
Kingussie to Kincraig - 6 miles
Kincraig to Aviemore - 6 miles

# Activities

When it comes to being active, there are few places in Scotland that can match the exciting range of activities in the Cairngorms National Park.

There are a number of large highland estates offering a host of attractions from sheep dog trials, horse riding and pony trekking, fishing, archery, guided wildlife tours and ranger-led walks. Some estates even offer special themed holidays such as photography and painting courses like those offered on the Royal Balmoral Estate in Ballater.

If you are an adrenaline junkie, you're sure to get a good fix when you visit one of the many activity centres providing watersports, climbing, snowsports, swimming and even gliding over the Cairngorms. The Extreme Dream Climbing centre is a new and exciting place to visit and caters for kids as wells as adults. The Loch Insh Watersports centre in Kincraig offers numerous activities including watersports and wildlife boat tours across Loch Insh.

It's all here and centres are open all year round, but one should always call in advance or visit web sites to get the very latest information.

pic - © Landmark Adventure Park

# Alvie Estate

Located on the edge of the Cairngorm National Park, Alvie & Dalraddy Estates total some 13,000 acres of land stretching from the River Spey, northwest over the Monadhliath Mountains to the watershed between the Dulnain and Findhorn rivers.

The estates provide a wide variety of habitat from the loch side wetlands of Loch Insh and Loch Alvie through farmland and pine woodland, up through the heather clad grouse moors to the high moorland tops, all spread around its central feature, Alvie House - an Edwardian shooting lodge.

As well as being a working estate providing forestry, landmapping & farming, it's is also a great place to explore, offering many exciting outdoor activities. In addition to traditional country sports there are opportunities to participate in the following:

**Clay Pigeon Shooting -** Enjoy a few hours shooting, in a rural Highland setting. The layout comprises traps for "Down the Line", "Driven Grouse", "High Pheasant" and "Springing Teal", with full instruction and equipment provided.

**Archery -** For budding Robin Hoods & Maid Marions Alvie offers fully qualified archery instructors with tuition and all the necessary equipment provided.

**Horse Riding -** Experience adventure on horseback at Alvie Stables. Superb riding is on offer through miles of magnificent countryside for both novices and experienced riders. To book direct call Ingrid on; 07831 4953397.

**Estate Tours -** General or specific tours of the Estate can be arranged lasting from an hour to all day. The tour can include visits to the working hill farm with its sheep and cattle, native pine and commercial woodlands, the fish hatchery, soft fruit farm at Alvie Gardens, the granite and slate quarries, the ancient standing stones, and a dam and water driven turbine that was once used to provide the estate electricity. There is always the possibility of seeing all sorts of wildlife including red deer, grouse, buzzards, oystercatchers, red squirrels and blue mountain hare.

**Fishing -** Loch fishing from a boat or from the bank. Loch Insh provides salmon, arctic char, brown trout and pike, while Loch Alvie and Loch Beag contain brown trout and pike.

**Facilities, opening and contact:**
Open all year and as well as activities, there are a number of well-appointed accommodation options with self-catering chalets, caravans and tent pitches.

**Location:** ●
The estate is 4 miles south of Aviemore.

tel: (01540) 651 255
www.alvie-estate.co.uk

# Cairngorm Sleddog Centre

The Cairngorm Sleddog Centre is the first and only one of its kind in the UK.

A few miles from Aviemore on the Rothiemurchus Estate, it's open all year round and contrary to popular belief, the dogs don't need snow to run on, they are just as happy pulling on wheeled sledges!

There are around 36 dogs from all over the word, such as Alaskan and Siberian huskies & Alaskan/Pointers and you are invited to go along and meet them before taking a trip in a buggy pulled by a team of 12 dogs across remote parts of the estate - and it isn't just day trips, the adventure can also be laid-on at night.

You can choose from a number of options, such as the trip entitled The "Sleddog Experience" These are great fun and last for around 20 minutes.

You can talk with the musher, and get hands-on on with the stars of the show. (Based on 2008/9 prices so call for latest rates). The "Sleddog Experience" from £60.00per person - under 16 yrs £40.00.

In the future the centre will offer a remote & unique Sleddog training trip, which will be the only one of its kind in the world. 2 visitors will be strapped into a a specialized Sleddog off-road, roll-caged trailer hitched up to a 4 x 4 training bike and the centre's best dog team & taken out for an hour on extreme trails. "The No Fear Sleddog Experience" will cost from £150 per person.

**Facilities, opening and contact:**
Open daily all year, but you do need to book ahead.

**Location**: ●
Form the roundabout at the south of Aviemore, travel 3 miles east pass the clay pigeon shoot on the right. Then 3/4 of a mile on you will see the centre sign. Park on the left and wait to be collected. The centre is a short 20-minute walk from the car park.

tel: 07767 270526  www.sled-dogs.co.uk

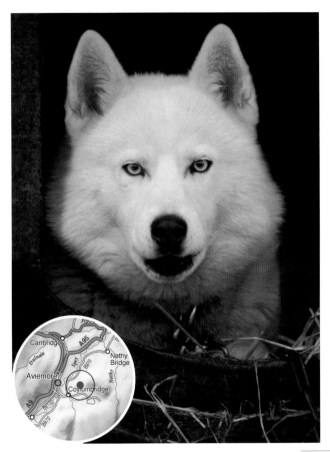

# Extreme Dream Climbing Wall

● Aviemore

Open all year round, the extensive adventure programme includes the very popular taster sessions (from £20) designed to give an exciting introduction to the world of Indoor Climbing. The Extreme Dream climbing wall has 42 ropes of climbing with over 160 challenging climbs to choose from.

They offer world class coaching for kids and adults on an hourly rate on a short or long term basis. Outside, Extreme Dreams activities are unique with the adventure River Raiders (3 hrs - £35), a high ropes course with Zip Lines, Tyrolean traverses and via Ferrata over the spectacular local gorge with a 250 year old bridge. Crag Rats (3 hrs - £35) is an insane crawl through tight squeezes and dark passages at a secret location and is an excellent fun intro to caving and climbing. There are also brilliant rock climbing sessions outside at superb local cliffs from £35.

**Facilities:**
Bouldering, Top Rope and Lead Area, Training Area, Film Zone and Viewing Gallery, Café, Climbing Shop, Dave Cuthbertson's Photo Gallery, Changing Facilities, Showers.

**Located** ● At the North End of Aviemore in the Dalfaber Industrial Estate

tel: (01479) 812466. See film of the centre and activities at: www.extreme-dream.com

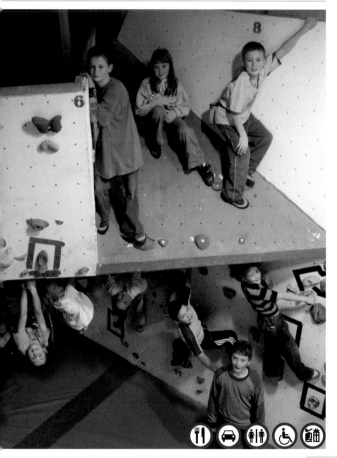

# Laggan Wolftrax Mountain Bike Trails

● Laggan

Laggan Wolftrax is a great mountain bike centre in Laggan, developed by the Forestry Commission Scotland in partnership with the Laggan Forest Trust. Set in a magical mixture of mature forest and open country - with fantastic mountain views - there are trails here to suit everyone, from novice to expert.

A series of trails are graded much the same as ski pistes: green for novices, red for intermediates and a double black diamond for the real expert. There's also a bike park, graded orange, which is half way between a blue and a red in difficulty. It can be freewheeled from top to bottom but note - this trail is not recommended for very young children. The red route has some easily bypassed black features to test the more adventurous intermediate riders, while the double black diamond trail is for expert riders only and will test your mettle. The black trail has some serious drop-offs and steep sections and is definitely not for inexperienced riders. Note - rider protection is strongly recommended.

**Facilities:** Adult bike hire from £20/day, child bike hire £15/day. Bike shop, café and toilets open daily. Check the website for information. tel: 01528 544 786, www.basecampmtb.com

**Location** ● Located 1 mile past Laggan along the A86 towards Spean Bridge.

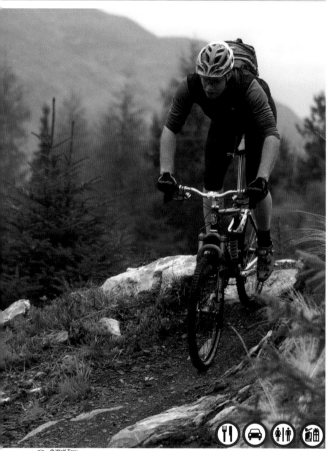

pic - © Wolf Trax

# Loch Insh Watersports

● **Kincraig**  STB ★★★★ **Visitor Attraction**

The Loch Insh Watersports Centre in Kincraig caters for just about every outdoor activity that you can think of, from sailing to archery.

The centre caters for individuals, families or groups offering sailing, windsurfing, kayaking, canoeing and river trips. Sailing is one of the most popular activities and accessible to everyone although there is minimum age of 6 for learning. Prices start from £10 an hour. Windsurfing is also popular with the option of an hour's lesson or a 2 or 5 day course, prices from £17 an hour. Kayaking and canoeing are possibly the easiest way to get active at Loch Insh. For those who wish to go further afield then a river trip in a canoe along the Spey is the way to do it, with a number of options available and no experience necessary (book in advance).

Fishing is another popular activity on Loch Insh where pike, salmon, trout and arctic char can all be found. The centre has its own well-stocked lochan, which was custom built for fly-fishing and is ideal for children. Instruction and rod hire is available. Early morning and late evening hires also available. One day's rod hire from £18 per day.

Wildlife enthusiasts can get up close by taking a wildlife boat tour and see goldeneye, wigeon, teal, mallard and tufted ducks. You may well see an osprey fishing. Binoculars and a wildlife identification leaflet are provided. It's possible to get a wheel chair down to the boat although some assistance is required to board. Adults from £8, kids from £6.50.

Other actions sports include skiing and snowboarding either on the dry slope or on the Cairngorms. Mountain bike hire is also available: the centre has bikes for all ages plus two child seats & junior link ups. Bike hire starts from £13 for half a day or £18 full day. Archery with tuition costs from £14.50.

**Facilities, opening and contact:**
To find out about costs for instruction go to the centre's web site. The restaurant and bar over looks the loch and along with the shop are open daily all year - call for times. Accommodation is also offered for individuals and groups, see the web site for details. Disable access to the centre is very good and you can get down to the loch side.

**Location:** ●
The centre is 1 mile from Kincraig and 7 miles from Aviemore.

tel: (01540) 651 272   www.lochinsh.com

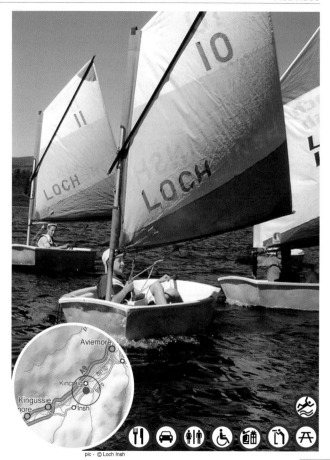

pic - © Loch Insh

# Loch Morlich Watersports

● **Glenmore** - *Aviemore*

It's surrounded by thick forest, but Loch Morlich is clearly popular. And for all sorts of reasons, including walking, picnicking, sunbathing. But its most popular draw in the summer months is the watersports centre, offering instruction in sailing, wind-surfing and canoeing. You can also go mountain biking or fishing.

The centre sits a few metres from the water's edge, and on hand are friendly staff and instructors. The centre has a fleet of Laser Picos, Fun Boats and Optimists. The different boats in the fleet offer a range of performance for all ages and abilities.

A 2-hour sailing lesson costs from £25 an hour, while a 1-hour windsurf lesson with board and wetsuit costs from £40. Full equipment hire without instruction is also available - check the website for prices.

For those who want a bit more, there are a number of courses available for junior, adult and family, run over various days.

**Location** ●
Form Aviemore, travel for 6 miles along the Cairngorm road and turn right in to the car park. Then walk to the beach.

**Facilities,** Cafe, toilets, picnic sites and shop

tel: (01479) 861221  www.lochmorlich.com

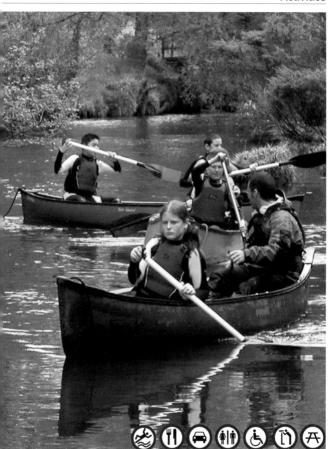

pic - © Loch Morlich

# Rothiemurchus

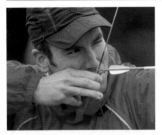

Rothiemurchus is an extraordinary Highland estate located just 5 minutes from Aviemore. It has an excellent reputation and is regarded by many as one of the finest outdoor recreation centres in the North of Scotland.

This fantastic place presents a unique blend of stunning landscapes, wonderful wildlife and exciting outdoor activities in an area of outstanding natural beauty. Set in breathtaking surroundings comprising beautiful lochs, rivers, moorland and forest you can enjoy over 30 different activities.

This is a great place for groups, families, couples or individuals and with such a diverse range of activities to choose from each person can choose to do their favourites. Whether you wish to cruise around Loch an Eilein in a Canadian canoe, explore behind

the scenes of the estate on a safari on foot, hand-feed the deer on a Land Rover tour, enjoy a superb quad bike trek or have a fly-fishing lesson there is something for everyone.

Rothiemurchus is a great place to walk and the safaris on foot are the best way to see the estate. Guided by a knowledgeable Ranger the walks can be tailored to your specific interests, or you can let the rangers take you on an unforgettable journey around the estate. If walking by yourself is more your thing, then pick up an Explorer Map from the Rothiemurchus Centre. This costs £1.50 and details 3 great walks around the estate. It also comes with an Explorer card which is valid for a week and gives you discounts around the place, free parking for 1 person at Loch an Eilein, a free postcard and discounts on clay shooting, fishing and in the farm shop. If you visit Rothiemurchus more often however, then become an annual Friend and receive a wide range of discounts on activities for a whole year. You can feel really good about becoming either an Explorer or a Friend as the money you spend goes towards caring and

## Activities at a Glance

**Archery**
**Astronomy**
**Canoeing**
**Clay Shooting**
**Deer Stalking**
**Family Activities**
**Fishing**
**Gorge Swimming**
**Gorge Walking**
**Hill Walking**
**Indoor Climbing**
**Land Rover Tours**
**Low Ground Walking**
**Mountain Biking**
**Pony Trekking**
**Quad Bike Treks**
**Safari on Foot**
**Rothie Rascals**
**Sled Dog Tours**
**Wildlife Photography**
**Wildlife Watching**
**4x4 Off-Road Driving**

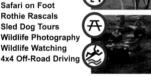

are available at Rothiemurchus include: pony trekking, 4x4 off road driving, archery, indoor climbing, astronomy, bat walks, mountain biking, sleddog trips, wildlife photography, wildlife watching, quad bike treks and clay shooting.

Set in absolutely breathtaking scenery and established for over 20 years, Rothiemurchus clay shoot is one of the best in the UK. Its exceptional facilities and top class tuition ensure that whether you are a complete beginner (12 years+) or a crack shot you'll have a sensational time. They offer lighter weight guns and low recoil cartridges for ladies and children so that everyone can have a great time.

If you fancy quad biking then book yourself onto a quad bike trek. Led by a fully experienced guide, your journey will take you along a stunning network of tracks and trails around the estate, through magnificent woodland, moorland and even through narrow stretches of the river, it's a great experience.

maintaining Rothiemurchus for future generations to enjoy.

Another way to see the estate is on a guided Land Rover tour. These are incredibly popular and people return time and time again requesting the same 'entertaining' ranger to drive them around. Not only will you learn all about the estates flora and fauna, its history and the people who live there you will have great fun too.

Other 'land based' activities that

For those wanting some adventure

# Rothiemurchus

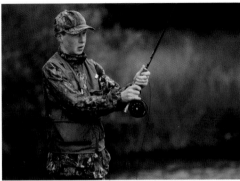

in the water then perhaps a spot of george swimming, gorge walking or even canoeing is more your thing? gorge swimming is great fun but don't expect to be jumping into heated pools, as the water in these parts are cold - but it's still great fun! Equipped with wetsuits, buoyancy aids and helmets this is a more 'adventurous' version of gorge walking. Fight your way upstream against the flow, clambering up small waterfalls, swimming through calmer sections and jumping into deep pools. When you reach the top just turn round and float or slide back down to the start. Instruction and super-vision is provided at all times. If this sounds a little too adventurous for you then perhaps you would be happier gliding around stunning

Loch an Eilein in a 2 man Canadian canoe. Paddle around the island with the castle in the middle of the Loch whilst perfecting your technique!

If you fancy a spot of fishing then you are spoilt for choice at Rothiemurchus. With numerous stocked lochs, rivers and streams to choose from and the chance to catch salmon, brown and rainbow trout, pike and char this offers a chance for both beginners and advanced fishers to enjoy a great day out. The professional and friendly instructors can give you a fly or bait fishing lesson or indeed guide you to some of the best fishing beats in the Cairngorms.

You can choose to fish in a

number of stunning locations from the River Spey to Loch Pityoulish, Loch an Eilein and the Hill Lochs to the Lily Loch. The Lily Loch is a great example of some of the fine fishing available at Rothiemurchus, stocked with naturally occurring wild brown trout, which are hard fighting, beautifully marked, in excellent condition and of a good average size. Fishing is by boat only, and only one boat is allowed on the loch at any one time, so you will need to book.

For those who just want a simple taster into fishing, then the alternative is the Rothiemurchus Fishery which is stocked with rainbow trout which you can either fish for or simply feed. Fly or bait, the fishery is great fun for the whole family whether you have fished before or not. The fishery, which is surrounded by stunning views of the Cairngorm Mountains, is located on the outskirts of Aviemore and within easy walking distance of the train station.

The fishery also offers a tackle shop, which is stocked with bait and equipment for hire and purchase. It's ideal for the visiting angler and also beginners wishing

to take up the art of fly-fishing. Rod, reel and line combinations are attractively priced for beginners, but also do have a look at the new Rothiemurchus custom-designed fishing equipment, which is now available.

**Facilities, opening times and contact**:
Rothiemurchus Centre has a gift and card shop, a farm shop & deli, restaurant, toliets and parking. Rothiemurchus welcomes visitors to the estate all year and is open daily (except Christmas Day):

You can find availability, book and pay for activities online at www.rothiemurchus.net Alternatively if you wish to speak to someone, you can either book over the phone (tel: 01479 812345) or pop into the Rothiemurchus Centre which is located along the road towards Cairngorm Mountain where the helpful member of staff can answer all your questions.

**Location:** ●
Rothiemurchus Centre is located 1 mile east of Aviemore along the Cairngorm road.

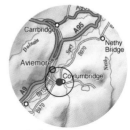

pics - © Rothiemurchus Estate

# Working Sheepdogs

Round up the kids and herd them into Leault Farm in Kincraig!

Local shepherd Neil Ross is renowned for his working sheepdog demonstrations.

They're staged daily, and you can watch up to eight beautiful beasts driving sheep and ducks, as trained by Neil who has featured several times on the much-loved TV series 'One Man and His Dog'.

The shepherd is a mine of information on sheep-farming, with plenty of practical advice on how to shear sheep and bottle-feed their lambs, etc.

The one thing guaranteed to put a smile on the kid's faces is a meeting with the friendly collie pups, which love to play - and melt hearts!

Souvenirs are always available after every demonstration, which tend to last for around 50 minutes.

**Location** ●
Leault Farm is located just off the A9 half a mile from the centre of Kincraig. Times vary seasonally, so call or visit the web to check.

tel: (01540) 651310
www.leaultfarm.co.uk

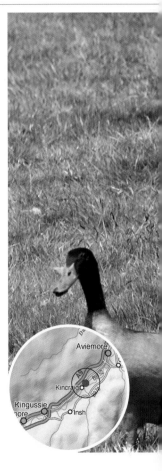

pic - © Sally Wallis

# Adventure Parks & Kids' Activities

Kids love to explore and there can't be many places better then the Cairngorms National Park to excite and interest them.

The hills, forests, glens and lochs are all alive with an abundance of wildlife to captivate the wee ones as they discover what's what.

The range of natural attractions to explore is awesome, from captivating walks around Loch an Eilein to the stunning views from the Cairngorms.

All the estates offer activities for children, such as gorge walking at Rothiemurchus to tractor rides at Balmoral Castle.

For kids who like to play, the Landmark Forest Theme park in Carrbridge is a must, as is The Fun House at Coylumbridge, while for kids who like to discover and learn about history, a day out at Balmoral Castle or a visit to the Highland Folk Museum in Newtonmore couldn't be better.

Fun at the Highlnd Folk Museum

For energetic children, there's the option to snowboard on the mountains, sail on one of the lochs, grass sledge on the hills, climb at various centres or play a round of golf at one of 11 courses.

Cara (the publisher's daughter) about to hit a hole in 1 at Dalfaber
Golf at Dalfaber

For children who like to take things a little more easy, there are dozens of easy to reach nature walks dotted all over the Cairngorms, with some stunning walks around Glenmore Forest to the wild trails around the the Glenlivet Estate.

Watersports on Loch Morlich

Centres providing family attractions also offer supervision and instruction. You will also be able to hire equipment and be supplied with safety equipment, such as safety helmets, and life jackets.

However, wherever you decide to take the children, they will have a great time and will soon want to come back!

BEWARE
FREE RANGE CHILDREN
SLOW

# Landmark Forest Adventure Park

● Carrbridge

STB ★★★★ Visitor Attraction

Seven miles north of Aviemore at the southern end of Carrbridge lies the Landmark Forest Adventure Park, which is undoubtedly one of the top attractions in the park. Kids of all ages, and adults, will love it here, with a host of attractions to explore, climb and discover. The 30-acre site is a superb outdoor activity centre right in the forest, with lots of fun activities ranging from water slides to treetop nature walks. There are numerous climbing frames, a parachute jump and two challenging high-wire courses.

There is enough going on that 3 hours will not be enough time to do it all. You can explore the ancient forest and follow the red squirrel trail and visit the feeding area. Or kids can check out Adventureland and explore the Ant City, which is set out over two floors with tunnel slides, and rope climbs. There's also the Twist Tower, which is an adrenaline rush, and a wild forest maze with puzzling routes.

Children who want to get behind the wheel can satisfy the desire and ride on a kiddie car or control a radio-controlled car (£1 coin operated).

The Timber Trail is also a great place to visit where you can experience the power of steam cutting machines and test your own crosscutting saw skills.

pic - © Landmark Adventure Park

# Landmark Forest Adventure Park

Landmark is not just about action, you can explore the hidden microscopic universe where you will find hands-on and fun exhibits. You can view strange micro-landscapes that will bring you face to face with some extraordinary creatures. You can also peer through big lenses or look up close at a cat flea.

Everyone will enjoy the tree-top trail, where you follow a path that rises up into the forest canopy.

And to get a bird's eye view, you can climb the wooden Fire Tower, the tallest timber tower in Britain. After climbing up the 105 steps, you reach a platform with views encompassing miles in each direction - and if you use the telescope, you can easily home in on the Funicular Railway on the Cairngorms, over 12 miles away.

In the wildlife feeding area, you are able to see various pinewood birds and red squirrels feeding on nuts really close up.

Thrill-seekers can try one of the water rides, which are a real buzz. The Falcon is some six seconds of free-fall freedom, similar to a 40-foot waterfall. The Otter, which is the longest ride, snakes through a dark tunnel, while the wildcat has a double kicker to rattle you as you descend.

### Prices at a Glance

(Based on 2007 prices so call for latest rates).
Between March & October;
Adults £9.75
Child £7.60
Family discount is available for one or more adults with kids. This is approximately 5% less than the individual rate.

Children are aged between 4 and 14 years inclusive.
Adults are 15 years and over.

Children must be supervised at all times and you should allow 3 to 5 hours for your visit .

For the very young, there is the Adventure Land play area with activities and obstacles, such as a rope course, a climbing wall, mini cars, wild forest maze and remote controlled car arena. The Spiral Tower is loaded with tunnels, ladders and a giant slide (restricted to 5 years and over) and tube slide. There is also a roof top view with 'glass' platform.

### Facilities, opening and contact:

The centre has a restaurant aimed at families, with a children's play area. Baby food is also available with warm-up facilities. There is also an outdoor snack station offering light meals. The shop offers a range of goods including books, jewellery, food, drink, cards and lots of other items. Access to shop and restaurant is free of charge. The park is open every day of the year except 25th December and 1st January. Closing times vary throughout the year, but the daily opening time is 10am. In winter the park may close due to bad weather and some attractions are closed all winter, such as the Watercoaster and Skydive, so you're advised to call before visiting.

### Location: ●

7 miles north of Aviemore at the southern end of Carrbridge.

tel:0800 731 3446   www.landmark-centre.co.uk

# Dalfaber Golf & Country Club

## ● Aviemore

The Macdonald Dalfaber Golf & Country Club has a host of activities for children and teens of all ages, and you don't have to be a time-share owner or club member.

The swimming pool costs from £6 for adults and £3 for a child. Each day there is a fun session known as the 'Splash Down' where kids get to play and swim with water toys - on occasions there is even a DJ playing tunes. Parents are able to leave their children, as the splash down is fully supervised by a pool attendant - however, at other times children must be accompanied by an adult.

There's also 9-hole golf course and junior size clubs are available for hire. The course will take about two hours to complete and costs £10 a round.

Next to the clubhouse is a children's play park with an obstacle course, rope climbs, swings, slides and play huts. Inside the club is a children's playroom with game machine, rides and a pool table. There's also a tots' playroom called Coca's.

**Facilities:** Bar, Steakhouse, shop and toilets.

**Location** ● The north end of Aviemore, off Dalfaber road just over the railway crossing.

tel: (01479) 811 244
www.MacdonaldHotels.co.uk

# Grass Sledging

• **Glenmore** - *Aviemore*

Located on a small hill known as the Hay Field just after the Glenmore Visitor Centre, grass sledging is a thrilling adventure and all the runs are safely marked.

You can hire the sledges at the field, which is a short walk past the Glenmore Visitor Centre attached to the car park next to the the road. Hire rates cost from £5 an hour and as well as the sledge, safety helmets are also provided. Instruction along with friendly supervision is also available.

Please note, to avoid damage to the grass and the hill side, sledges can not be operated in bad weather, and sledges are only usually available during the summer months.

**Facilities:** Located at the Glenmore Visitor Centre, cafe, shop and toilets.

**Location** ●
6-1/2 miles east of Aviemore and 1/4 mile past the Glenmore Visitor Centre.

tel: (01479) 812 296

# Lecht 2029

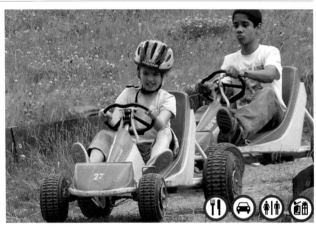

Lecht 2029 offers a number of fun activities. You can ride a kart down the hill side on the grass covered ski slopes. There's also quad biking for those aged 6 and over on a hard base track. Alternatively you can hurtle round a track in a Fun Kart which is a dune-buggy-type of kart. Fun for everyone from age 10. Kiddie karts also available for the under 10s (from around age 4).

Other attractions are Bullet Tubing which you sit or lie in a giant tube, then whizz downhill on a track. There is also a dry ski slope for skiing and snowbarding with full equipment hire. And for those wishing to take things more easily, then you can take a chairlift ride with great views of Ben Avon, Lochnagar and the Cairngorms.

**Facilities:** Bar, restaurant, shop and toilets.

**Location** ●
6 miles south of Tomintoul along the A939

tel: 019756 51440
www.lecht.co.uk

# Macdonald's Leisure Arena

● Aviemore

The Macdonald Aviemore Highland Leisure Arena is a £5.5m complex which first opened its doors to the public in 2004.

It's a modern centre with a 25-metre swimming pool the kids will adore - especially the water slide and wave machine. The pool is ideal for all ages with its gentle descent to the water. There's also a safe toddlers pool, with life guards always on duty. It's the perfect place to spend an hour or two, and the arena is a joy for the whole family. The pool is open daily from 8am to 8pm.

If you don't want to swim, you can either sit out and watch from a lounger in the 'beach area' or take the kids into E-zone, where they can test their reactions with a variety of virtual reality and computer games to suit different ages. It's open daily between 9am and 9pm but times can vary throughout the year. A range of both swim and leisure wear may be purchased at the Arena.

**Facilities:** Cafe, shop, gym, beauty treatments and toilets.

**Location** ●
Located on the Resort next to the Macdonald Highlands Hotel.

www.MacdonaldHotels.co.uk/Aviemore
tel (01479) 815 100

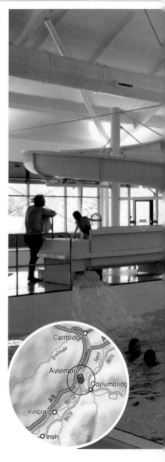

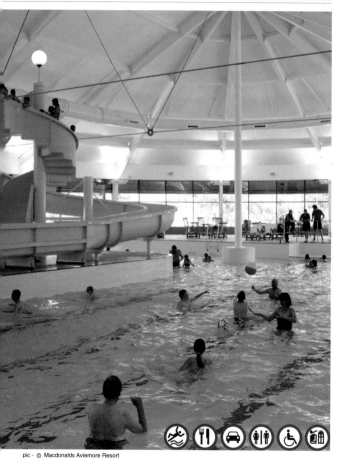

pic - © Macdonalds Aviemore Resort

# Children's Play Parks

## • Around the Park

**Play Parks in Aviemore.**
In the Macdonalds Aviemore Highland Resort, there is a new fenced play park that is a well set out with a host of attractions to keep children amused for hours. There are numerous rope swings, climbing frames and a fun train. The park is found behind the Macdonald Aviemore Inn Hotel with nearby parking.

There is a fenced play park at Royal British Legion, which is past the fire station in the centre of the village. Off Burnside Road there is a small fenced off play park, while around Morlich Place there are two open play parks.

There is an open play centre at the Dalfaber Golf & Country Club at the north end of the village.

At the Coylumbridge Hilton Hotel there is a soft surface fenced play park open to the public.

**Play Parks in Ballater**
There is a modern open play area with swings etc in Monatrie Park.

**Play Parks in Carrbridge**
In the village centre next to the school, there is an open play park with swings and frames.

The 10.20 **Cara** express

**Play Parks in Dinnet**
There is a small open play park opposite the Victoria Restaurant, consisting of two wooden framed swings and a small wooden climbing frame.

**Play Parks in Grantown**
At the north end of the village there is a fenced play park. There is also an adventure centre at the Revack Estate which has climbing frames, an aerial cableway, swing suspension bridge, assault wall, stepping logs a mini log cabin and a rope orienteering course.

Abby swinging it

### Play Parks in Kincraig
The Loch Insh Watersports Centre has a safe play area ring fenced and loaded with lots of equipment for tots to play on including a see-saw, a slide, swings, bounce boards, climbing frames and two flying foxes. Entrance is free to patrons of Loch Insh, otherwise a £2 charge for the day. All children must obtain a stamp from the gift shop and be supervised.

### Play Parks in Kingussie
There is an open play park next to the Doctors surgery at the south of the village.

### Play Parks in Newtonmore
There is a fenced off adventure centre at Highland Folk Museum at the north of the village.

### Play Parks in Strathdon
Opposite the Post office in the centre of the village is a small fenced play park.

### Tomintoul
In the centre of the village, set just of the main road is a small walled play park open to all.

# Outdoor Discovery

## • Aviemore

Outdoor Discovery is the exciting adventure centre located at the Hilton Coylumbridge Hotel offering kids somewhere to burn off their energy. Equipped with four Super Jumper trampolines, children can bounce as high as their imagination will allow, with heights of 8 metres possible - and even the youngest of kids can have a go; jumps cost £5 per person.

Also at the centre is a climbing wall for all ages and abilities with varying grades of climb, which can be as challenging as you like. Special one-piece harnesses and helmets are also provided along with qualified instructors.

One of the other exciting features is the skate park and rink. During the winter the rink is an ice skating arena and at other times a rollerblade park. For skateboarders there is a small skate park with ramps and rail slides. The centre also runs various outdoor courses offering snowsports and water sports for all the family. There is also a dry ski slope.

**Facilities:** Bike hire, Bar, restaurant, shop and toilets.

**Location** ●
2 miles from Aviemore at Coylumbridge.

tel: (01479) 812335 / 811066
www.outdoordiscovery.co.uk

Cara turning things upside down

# Rothiemurchus for Kids

Rothiemurchus is a really great place for the kids, there's so much to explore and learn about in the great outdoors. With activities especially designed for families and children and a 'Rothie Rascals' club children are encouraged to respect and learn all about the wildlife and the environment whist having bucketfuls of fun!

Accompanied by a Rothiemurchus Ranger there are some fantastic seasonal activities and events arranged for families and children. There is also a great selection of regular activities available including:

**Archery**
(min 8 yrs, under 12s must be accompanied)
**Canoeing**
(min 5 yrs, under 12s must be accompanied)
**Clay Shooting**
(min 12 yrs, under 16s must be accompanied)
**Fishing** (no min age)
**Gorge Walking**
(min 6 yrs, under 10s must be accompanied)
**Land Rover Tours** (min 12 yr)
**Indoor Climbing**
(min 5 yrs, under 10s must be accompanied)
**Mountain Biking** (no min age)
**Pony Trekking** (min 4 yrs)
**Safaris on Foot** (min 3 years)
**Quad Bike Trekking** (min 12 yrs)
**Sled dog Trips**
(min 6 yrs, must be accompanied)

Another great attraction at Rothiemurchus is the fishery which is a fun way to get up close with fish, either by having a go at fishing or just feeding the rainbow trout populating its freshwater pools. Buy a bag of fish food for 50p and see the excitement as the water comes alive with thousands of hungry mouths.

At the Fishery you can hire a rod and reel with a choice of hooks. There's a wee stocked loch especially designed for children, with trout around 1lb in weight. You can have a go yourself or perhaps you would like a lesson from one of the friendly staff at the fishery who will give you some 'top tips'.

The fishery is also a great spot for bird-watching, with a hide where you can view the wide range of bird life the lochs attract, such as golden eye duck, mute swans and the magnificent osprey which help themselves to the rainbow trout during the summer months.

**Contact and general informatiom.**
tel: (01479) 812345
www.rothiemurchus.net

pic - © Rothiemurchus Estate

# Smarty Art

● **Grantown-on-Spey**

For those kids with a creative and artistic flair, a trip to Smarty Art's ceramic painting studio in Grantown-on-Spey is a must.

Located along the high street at the north end, Smarty Art is a bright and cheerful studio where children and adults alike are welcomed to have great fun painting their own ceramic pots and plates.

You are able to choose from a large selection of white ceramic ware known as bisque. There are plates, money banks, mugs, figures and bowls all waiting to receive your own design and colours, along with all you need to paint them.

After you have painted your ceramic, it is then fired in the kiln after which you can take it home. You can have it sent on to your home address should you wish.

The studio is open Wednesday, Thursday, Friday and Saturdays from 10am to 4.30pm and 12pm to 4pm on Sundays.

**Facilities:** Tea and coffee facilities.

**Location** ●
On the high street at the north end of town.

tel: (01479) 8735520
www.smartyart.co.uk

48

# The Fun House

If the weather is bad outside you can't beat The Fun House at Hilton Coylumbridge - one of Aviemore's favourite attractions! The Funhouse is aimed at kids of all ages with a modern video arcade and games room, two 9-hole crazy golf course, soft play areas and Cyril's Treehouse which is a giant climbing frame.

In the video-games arcade there are numerous games to test your skills such as a Thrill Rider, a basket ball game, air hockey and a motion simulator ride. There is also 10-pin bowling which is great fun for all family.

The adventure 9-hole golf course will test your putting skills and is a nice way to pass half an hour's leisure time. Junior size clubs are provided and a game cost £3 or £2 for members.

Most kids head straight for Cyril's Tree House and soft play area, and it's easy to see why! The large climbing frame is set on on various levels and caters for kids as young as two. Entry cost from £1.50.

**Location** ●
The Fun House is 1-1/2 miles East of Aviemore at Hilton Coylumbridge Hotel.

tel: (01479) 813 081
www.hilton.co.uk/coylumbridge

# Creative Interests

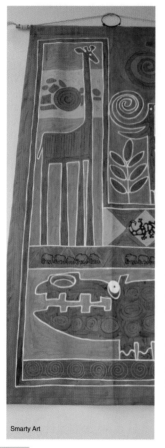
Smarty Art

Arts and crafts abound in every corner of the Park.

Highland history is steeped in tradition and mysticism and it's through the talents of the many local artists and craftsmen that the story can be told in so many fascinating forms.

Around the Cairngorms National Park you will find innumerable artistic treasures, some natural, others lovingly crafted and painted by skilled technicians and artists who have acquired the skills which have been passed down the local generations.

Galleries are always hosting events which you are invited to attend, while visitors who like to get their hands dirty can visit potteries and throw pots themselves or visit craft centres and paint pictures or ceramic ware.

For those who really want to learn, you can sign up for painting and wildlife photography courses, with many held over a number of days and run by professionals.

## Aviemore Art Association

Work by local artists in Aviemore is on permanent display, and available for sale, in Cafe Bleu. The themes change according to the season.

The beach
*Daniel Cottam*

Forest Walk - *Molly Sangster*

Displayed here are a few examples of paintings by Anne Vastano, Bobbie Capuano, Marilyn Morrissey, Daniel Cottam, Lynny Cairney and Molly Sangster.

Botanics
Ann Vastano

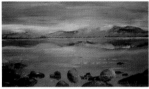

Loch Garten - *Bobbie Capuano*

Aviemore Art Association, which meets every Tuesday evening in the Village School, is always on the look-out for others to join. Although mainly a self-help group, regular tutorials, run by experts, take place. Anyone interested in having a go should contact the Secretary at (01479)812 608.

Dotterel - *Lynny Cairney*

The annual exhibition has become a very popular summer attraction in the village and the fifth event takes place in St. Andrew's Church Hall from 6th to 9th August, 2008.

Cottage Achiltibuie - *Marilyn Morrissey*

# Creative Interests

### Caroline Pilgram — *Artist*

**Based in** - Newtonmore tel: (01540) 670140
email: carolinepilgram@fsmail.net
Caroline paints mostly landscapes but she also explores other areas. Her preferred medium is oils but she also works in watercolour. Caroline is a member of the Strathspey and Badenoch Society of Artists and has exhibited in their summer and winter exhibitions.

### Derek Young — *Artist*

**Based in** - Nethy Bridge tel: (01479) 821318
www.abernethyart.com
Derek has painted and tutored for 15 years. An integral component in Derek's paintings is a technique which produces the complex effects present in his work. This adds a unique abstract quality and favourite subjects or views may be reinterpreted without two works ever being identical. Commissions accepted for subjects compatible with Derek's interpretation/methods.

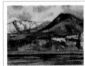

### James M Fraser — *Artist*

**Based in** - Nethy Bridge tel: (01479) 821673
email: jamesmfraser@btinternet.com
James trained at Edinburgh College of Art where he specialised in drawing and painting,  His work is a combination of intuition and realism. A strong believer in the discipline of drawing, the expressive qualities of his work reflect what he sees in a vital, distinct way. His preference is for working in oils, acrylics and gouache. James also teaches art to adults and takes on commissioned portrait work.

### Jean Noble
*Artist*

**Based in** - Newtonmore tel: (01540) 673392
www.drnoble.co.uk/jean-noble

Jean is a full-time painter and art tutor whose art is a mixture of realism and fantasy. She paints trees and landscapes with gentle gradations of tone and colour. Her work also incorporates mythology and religious themes. Jean's major body of work, the Cycle of the Trees of Life, and other paintings can be viewed on her website.

Spot On Sponsor

### Liz Hall - Wild and Art
*Artists*

**Based in** - Newtonmore tel: (01540) 670191
www.wildandart.co.uk

Liz studied art and design in London and went on to do art therapy and psychology. She now runs Wild and Art, which offers 'creative adventures' through art workshops and courses, for all ages and abilities. Liz works in a variety of media: painting, textiles, clay and printmaking. Her work is emotive, capturing the wildness and dramatic light of the landscape of the Highlands, its wildlife and its people.

### Philippa Mitchell
*Artists*

**Based in** - Kingussie tel: (01540) 662332
email: philippa.mitchell@virgin.net

Philippa fits in her art around full-time teaching within the Cairngorms National Park. Light, landscape, the wildlife, culture and the people of the Highlands of Scotland have all helped to shape her work. Paintings, collage and mixed media pieces have been exhibited in the Society of Badenoch and Strathspey Artists exhibitions.

# Creative Interests

### Rosie Fisher *Artist*

**Based in** - Grantown-on-Spey. tel: (01479) 873228
email: rosie@grantown.freeserve.co.uk
Rosie's work is usually figures, musicians, flowers and the natural world, although she has a soft spot for boats and anything quirky! She paints in acrylic and oils and loves to draw in charcoal and carves both stone and wood.

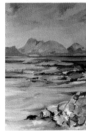

### Valerie Fairweather *Artist*

**Based in** - Boat-of-Garten tel: (01479) 831212
email: valeriefairweather@lineone.net
In her paintings Valerie endeavours to catch the magic of a moment in the landscape, the shape of the land, fleeting light, the power of the mountains, the swirl of a burn and - above all - the strength and complexity of our native Caledonian pine. The Cairngorms provide frequent inspiration as does the landscape of Assynt, which she visits frequently. Many of the smaller watercolours are done during long days walking in the hills. The larger watercolours and oils are completed in the studio.

## Miscellaneous Arts & Crafts

### Cairngorm Framer *Picture Framing*

**Based in** - Boat-of-Garten tel: (01479) 831 462
www.cairngormframer.co.uk
James Gordon produces framed images of places of interest and outstanding beauty in and around the Cairngorms National Park. He also exhibits his work at local craft fairs, Speyside Heather Centre, Grantown Museum and on the internet.

### Frances Crawford    *Art Leasing Consultant*

**Based in** - Glendeskry, Strathdon tel: (019756) 51719
Mobile: 0797 4266118 email: francescrawford@yahoo.com
Colour is important in Frances' paintings. Layers of transparent glazes result in paintings with depth and vibrancy. Frances paints from imaginary, symbolic subject matter. Her work incorporates elements of landscape, but it is the spirit of the land rather than the pure physical representation of it which appeals.

### Garten Guitars    *Hand Crafted Guitars*

**Based in** - tel: (01479) 831212
email: gartenguitars@tiscalico.uk
Kevin Redgewell has been playing the guitar for over thirty years, so has an appreciation of the tonal and aesthetic qualities of many instruments. As Kevin enjoys working with wood he decided to build his own acoustic guitar from scratch. Kevin has now set up a small workshop for making hand-crafted acoustic guitars with a musical quality he hopes will be appreciated by musicians of all standards.

### Pat Hughes    *Sculptor*

**Based in** - tel: (01479) 872533
email: potterysculpture@madasafish.com
Pat is a Fine Art graduate and sculptor who uses traditional methods to create figurative and semi-abstract pieces in terracotta and white earthenware clay. Smaller forms start as simple hollow eggs smoothed into their final shape. The human form has always been at the core of her work but, since moving to Strathspey, the animals and birds inhabiting the Cairngorms have become a new and exciting inspiration.

# Creative Interests

### Christine Mullen Jewellery

Aviemore - tel: (01479) 812 812
mobile 07737365428

Christine is a local Aviemore goldsmith who specialises in all precious metals. Her Scottishness is evident in her free flowing designs. View and buy her work at Dalfaber Golf & Country Club Thur, Fri and Saturday evenings. Private commissions.

### Elf Jewels

Laggan - tel: (01528) 544 244

Unique jewellery handmade in Laggan Bridge. Semi-precious stones, sterling silver, children's and commissions, demonstrations and sales in Coylumbridge Hilton Hotel on most Sundays.

### Frank Bruce Sculpture Trail

**Located at Feshiebridge in Kincraig**

The Frank Bruce Sculpture trail is an unusual new walk next to the River Spey. As you walk round the wooded trail, at each turn you come across a sculpture carved out of tree trunks or stone. The sculptures are intense, and one wonders what the artist takes in his tea. Strange and unusual, the images will leave you asking questions. The trail has around 14 sculptures and the path is fully accessible by wheel chair from the car park, which is 200 metres from Feshiebridge.

### Purple Heather Art Holidays  *Painting holidays*

**Based in** -  Nethy Bridge tel: (01479) 821673
www.purpleheatherart.co.uk

Purple Heather operates drawing and painting holidays and short breaks in the area. Clients work on location and all excursions are accompanied by an experienced tutor. Clients benefit from a high level of personal attention while the informal approach makes for a relaxing, enjoyable art holiday. Half and day trips are also available.

### Valerie Emmett  *Botanical Illustrator*

**Based in** -  Newtonmore tel: 01540 661962
email: ecubed@btinternet.com

After a lifetime involved in science research and education, Val now combines her interests in natural history and the visual arts to perfect her skills in botanical illustration. She draws and paints directly from the living material using watercolour as her chosen medium. Val strives to portray both the beauty of the plants she illustrates, occasionally setting them in their natural habitat, as well as turning to her microscope to magnify some of the essential details that normally elude the casual observer.

### Valeria Sofar  *Card Maker*

**Based in** -  Aviemore tel: (01479) 811536
email: val.sofar@gmail.com

Valeria takes great delight in everything she makes from cross-stitch framed wall hangings to cushions and cards. She also makes 3D paper cards that include techniques such as decoupage and embossing. Commissions are undertaken for special occasion cards and gifts.

# Creative Interests

## Galleries, Studios & Workshops

Open all year from
Mon to Sat 9-5.30pm.
Sun 10.30-5pm.
Free entry
tel (01479) 872 074

### A'Anside Studios                          *Tomintoul*

A'Anside Studios is based in Tomintoul and owned by self-taught cabinet maker Barry Horning and his wife Jacqui. Together they have been designing and crafting the finest in wood and stained glass since 1992.

Barry uses Scottish hardwoods highlighted with farmed tropical species to create bespoke furniture, jewellery boxes, writing slopes and humidors in modern and traditional styles. Jacqui, a stained glass artist, creates a myriad of designs for lamps, mirrors, windows and decorative panels in Victorian, Art Deco, Mackintosh, Prairie and late 20th Century styles
www.aanside.co.uk

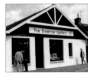

Free entry
tel (13397) 41681

### Braemar Art Gallery                          *Braemar*

The gallery, run by art enthusiast Andrew Braidwood, is in the centre of the village. Braemar gallery has an eclectic mix of paintings, etchings, prints, sculpture, pottery and jewellery, offering a varied and vibrant selection of new and interesting artists as well as a fine collection of work by well-established names in Scottish art. In the gallery you'll see such names as Pam Carter, Hamish Macdonald, Francis Boag, Jim Wylie and Ken Ferguson, to name but a few.

As well as exhibits in a wide variety of styles, the gallery also holds exhibitions and events to feature exciting new work.
www.braemargallery.co.uk

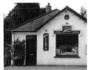

## Carrbridge Artists Studio          *Carrbridge*

The studio, located in the centre of the village opposite the Post Office, has on display a selection of landscapes and wildlife pictures by artist Jeff Buttress.

Open all year but hours do vary so ring ahead. Free entry.
tel (01479) 841 328 / 841 247

There is a permanent exhibition of Jeff's work in watercolour, pastels, oils and pencil studies as well as a selection of his paintings reproduced as fine art prints and greetings cards. You can also see Jeff at work and view work in progress along with an ever-changing exhibition of recent work.

Also available are unique pottery sculptures and jewellery by ceramic artist Alice Buttress. At the rear of the studio is the new chainsaw sculpture garden, which also offers a selection of bears, tree spirits, etc. - or commission your own.
www.carrbridgestdios.com

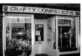

## Crafty Companions          *Kingussie*

You'll find Crafty Companions at the north end of Kingussie along the high street. As well as enjoying a craft shop, you can also sign up for the weekly craft club, which is on Thursdays from 1 to 3pm weekly.

The shop is located at the north end of the high street.
Open Monday to Saturday 9.15-5pm.
Wednesday 9.15 – 2.0
Closed Sundays.
Free entry
tel (01540) 661 777

The well-stocked shop offers a large selection of craft materials and tools to suit creative people of all ages, from the professional artist to the most addicted hobbyist, including a range of kits and materials for children.  There is a helpful website, where you can buy materials and pick up craft tips.
www.craftycompanions.co.uk

# Creative Interests

Galleries, Studios & Workshops

### Knock Gallery

*Crathie/Ballater*

The Knock Gallery has strong connections in central Europe, and shows paintings and prints from all the major artistic centres in Poland, several in the Ukraine, and some in Russia. Several outstanding Scottish artists are also shown.

Open daily from 9.30 until 5.30. Closed on Monday. Free entry
tel (013397) 42360

In addition to visual imagery, the gallery always shows an extensive collection of the work of the best Polish and Lithuanian silversmiths working with Baltic amber to produce unique pieces of jewellery.

Visitors often arrive at the gallery, perched 1400 feet above sea level, to admire its awesome views over a vast Highland mountain landscape.
www.knockgallery.co.uk

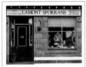

### Lamont Sporrans

*Braemar*

Specialist Highland dress and sporran makers offer individually designed kilts, made-to-measure on the premises, along with tartan trews and unique silk and worsted tartan skirts. Kilts, trews, plaids, jackets, sashes etc are made from the very best materials, sourced, wherever possible, from Scotland. You can design your own kilts with a Celtic or thistle theme and a matching waist buckle, cantle or a kilt pin.

Open Mon/Sat 10.30-5.30pm. Sundays 12-5.30pm.
Free entry
tel (013397) 41404

The shop stocks a wide range of accessories, such as sgian dubh, dirks, plaid brooches, ghillie brogues, tartan waistcoats and hats.
www.sporrans.net

### Larks Gallery

*Braemar*

Larks Gallery is located along Braemar road in Ballater and features a superb exhibition of contemporary Scottish Art.

Open from 10am to 1pm when closed for lunch, then open 2pm to 5pm. Free entry. tel (013397) 55888

The gallery houses an ever-changing selection from leading Scottish artists, as well as some of the best emerging talents in painting, sculpture, ceramics, glass, textiles, photography and jewellery design.

There is a large selection of paintings by artists such as Sandra Johnston, Stefka O'Doherty, Susie Hunt, John Todd, and many more.

You can call in to view paintings on most days except Tuesdays and Sundays, when the gallery is closed.

### Loch-an-Eilein Pottery

*Aviemore*

Loch-an-Eilein Pottery is a small, rural, unique craft pottery owned and run by Penny Weir.

The pots are all hand-thrown in red earthenware by Penny, who specialises in jugs of all sizes from creamers to pitchers, and in large breakfast cups, teapots, mugs both large and small, and storage jars. Pots are glazed in blue and green and in a rich turquoise, or in majolica, which is a white glaze with a blue design painted or sponged on. You can also 'Throw Your Own' pots which are then glazed and posted on to you.

Open from 27th of March until the end of October, from 10am until 5pm on Tues, Weds and Thursdays. Free entry.

Penny also runs a series of workshops, for those who want to get covered in clay.
www.penspots.co.uk

# Creative Interests
## Galleries, Studios & Workshops

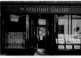

### McIntosh Gallery & Flying Carpets  *Kingussie*

Located in the centre of Kingussie, the McIntosh Gallery features a diverse range of modern and traditional paintings and prints, from an exciting blend of contemporary Scottish Artists.

Flying Carpets, which is also located in the same building as the McIntosh Gallery, specialises in importing new and antique rugs, carpets, textiles and other crafts directly from Central Asia - Afghanistan, Turkmenistan, and the North-West Frontier province.

Open  Mon to Sat
from 9.30-5.30pm.
Free entry.
tel (01540) 662 280

There is a large selection of carpets on display which are all hand-picked from the country of origin and adhere to a Fair Trade policy.
www.flyingcarpets.co.uk

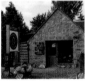

### Nethybridge Pottery            *Nethy Bridge*

Nethybridge Pottery is situated about 2 miles north of the village of Nethybridge en route to Grantown-on-Spey. The workshop is based in a 200-year-old stone steading and was originally established in 1998. It's run by potter Rob Lawson, and you will find a wonderful range of interesting, functional pieces of work which were all made in his workshop.

Open Tues to Fri 10-
5pm.
Free entry
tel (01479) 821 114

Much of his work is hand-thrown stoneware, wonderfully glazed in a variety of vibrant, multi-coloured glazes. Visitors are welcome to walk around and view the showroom, which only displays items made in the workshop - the exclusive outlet for Rob's work.
www.nethybridgepottery.co.uk

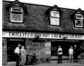

## Newtonmore Craft Centre & Gallery

Newtonmore Gallery is the working studio of acclaimed artist David Fallows, whose work features in private collections in over forty countries.

Open all year round from 9-5.30pm Mon-Sat. free entry
tel (01540) 673912

The gallery and craft centre is located in Newtonmore's Tourist office and houses an impressive selection of original paintings and limited prints.

The gallery has a constantly-changing display of original work by several artists, including Jean Noble's superb oils, plus a range of limited edition prints. David is usually on hand to answer questions about painting techniques and is happy to offer a demonstration when possible.
www.newtonmore.com/craftcentre

## Sandra Geddes Castleton Crafts    *Braemar*

Castleton Crafts Workshop is a small art-and-craft workshop and shop where Sandra specialises in kiln-fired and hand-painted ceramics, as well as beautiful landscape paintings and wonderful photography.

Open Mon to Sat 10-5pm. Closed Wed. Free entry.
tel 01339 741426

As well as a wide selection of various crafts (including wedding-related items such as garters, horseshoes, invitation cards, etc) the shop also has lots of greeting cards in various styles, specifically the craft of pergamano (which is very ornate, lacy effect or plain, done on parchment).

'Wet day' workshops are available for greetings cards and ceramic paintings. Phone in time.

# Creative Interests

## Galleries, Studios & Workshops

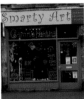

tel (01479) 873552

### Smarty Art
*Grantown-on-Spey*

Smarty Art is a new craft centre run by Gill Sunde, a local art teacher offering professional advice on how to create wonderful pieces of locally-produced art. Gill has a particular flair with colour and craft techniques.

The centre is a bright a cheery place and offers a warm welcome to all its visitors. There is a great selection of ceramic pottery that you can paint after its been fired - firing takes place twice a week, your handiwork then parcelled up and posted on, if requested.

**Spot On Sponsor**

Open 11-5pm
(Sun 2-5pm)
Closed Tues.
By appointment only
between Jan 2nd and
March 31st.
Free entry
tel (019756) 51287

### The Lost Gallery
*Strathdon*

The Lost Gallery is found in Strathdon. The guiding policy at the gallery is simple enough: the aim is to exhibit works by the modern Scottish artists who most excite the owners, artist Peter Goodfellow and his wife Jean.

The Lost Gallery is widely considered one of the most interesting and unusual venues in Northern Scotland, with an excitingly eclectic selection of paintings, sculpture and photography.

The venture has built up a reputation over a number of years for showing both indoor and outdoor sculpture from around the globe.
www.lostgallery.co.uk

### The McEwan Gallery *Glengarden*

The McEwan Gallery is located in the hamlet of Glengarden, near Ballater of the A939.

The gallery boasts a huge selection of works by artists such as Claude Harrison, Adrian Jones, Alexander Nasmyth, James Renny, Fred Hurst and many others, with paintings dating back to the 18th century. There is also a wide choice of sculptures.

Open Tues to Sun 11-5pm. Closed Mondays. Free entry
tel (013397) 55429

Also available is an impressive range of prints, some wonderful pottery and a fascinating selection of books.

The gallery is open to the public from Tuesday to Sundays and closed on Mondays, but it is advisable to phone before visiting to check on opening times.
www.mcewangallery.com

### Tomintoul Art Gallery *Tomintoul*

Tomintoul Art Gallery is a contemporary Batik art gallery with a distinctive Scottish flavour. It's the home of Jane Lannagan, who can be seen creating distinctive artworks, decorating cloth with wax and dyes. Also on offer is a selection of original paintings, along with an amazing array of wooden, metal, glass and ceramic pieces crafted by Scottish artists.

Daily from 11am to 6pm. Free entry
tel (013397) 55429

The gallery also stocks a wide variety of hard and soft wood picture frames, mountboards and backing boards as well as glass cut in the gallery to your size.
www.tomintoulgallery.co.uk

# Cultural Interests

## Museums and Heritage Centres

The park has some excellent museums, all of which give a different slant on life in this "highly" historic part of Scotland!

The Clan McPherson Museum in Newtonmore and the Highland Folk Museums in Kingussie and Newtonmore are just two of the award-winning examples of attractions where you can find out what the old highland life was like many years ago.

The museum in Tomintoul gives a fascinating insight into life in the area, with sets showing how locals actually lived and survived.

Grantown's museum is another highly rated centre, telling the complete story of the town.

The Glenesk Folk Museum in the Angus Glens details the life of the glens and has on show a fine collection of artefacts giving some captivating insights.

Fans of Royal history can find out just why the Royal Family has had such a strong attachment with Deeside by visiting the Old Royal Station in Ballater.

# Braemar Highland Heritage Centre

● Braemar

The Braemar Highland Heritage Centre gives an indepth insight to the life and times of the small rural village and the surrounding area with exhibitions and audio-visual presentation on Braemar, its history, geography and ecology.

Braemar, which is famous for a number or reasons not least its royal connections, is located in the upper Dee Valley and sits at an altitude of 339m(1100ft). The village is also officially the coldest place in the UK. In 1895 and 1982 temperatures dropped to 28.2 degrees Celsius.

It is said that the Gaelic Bràigh Mhàrr refers to the area of upper Marr (as it literally means), i.e. the area of Marr to the west of Aboyne, the village itself being Castleton of Braemar (Baile a' Chaisteal Bhràigh Mhàrr).

The heritage centre, in the centre of the village opposite the Fife Arms Hotel, has free entry and you will be able to find out about the area's long royal history dating back hunderds of years - long before Queen Victoria, who has had a strong influence in the area, siting her Scottish Country home at Balmoral Castle.

You are free to browse the centre and learn not only about folklore, but also all about the landscape and the abundant wildlife that can be found in the nearby nature reserves and up on the Cairngorm Mountains which shadow the village.

Braemar is best known for the Braemar Gathering, held annually on the first Saturday in September, and is attended by the Queen and senior members of the Royal Family. Full details of the gathering can be found in the heritage centre along with times and ticket prices.

As well as exhibitions and a film exploring the history of Braemar, its royal connections and landscape, the centre also has a strongly-themed retail shop featuring heritage and clan products, tartan, wool, cashmere and interesting gifts. The centre also houses a Tourist Office.

**Location**: ●
Located in the village centre opposite the Fife Arms Hotel with parking outside off the main road.

**Facilities & Contact** .
Opening times:  Open daily all year.
Free entry.  tel: (013397) 41944

# Clan MacPherson Museum

• Newtonmore

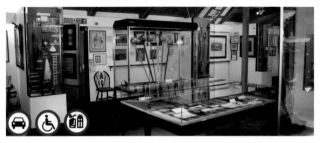

The Clan Macpherson Museum can be found at the south end of Newtonmore's main road. Opened in 1952, it was the first museum of its kind, with many of the artefacts having been acquired by clan members for subsequent donation to the collection.

The name Macpherson, MacPherson, or McPherson, derives from the Gaelic Mac-a-Phearsain, literally "Son of the Parson". They are descendants of Mhuirich Vattanach, Fourth Chief of Clan Chattan, who was the parson of Kingussie. His second son was the first to be called Macpherson.

The Macphersons, who are sometimes called the Clan of Three Brothers, were gifted land in Badenoch King Robert Bruce.

The museum's many relics tell a fascinatingly rich story, with historical interest not only to Scottish clansmen and women but to all who are attracted by a story of high resolve, patriotism and loyalty.

On display is a treasure trove of relevant relics, all contributing to the story of the historic clan's life and families, highlighting their place in society from past to present.

The museum also includes audio-visual displays about the Macpherson clan and the Badenoch area in general. Exhibits include James Macpherson's fiddle, the Banff clock immortalised in Burns' song "Macpherson's Rant" and relics associated with Prince Charles

Edward Stuart (Bonnie Prince Charlie), Old Cluny's sword recently rescued from America, and many other items of interest. A reference library is also available for those with an interest in the Badenoch area or their own Macpherson genealogy.

The historic Feadan Dubh (Black Chanter) is one of the museum's most prized possessions. Of its origins there are no definite details. One story insists the chanter fell from Heaven in the Clan Battle at the North Inch at Perth - an account made even more popular by Sir Walter Scott in his "Fair Maid of Perth" published in 1828.

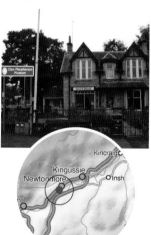

**Facilities**:
The museum is open from 1st April to 31st October each year from 10am to 5pm (last entry 4.30pm), and there is no admission charge, although donations are always welcome. A small stock of Macpherson related souvenirs is available for sale.

**Location**: ●
Main Street Newtonmore
tel: (01540) 673332
www.clan-macpherson.org

# Grantown Museum

• Grantown-on-Spey

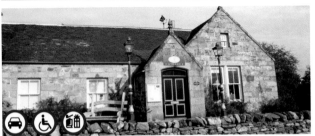

Grantown Museum tells the story of Grantown-on-Spey, a fine example of an 18th century planned town. The story is brought to life through the museum's extensive photographic collection.

Visitors can learn the history of the people and buildings which made Grantown what it is today.

Extensive records relating to the founding of Grantown-on-Spey in 1765 form the basis of both traditional and modern, interactive audio visual displays.

Find out about Queen Victoria's visit in the 19th century, the coming of the railways and the development of the village as a popular holiday haunt.

The true value of a museum is its hold on its subject's roots, a firm grip enabling visitors to journey from Then to Now. With no memory, no sense of belonging, lives have no real meaning, but in Grantown the museum means a truly fascinating trip for all.

It begins in 1765. Grantown Museum tells the story from the town's infancy and is a source of great pride to its latest generation. The museum was awarded 'Commended' in the Scottish Museum of the Year Awards 1999. Temporary exhibitions are also a regular feature.

The museum hosts meetings of the Grantown Society and houses its archives. It provides research facilities for genealogy and local history - Grantown is the traditional home of the Clan Grant and the museum receives frequent visits and enquiries from Grants all over the world.

The museum actively encourages visits from school groups, whether undertaking research or working on special projects, and volunteers are on hand to help with any queries.

For schools working on World War II, a loan box of artefacts is available. The museum also has two computers which visitors can use to access the internet. It also lets you view and print out local records from the last 300 years, courtesy of the Grantown Society.

As well as disabled toilets, the main entrance to the museum has a purpose-built ramp and with all five galleries located on the ground floor, wheelchair access is excellent. If required, vehicle access directly to the main door can be arranged.

**Location**: ●
The Museum is situated along Burnfield Avenue in the centre of the town.
tel: (01479) 872478
www.grantownmuseum.co.uk

**Facilities**:
The museum is open March to December, Monday Saturday 10am - 4pm.
Entry fees are: Adults £2.00
Concessions £1.00. Child (10-16) £1.00.

# Highland Folk Museum

The Highland Folk Museum at Newtonmore brings to life the domestic and working conditions of earlier Highland people. Visitors to this living history museum can learn in a safe and friendly environment, how our Highland ancestors lived, how they built their homes, how they tilled the soil and how they dressed. An award-winning attraction, the museum encapsulates human endeavour and development in Highland life from the 1700's to the present day. The aims include preserving and recording aspects of Highland life from the 1700's onwards, as well as interpreting the people's lives through interactive living history and activities.

The Kingussie Museum is only open for advance group bookings in 2008 (Easter to end of October).

The Highland Folk Museum is situated within the boundaries of the Cairmgorms National Park on two sites: one in Newtonmore; the other two-and-a-half miles away (4Km) in Kingussie.

In addition to interpretation and activity programme, visitors to the site are offered an audio visual introduction, café facilities, toilets, children's play area, shop, picnic areas and on-site travel in period style vehicles.

**Location**: ●
The Kingussie Museum is situated along along Duke Street at the north end of the village. The Newtonmore site is on the outskirts of the village at the northern end.
tel: (01540) 661307
www.highlandfolk.com

**Facilities**:
Kingussie - Shop, toliets, picnic area and car park. Newtonmore - Indroductory dvd, cafe, gift shop, toilets and parking.

pic - © Highlnd Folk Museum

# The Glenesk Folk Museum

The Glenesk Folk Museum at the Retreat was set up in 1955 by Miss Greta Michie, a local farmer's daughter and school teacher, based on the Scandinavian folk museums she had visited in Norway. The Retreat has a large collection of artefacts, most of which pertain to the Glen, on display in the museum.

The original building, a very small cottage, was built in the 1840's by Captain J E Wemyss as a "retreat" from his life at sea, but over the years it has been enlarged a few times, eventually housing the museum, tearoom and gift shop.

Over recent years a refurbishment programme has been undertaken with the help of various funding bodies. A purpose - built museum houses a diverse collection of artefacts, which give a captivating insight into life in the glen over many years.

There is a display area dedicated to showing artefacts of children's books, toys and games. School books, an abacus, a bell and a tawse are also important features. Children are encouraged to play with replica toys and dress up to develop their imaginations about the past. On a fine day children have the opportunity to play peevers and other playground games in outside area. School visits are welcomed and can be booked through the website or by phone.

The Glenesk Trust , made up from local people, has been set up and now own and run this visitor attraction with all its community facilities. The traditional tearoom is now also a licensed restaurant, serving high teas with home baking. Beautifully cooked meals can be enjoyed throughout the summer months. There is also a large, well - stocked gift shop.

**Location**: ●
The museum is located 10 miles north of Edzell along the B966. There is ample car parking with good wheelchair access.

**Facilities**:
Open Easter weekend
Saturday, Sunday until mid May, then daily mid November   12 to 6 pm
Sunday late night opening from mid May
Themed evenings throughout the open season, check website for details.
Cafeteria, restaurant, picnic area.
and shop. There are also facilities for private functions and events. Meeting room available.Object study facilities available (enquire in advance).

**Contact**:
tel: 01356 648070
email: visit@glenesk retreat.co.uk
www. gleneskretreat.co.uk

# The Old Royal Station

● Ballater

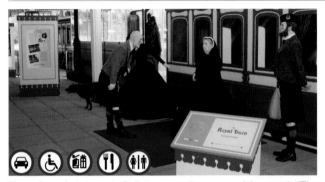

The railway first came to Ballater in 1866, when the Deeside Railway built its station here.

The railway through Deeside began on 7th September 1853, when the line opened between Aberdeen and Banchory. On 2nd December 1859 the line was extended to Aboyne and on 17th October 1866 to Ballater, which became the terminus. A track was laid to the Bridge of Gairn but was not used and its alignment is today the walkway known as the Old Line. Originally the whole line was a single track with passing loops but between 1884 and 1899 a double track was laid to Park (by Drumoak) enabling a frequent suburban service between Aberdeen and Culter. This popular service was nick-named 'The Subbies'.

Located on Station Square in the centre of Ballater, the Old Royal Station opened as a museum and exhibition in 2001 following extensive refurbishment of the former terminus of the Deeside Railway, which closed in 1966. The building contains a tourist information centre, together with shops and a restaurant and an exhibition entitled 'Royalty and Railways'. This explores the grandeur and ceremony, which accompanied Royal visits.

The Deeside Railway was extended to Ballater in 1866 and, before it closed, the station was visited by no less than six reigning

British monarchs en route to their retreat at Balmoral Castle. In addition, numbers of European Royalty passed through the station travelling to visit the British Royal family including, in 1896, Nicholas II the last Czar of Russia.

Ballater Station was at first a simple booking office on a single platform, but in 1886 the Royal Waiting Room was built to a design approved by Queen Victoria.

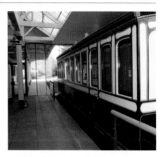

Having fallen into disuse after the closure the station was refurbished and used as an area office by the local District Council. The Royal Waiting Room was visited by Queen Elizabeth on its centenary in 1986. Afterwards Her Majesty inspected the Royal Guard in front of the station, as had been the tradition after the arrival of the Royal Train. In 2002 after extensive refurbishment the station buildings were re-opened as a visitor centre also housing the local tourist office.

The centre offers a very informative historical and educational insight on railway life dating back many years - and acknowledges how important the Royal connection has been to the area.

**Location**: ●
The Old Royal Station is located in the centre of Ballater.
tel: (013397) 55306
www.royal-deeside.org.uk

# Tomintoul Museum

● Tomintoul

Tomintoul Museum, in the centre of the highest village in the UK, aims to inform the visitor what life has been like in a remote highland village which is often cut off from the rest of the country during the winter snowstorms.

The museum houses items conveying the area's natural sciences and social history.

It was the 4th Duke of Gordon who planned and designed the village in 1776. The Duke's plan can still be seen today in the wide main street and central square but the flax and linen industry which was intended to support the inhabitants never succeeded - perhaps unsurprisingly, since Tomintoul lies at a height of 1165 ft (350m).

Housed next to the Tourist Information Centre in the Square,

the museum was founded following the Tomintoul bicentenary exhibition in 1976. It includes reconstructions of a farmhouse kitchen and of the old village smithy. There is also a display on peat cutting and the main exhibition area includes some fascinating material on local history and wildlife. A range of publications is on sale.

On display is a reconstructed crofter's kitchen and a reconstructed village blacksmith's shop (the 'Tomintoul Smiddy'). You can also experience the sights, sounds and smells of rural working life.

Wildlife in the Highlands is crucial and the museum has a number of fine displays depicting local species.

You can also unearth facts about the history of Tomintoul and Glenlivet, including life on the Glenlivet estate.

The museum includes a shop and reception area, also offering guided tours to groups and schools, and the Tourist Information Centre is also conveniently situated within the museum building.

From time to time craft demonstrations are run in the museum during the summer.

**Location & Contact**: ●
Museums Service
Falconer Museum
Tolbooth Street, Forres. IV36 1PH
Tel:01309 673701
Email:museums@moray.gov.uk

**Facilities**:
Seasonal April to October
April, May & October: Monday to Friday
09.30 to 12.00 and 14.00 to 16.00
June to August: Monday to Saturday
09.30 to 12.00 and 14.00 to 16.30
September: Monday to Saturday 09.30 to
12.00 and 14.00 to 16.00
Admission to the museum is free.
Closed on public holidays.

Free public car-park in the square.

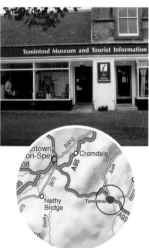

# Historic Interests

To tell the whole history of the Cairngorms National Park in this small book would be impossible, but you can rest assured that there is an abundance of historic gems to discover, dating back many hundreds of years.

There are numerous castles to explore, ranging from the ancient Castle Roy at Nethy Bridge (dating back to around 1226) to the relatively "new" Balmoral Castle of 1856 outside Ballater in the east of the park.

Many of the historic settlements dotted around the park over the centuries have disappeared, but if you look closely when exploring some of the far-flung areas you will come across many remnants.

Wherever you go, it is clear the Cairngorms National Park is a treasure trove of historical gems.

Happy hunting!!

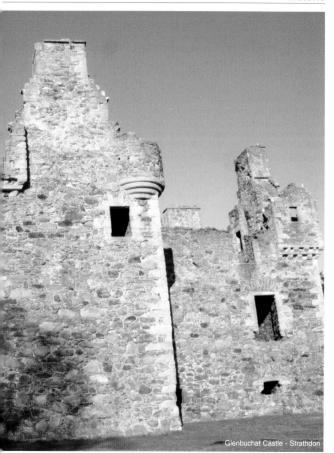

Glenbuchat Castle - Strathdon

# Auchernach Walled Garden

## • Strathdon

The Auchernach Walled Garden, at Glen Nochty in Strathdon, dates back to 1810 and was build by Lieutenant General Nathaniel Forbes of the Honourable East India Company.

For many years this stone walled garden and the ruins were lost from view and hidden under a forestry plantation. However, it's now been revealed after a considerable amount of tree felling.

The structure is said to resemble that of an Indian hill fort with its set of prominent round and square towers which overlook Glen Nochty, an area of thick pine forest and barren hills.

There are no actual gardens left, but there is still an amazing amount of interesting plant and insect life to discover.

**Location**: ●
The site is easily reached from the centre of Strathdon. In the village turn up the road behind the post office and travel along the minor road following the sign for the "Lost Gallery". Continue along the road for around 2.5 miles and you will see the site on the right.

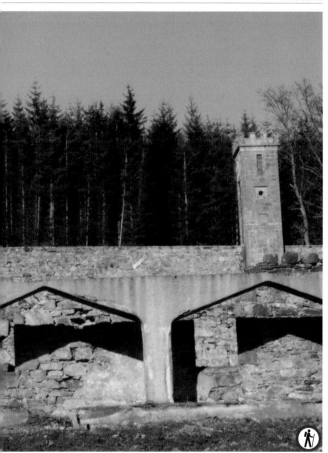

# Balmoral Castle

Balmoral Estate came into the world as Sir William Drummond's home in 1390 but the area was formerly owned by King Robert II (1371–1390), who had a hunting lodge in the area.

After Drummond, the estate was sold to Alexander Gordon, the 3rd Earl of Huntly, in the 15th century. The estate remained in the family's hands until it was sold in 1662 to the Farquharsons of Inverey, who sold the estate in 1798 to the 2nd Earl of Fife. The estate formed part of the coronation activities and events of King George IV in 1822.

Although it's called a castle, in truth the Balmoral that exists today is more a hunting lodge built by Prince Albert in 1852 for Queen Victoria, who fell in love with the area after spending holidays in the area.

The current castle is not actually the original building, the first castle having been built in the fifteenth century, but it was considered too small so a new castle was constructed on the site about 90 metres north of the old building, which Prince Albert had demolished and replaced in the neo-Gothic, 'Scottish Baronial'

style which you see today, complete with its distinctive tower.

With the help of Aberdeen Architect William Smith, Prince Albert played a leading role in the castle's design and the layout of its grounds and gardens, the project being completed in 1856.

Today Balmoral is a working estate with over 50 full time staff, and is closely linked with the local community. The estate comprises 18,659 hectares owned between Balmoral, Birkhall and Glen Doll, with 2,940 hectares of grouse moor at Corgarff. There are seven Munros within its boundaries, while 3,000 hectares are afforested and 190 hectares arable and pasture.

Balmoral is best known as a royal residence. When Queen Victoria died in 1901 the estate passed, under the terms of her will, to Edward VII and from him to each of his successors. It remains the traditional holiday home for the Queen and members of her family.

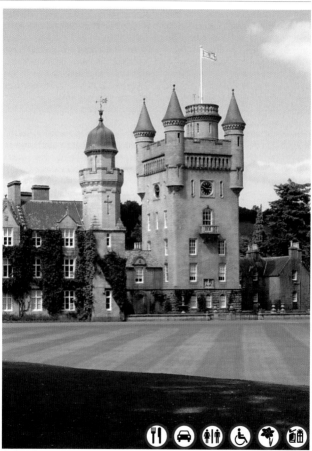

pic - Stuart Yeates

# Balmoral Castle

Over the years the gardens have been improved and extended to include a formal garden, kitchen garden and water garden. This is situated near to Garden Cottage, which is not open to the public, however it is possible to glimpse the interior of the cottage through the window. Queen Victoria used the cottage at times to take breakfast and as a quiet retreat to write her famous diaries.

The castle and gardens are open to the public from April to July each year, with winter tours held during parts of November and December. Audio tours are available along with exhibitions and walks. There is also a coffee shop where you can have home-made Balmoral Broth. The castle also has a gift shop stocked with souvenirs.

The only part of the castle open to the public is the Ballroom, which contains paintings and works of art. To commemorate The Queen and The Duke of Edinburgh's Golden Wedding back in 1998, the walkway leading up to the Ballroom was replanted with low-growing culinary herbs and herbaceous plants, presented by The Royal Regiment of Artillery and The Corps of Royal Engineers.

A special collection of Royal ball gowns, which include those worn by the Queen and the late Queen Mother, are also on display in the Ballroom. There is also a restored Victorian cot, which may have been used by Queen Victoria's children during their visits.

Beyond the Ballroom, in the Carriage Hall Courtyard there are various other exhibitions detailing the estate's history, the area's environment and wildlife.

You will also find on display a tartan known as the Balmoral, which was worn by the Balmoral Highlanders and is today the uniform worn by the Queen's piper.

There is also a display of Christmas cards sent from the Queen and the Duke of Edinburgh, dating from 1950 to the current day.

There are numerous other activities on the estate, including guided walks with a ranger around the grounds and gardens which take in various monuments and cairns.

Walks last approximately two hours and cover between two and three miles. There is no charge for the tour but you do have to pay an estate admission fee.

If you wish to go further afield you can take part in a Luxury Land Rover Safari, to see and photograph the estate's wildlife, such as red squirrels, roe deer, red grouse, black grouse, ospreys and golden eagles. Binoculars and telescopes are available.

Safaris, which are not available during August, September and October, last for about 3 hours and take you around the parkland of the castle, through Caledonian Pine Forests and over open moorland at the foot of Lochnagar.

Morning safaris start at 9.00 a.m, while afternoon safaris start at 2.00 p.m. Booking is essential as there are only a limited number of safaris each week. Vehicles can carry 4/6 depending on the rear seats.

**Location:** ●
Balmoral Castle is located 9 miles west of Ballater along the A93. As you approach, you will see Crathie Church on the right while opposite on your left is the castle car park and the tourist information centre.

**Facilities, opening and contact:**
Gardens, coffee shop and souvenir shop.
Open times: the grounds, gardens and exhibitions are generally open from March to the end of July but are closed to the public during August, September and October when The Royal Family are in residence, however guided tours are also available during November and December. Daily hours 10am to 5.00pm
Entry costs: from £7 adults, £3 child. Family ticket (2 adults 2 children) £15.
The estate operates an access for all policy with excellent facilities for the disabled visitor.

www.balmoralcastle.com
tel: (013397) 42534

# Blairfindy Castle

● Glenlivet

Blairfindy Castle is a small castle located close to the River Livet and next to Glenlivet Distillery.

It's a traditional 16th century tower house with an L-shape plan.

Earl of Huntly of the Gordon clan built the castle in 1586, some say as a hunting lodge as well as a control point covering the main access to Gordon country from across the Ladder Hills.

Today the castle is a ruin. In fact, it is in such a bad state of repair that it has been fenced off to protect the public from falling masonry.

Its only inhabitants today are the screetching rooks which lend the place a Hammer House of Horrors atmosphere, those unnerving calls echoing around the roofless structure.

**Location**: ●
Blairfindy Castle is 15 miles north of Tomintoul along the B9008. Follow signs for Glenlivet Distillery. The castle is located close to the distillery a few hundred metres past the visitors car park down a short lane.

Note: the castle is sealed off for safety reasons; so do not enter the surrounding fence.

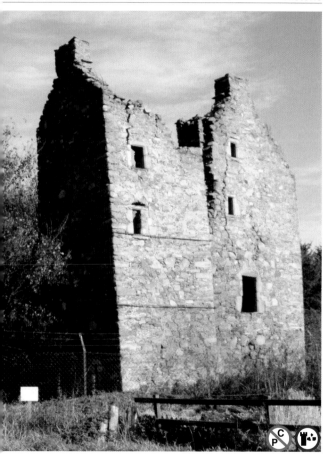

# Braemar Castle

## • Braemar

This fairy-tale castle has seen its share of troubles over the years since it was built in 1628. The "Black" Colonel of Inverey, the enemy clan leader, attacked and burned the castle in 1689 and after being rebuilt the L-shaped Castle with its remarkable star-shaped defensive curtain was garrisoned by Hanoverian troops for some 60 years after the 1745 Jacobite rebellion.

The castle, situated just outside Braemar, had its first tower constructed back in 1628 by John Erskine, the 7th Earl of Mar, to replace the older Kindrochit Castle. An important garrison during the Jacobite uprising, Braemar was attacked and burned by John Farquharson, the Black Colonel of Inverey in 1689, killing John Erskine. The site was left in ruins until 1748, when it was leased to the government by Clan Farquharson of Invercauld to serve as a garrison for Hanoverian troops. Graffiti left by English soldiers can still be seen in some rooms.

In 1797 the castle was returned to the Farquharson clan and its restoration as a clan seat began.

The castle has an L-shape layout, with a star-shaped curtain wall and three-storey angle turrets. The main entrance to the castle retains an original iron yett.

Today the castle is owned by Braemar Community Ltd, which holds a 50 year lease and plans to re-open the building to visitors.

It is currently undergoing major restoration and is not open to the public. However, the outer walls and grounds are open to all. Work has started to get the building into shape and it should re-open this year.

Located close by is a cairn on Creag Coinnich, erected when Braemar Castle was vacated by government troops in 1831.

**Location:** ●
As you leave Braemar towards Ballater, the castle is located on the left hand side of the A93.

**Facilities, opening, contact.**
Open times: The outer walls and gardens are open daily. Free entry.

www.braemarcastle.co.uk
tel (013397) 41404.

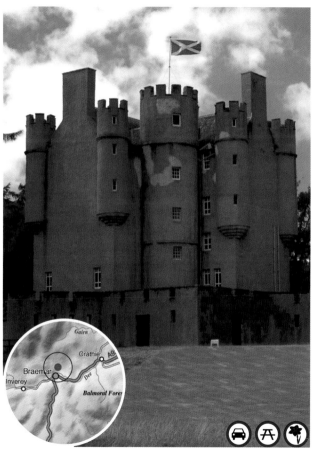

pic - Elnur

# Cambus O'May Suspension Bridge

● Ballater

The river Dee has a series of steel suspension footbridges of which the best known is that at Cambus o' May, constructed in 1905 and rebuilt 90 years later. Its original purpose was to provide direct connection between Cambus O' May and the lands of Ballaterach on the southern bank.

Located two-and-a-half miles east of Ballater just off the A93, the bridge - which is for foot traffic only - was cast in Aberdeen. There was originally a ferry here, hence the old ferry inn near the bridge.

As well as parking and forest walks, this is a good site for a picnic. You can also reach the bridge via a walk east from Ballater on the old Deeside railway line.

**Location**: ●
The Cambus O'May Suspension Bridge is 4 miles (6.4 km) east of Ballater on the A93.

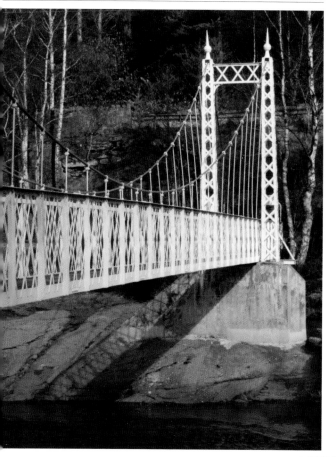

# Castle Grant

**● Grantown-on-Spey**

A Nottinghamshire land-owner named Le Grand obtained land in Strathspey in the 13th century, founding the powerful clan which spread over Strathspey and the Grampian mountains into Aberdeenshire. The Grants supported Robert the Bruce in the 14th century and John and Randolph de Grant were captured at the Battle of Dunbar in 1296. Around the time when they were released, the family obtained lands at Glenmoriston and Glen Urquhart, which is still in the clan ownership.

The first authenticated chief of the Highland clan was Sir Ian Grant, who was Sheriff of Inverness in 1434. In 1493 the Grant lands became the barony of Freuchie and Sir James Grant built a castle there in 1536.

Originally called Castle Freuchie, it was renamed Castle Grant at the end of the 17th century. The original Z-plan tower house was enlarged considerably from 1750, with the eventual addition of projecting lower wings and paved courtyard.

Like most clans, the Grants had occasional feuds with their neighbours and they joined the Campbells against the Gordons of Huntly in 1594. The Grants were loyal to the crown in the Civil War in the mid-17th century and joined the Marquis of Montrose on his campaign after the Battle of Inverlochy. Grants also gave shelter to the MacGregors during the persecution of that clan, as there had been a long history of alliance between the two. Later, the Laird of Grant supported William and Mary and their government and did not get involved in the Jacobite Uprisings of 1715 and 1745 although the Grants of Glenmoriston and others in the clan supported the Stewarts.

Robert Burns visited Castle Grant in 1787.

The Grants were elevated to the title of Earls of Seafield in 1811, but in the 19th century the 27th chief of Clan Grant had a serious dispute with his brothers and the estates were split up - the Seafield Earldom was lost to the chief of the clan, but the line continued with the title Lord Strathspey of Strathspey..

**Location:** ●
Castle Grant is located a mile north of Grantown of the A939 on the right.
Note: the castle is not open to the public.

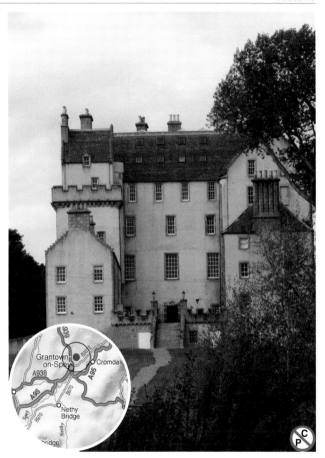

# Castle Roy

• Nethy Bridge

Castle Roy near Nethy Bridge is one of the oldest in Scotland. It has a simple enclosure, plain curtain walls and stolid tower once protecting the inhabitants of the courtyard's wooden lean-to buildings.

Dating back centuries, the castle may have been built soon after 1226 by James, son of the Earl of Mar, to whom Alexander II had granted the Lordship of Abernethy.

Castle Roy is said to have been a stronghold of the Comyns, but nothing authentic is known of its history. However, located south of the village, the castle sits next to the Old Kirk, and stands elevated.

It has a high enclosing wall, sitting on a rocky site which in turn is raised by around 10 to 15 feet above the surrounding fields.

The walls of this ruin, some 7ft thick and around 25ft high, are built with strong rubble-work and have stood the test of time, surviving unnumbered harsh, hairy, hoary Highland winters.

The inner space of the castle measures 80ft long by 53 ft wide from east to west.

The entrance is an 8ft wide doorway, set in the in the north wall, the inner pointed arch of which still stands.

There is a square tower at the north-west angle, and the remains of a large window near it, which has also a pointed arch.

At the south-east angle the wall is broken away, as if for the purpose of adding a tower similar to that at the north-west angle, but apparently no tower has ever been built.

The recess in the wall at the south-west angle, which is on the ground level, seems to have been used as latrines.

The castle is open to the public every day of the year and there are no entrance charges or restrictions.

**Location:** ●
Castle Roy is located a mile north of Nethy Bridge along the B970. You will see the ruins on the left just past the church and infront of the parking area.

**Facilities, opening and contact:**
The ruins are open daily all year and there is no entry charge.

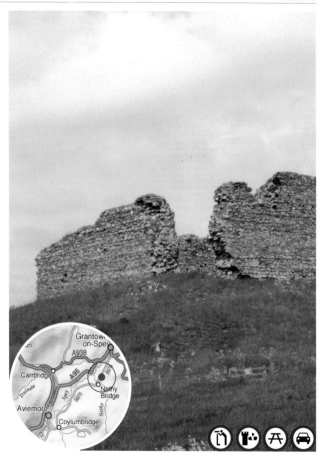

# Clova Castle

● Angus Glens - *Glen Clova*

The remains of Clova Castle are located on a patch of land just north of the River South Esk, which runs through Glen Clova and Glen Doll.

The castle dates back to the 16th century, but like the remains, there is not a great deal that is known about its history.

Once owned by the Ogilvy family, Clova Castle was a typical tower house of the time and which its thought was destroyed by a gang of wild Highlanders known as Catterans who were originally from the Grampian mountain area and who set out to pillage settlements all over the Angus Glens.

Very little of the castle remains today, all that you will see is the lower part a tower that would have once been a stair well.

**Location**: ●
Clova Castle is located just out side the hamlet of Clova on the left hand side of the road heading towards Glen Doll. The ruins are perched on the hill side a few hundred metres from the road. Note that there is no proper parking, you may want to park in Clova and walk along the road which is about half a mile.

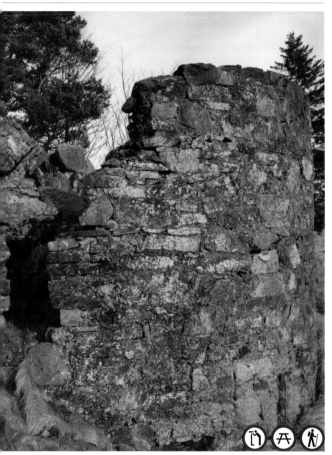

# Corgarff Castle

• Corgarff

Through much of its history Corgarff has been of strategic importance, guarding the quickest route from Deeside to Speyside, a route later followed by the military road from Blairgowrie to Fort George. Its location has ensured Corgarff's eventful, sometimes tragic history.

The castle is thought to have been built in about 1550 by John Forbes of Towie. It would initially have comprised a tower house set within a walled enclosure. The tower house would have been similar to the structure you see today: the surrounding wall would have been very much simpler and probably rectangular in plan.

The Forbes family were supporters of the future James VI in the years following the imprisonment of Mary Queen of Scots in England. The Gordon family from Auchindoun near Dufftown were supporters of the claim of Mary to the Scottish throne.

This led to feuding between the two clans, and in November 1571 Adam Gordon of Auchindoun tried to capture Corgarff. The Forbes menfolk were absent, but John Forbes' wife, Margaret, refused to

surrender the castle and shot one of Gordon's men through the knee with a pistol. In response Adam Gordon piled kindling against the castle and burned it down, killing all within the castle except for Margaret Forbes who fled to Ireland, where she gave birth to John's son Alexander. Not surprisingly, the castle is believed to be haunted.

In 1607 it was taken over as a base for local bandits, who plundered the surrounding area until 1626 when it was acquired by John Erskine, 18th Earl of Mar. In 1645 the castle's strategic location led to its use as a mustering point for James Graham, 1st Marquess of Montrose, commander of the Royalist forces in Scotland during the Civil War. During the 1689 rising led by John Graham, 1st Viscount of Dundee, Corgarff was again burned down, this time by Jacobites to prevent it being used as a base by supporters of William of Orange.

In 1715 Corgarff once again played an important role in national events. John Erskine, 22nd Earl of Mar launched the Jacobite rising from Kildrummy Castle in Strathdon. He then came to Corgarff to assemble and equip

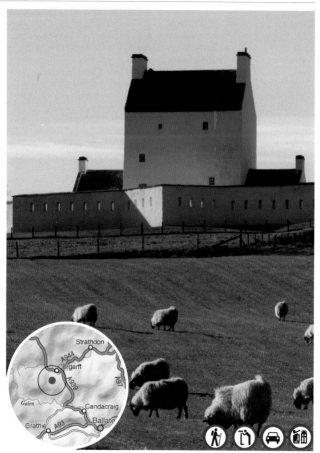

# Corgarff Castle

his army before marching on to Braemar. After the 1715 rising had been quelled, government forces yet again burned down Corgarff, and the Earl of Mar's estates were forfeited.

The castle was then returned by the Government to the Forbes family. But 30 years later it was caught up in the maelstrom of Scottish history again: by early 1746 Jacobite forces were using Corgarff Castle as an arms store after their retreat from Derby. A forced march by 300 Government foot soldiers and 100 dragoons through the snow from Aberdeen caught the Jacobites off guard...

When the troops arrived the Jacobites had fled, so hurriedly that there was a cat asleep in front of the still burning fire. The troops also found large quantities of gunpowder and over 300 muskets, which they either destroyed or took back to Aberdeen. The Battle of Culloden, which took place some weeks later on April 16, 1746, was so one-sided that the loss of these weapons by the Jacobites was probably not decisive, but did very little to lift their morale.

The Corgarff Castle you see today owes much to events following the 1745 uprising. In an effort (either successful or unnecessary, according to your point of view) to suppress the Highlands once and for all, the Government stationed outposts of troops right across the country.

In 1748 Corgarff Castle was converted into barracks. At the same time it acquired flanking pavilions and the very unusual star-shaped encircling wall. This was well equipped with musket loops, but it is obvious from the design that attack by artillery was not expected. In the event, these defences were never tested.

Over the following years, Corgarff was used as a base for around 50 men under the command of a junior officer. Half would have been quartered in the castle itself. The other half were divided into small and widely scattered patrols, and based in a variety of barns or the homes of a largely hostile population. They spent much of their time chasing Highlanders unwise enough to wear their kilts (illegal since 1746), carry weapons, or smuggle whisky within view of the troops.

Life in the barracks would have been comfortable in terms of 1748 expectations. But when looking round the recreated barracks at Corgarff, remember that the beds, which look generously sized, were intended to be used by two soldiers. And although it would not have happened at an outpost like Corgarff, in a larger base like Fort George up to one in a hundred soldiers were allowed to marry, and his wife and any family would also live in the barrack room.

think how it would have looked to a soldier in winter, amid a hostile population and a very long way from home.

From 1802 the castle was used as a farmhouse, but the Government repurchased it in 1827, this time as a base designed specifically to tackle whisky smuggling and illegal distillation in the area. From the army's final departure in 1831, the castle went into a steady decline. Its last residents were the Ross sisters, known locally as the Castle Ladies, and they left during the First World War.

Corgarff Castle passed into state care in 1961 and has in recent years been wonderfully restored by Historic Scotland to the condition it would have enjoyed in the years following the 1748 conversion. And while you peer out of the upper floor window at the lovely views over Strathdon,

**Location:** ●
Corgarff Castle is located south of Tomintoul along the A939 and 10 miles past the Lecht Ski area on the right.

**Facilities, opening and contact:**
Summer; 1st April to 30th September, Monday to Sunday 9.30am to 6.30pm. Winter; 1st October to 31st March Saturday and Sunday only 9.30am to 4.30pm. Last tickets sold at 6pm (4pm in winter). Christmas and New Year Period Closed 25th, 26th December and 1st, 2nd January.
Accessibility: The west pavilion housing the bakehouse and brewhouse is accessible to wheelchair visitors or with limited mobility but there is no suitable access to the main tower. Sound loop available.
Parking: A five minute walk from the steward's point on a rough track up a steep hill. Visitors with disabilities can be set down nearer the castle by prior arrangement.
Entry costs: £4.50 adults, children £2.50.

www.historic-scotland.gov.uk
tel (01975) 651 460

# Crathie Church

● Ballater

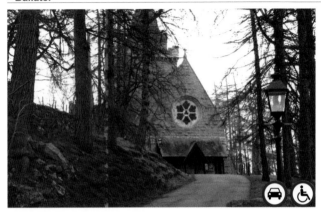

Crathie Kirk, a small Church of Scotland parish church in the village of Crathie, is best known for being the regular place of worship of the British Royal Family when they're holidaying at nearby Balmoral Castle.

Crathie has been a place of Christian worship since the 9th century when a church was founded on the banks of the River Dee by Saint Manire (Bishop of Aberdeenshire and Banff and a follower of Saint Columba, the pioneer of Christianity in Scotland). It is traditionally held that Manire baptised Pictish converts in a pool of the Dee east of the modern village of Crathie.

A single standing stone at Rinabaich is all that remains of Manire's church (where Manire himself is reputedly buried).

**Location:** ●

Crathie Church is located 9 miles west of Ballater along the A93. As you approach, you will see the entrance on the left while opposite on your right is the Balmoral castle car park and the tourist information centre.

# Dun Da Lamh Fort

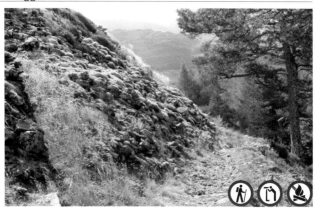

Dun Da lamh Fort was an impressive fort with massive ramparts situated on top of a wooded hill south west of Laggan.

Pronounced 'dun da larve' its name means 'fort of the two hands'. However, it's also known as Black Craig, a promontory fort of stone often described as Iron age or Pictish.

The Fort is reasonably easy to reach and can be seen from the Newtonmore-Fort William road. You will, however, have to track some rough terrain with some notably steep and rocky sections, so it would be a good idea to wear a good pair of walking boots.

**Location**: ●
Dun Da Lamh is located in the Black Wood 2 miles south west of Laggan. To get to it, drive past the Laggan Stores along the back road to Spey Dam. Directly south of the dam you come to a sharp bend in the road and on the left you will see a sign post for General Wades Military Road. The fort's actual location is 500 yards south on a hill to the right of you as you walk down the track. There is parking near Spey Dam.

# Drumin Castle

● Glenlivet

Located above the Rivers Livet and Avon on the Glenlivet Crown Estate, north of Grantown-on-Spey, are the ruins of this fortified tower house, dating from the 15th century.

The exact history of Drumin Castle is sketchy, with few historical documents available, however it's said that King Robert II granted the lands of Strathdon, including Drumin, to his son Alexander Stewart (better known as the "Wolf of Badenoch") in 1372.

There are no remains of the south-east wall, most of the south-west wall and some of the north-east walls. The north-west wall has the remains of a corbelled parapet, machicolation and a bartizan at the west corner. Above the single barrel-vaulted cellar was a first floor hall, second floor hall and third floor chamber and mural chamber.

There is little evidence of the roof structure but the existing walls are very thick and faced with a coarse freestone rubble in lime mortar with roughly shaped freestone dressings along with pinnings and traces of harling. There are the remains of plaster on the upper window reveals and internal wall surfaces. Corbels and the remains of a fine sandstone fireplace survive at third floor level.

Around one part of the castle there is a walled falt garden area with a bench.

Access to the castle is via the car park at the foot of the hill. The 500 metre walk up only takes a few minutes but it is steep and winds its way up through tight trees and could be testing for the elderly. However, there is alternative access to the castle at the top of the hill for the disabled via the private gardens adjacent to the farmhouse, but note this access point is for wheelchair and disabled visitors only reached from a designated disabled car park.

The main lower car park is also sited on the route of the Drumin Circular Walk (approximately 2 miles), which follows the river Livet before climbing up past Glenlivet School and returning through pine and larch woodland. The walk is well marked with information posts.

**Location:** ●
Drumin Castle is located in Glenlivet close to the school off the B9136 on the bend in the road. Follow the signs down to the car park which is about half a mile along.

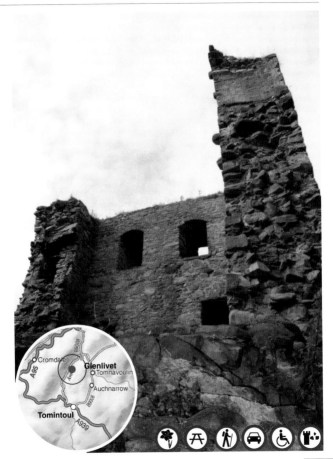

# General Wade's Military Road

## • Laggan

Back in 1724, after the Jacobite Risings of 1689 and 1715, General Wade was appointed by King George I to quell the clans, by disarming them and preventing them from forming allegiances with each other. To do the job he needed to get his armies around the Highlands quickly and efficiently, and one of his main tasks was to build military roads.

In 1731 General Wade and 500 of his men began the construction of a military road between Fort Augustus and Laggan, to link up their garrisons and avoid a long, arduous walk around the mountains.

For over a hundred years the road was the highest in the UK. Today, it's a national monument and closed to all vehicles except those authorised by landowners, etc.

But it is open to the public, and has become a very popular walk and cycle track, linking up with the famous Corrieyairack Pass running between Fort Augustus and Melgarve.

**Location**: ●
There are numerous spots where you can pick up Wade's roads in Laggan. The Corrieyairack Pass scetion can be joined at the Spey Dam.

# Glenbuchat Castle

● **Strathdon**

Glenbuchat is a Z-plan castle, built for John Gordon of Cairnburrow in 1590. In 1701 it was bought by a different branch of the Gordon family and became the home of another John Gordon, who came to be known as 'Old Glenbucket'. He was a prominent supporter of the Jacobite cause and a hero of the Jacobite Risings of 1715 and 1745. Such was his infamy that he is said to have haunted the dreams of King George II.

By 1738 the castle had been abandoned as the Gordon family home, and was already partly unroofed when it was sold to the Duff Earl of Fife.

The castle has a rectangular central tower with two square ones at diagonally opposing corners. Two stair turrets rise from the first floor level and are, unusually, supported by flying arches. The main entrance was protected by a wooden door that could only be opened if the iron yett (gate) behind it was opened first.

There were cellars and a kitchen on the ground floor and the laird's hall and accommodation above. The interior of the castle was remodelled, probably around in 1701.

The laird's hall was divided into two to create a dining room and a drawing room more suited to contemporary social taste, and the ceiling was lowered to make space for a new second floor beneath the old garret. By using wooden partitions, four extra bedrooms were provided on the new floor, in addition to those in the towers.

Until the castle changed hands in 1738, it was owned by the Gordon family. In 1840 the roof was removed and the castle deteriorated. In 1946 the castle became public property and is now managed by Historic Scotland.

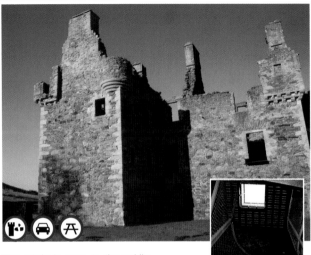

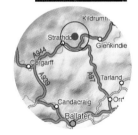

The castle is open to the public free of charge. To gain access you have to go round the castle to the grassy courtyard reached from the car park track.

A lot of restoration has been done over the years, including the construction of a central wooden viewing platform. You can walk around the first floor, and explore the vaulted ground floor although, some of the rooms are very dark, so take a torch!

**Location**: ● From Strathdon head west along the A97 for 5 miles turning left at the castle sign up a short road to the car park. Accss to the castle is possible on a wheel chair, but you can't get in side with a wheelchair.

115

# Glen Mark & The Queen's Well

Glenesk, something like 16 miles long, is a barren moorland on hills lying at the base of the Grampian mountains and is the most easterly of the Angus Glens. It borders Glen Lethnot to the west and Aberdeenshire to the north.

You reach the place via the B966, Edzell/Fettercairn road off the A90, but note - there is no through road. The way in is the way out!

It is a traditional glen, divided into three privately-owned estates whose main interests are sporting - grouse and pheasant shooting and deer stalking. Consequently, game-keeping employs more permanent and seasonal staff than any other business.

At the head of Glenesk, the Queen's Well can be found. It was built in commemoration of Queen Victoria, who once stopped for a drink of water on her way from Deeside to Glenesk. Invermark Lodge is at the foot of the Ladder Burn - the usual starting point for mountaineers tackling Mount Keen - and Queen Victoria stayed at the Lodge for a night when, after the death of the Prince Consort, she rode from Balmoral to Glenesk.

It is quite possible that she was accompanied by the famed John Brown during this visit. Visiting the Queen's Well is made easier by the siting of a car park two miles away. The walk from there is very gentle over the slightly rolling landscape of Glenmark.

This crown-shaped edifice was built to commemorate the occasion, on 29 September 1861, when Her Majesty and Prince Albert came across the hills from Balmoral Castle and met with Lord Dalhousie. They picnicked at this spot before travelling on down the glen. The well is artesian and there is an inscription around its base reading: "Rest here weary traveller on this lonely green, and drink and pray for Scotland's Queen". There is also a plaque on one of the columns which reads, "Her Majesty, Queen Victoria, and his Royal Highness the Prince Consort, visited this well and drank of its refreshing waters, on the 20th September, 1861, the year of Her Majesty's great sorrow".

**Location**: ●
The Queen's Well is situated 2 miles along Glen Mark, which is at the head of Glen Esk and north of Loch Lee.

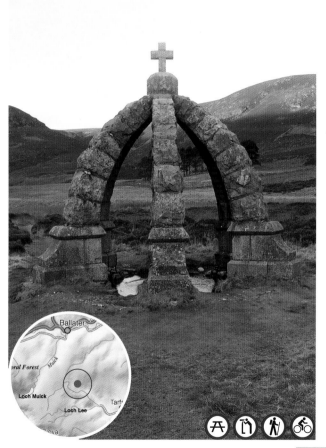

# Invermark Castle

- **Angus Glens - *Glen Esk***

Situated south of Ballater in the Angus Glens at Glen Esk, this fortress was built in 1526 by the Lindsay family to incorporate the tall tower house dating back to the 1300s, which went up to guard the southern end of the strategic pass leading from Deeside.

Invermark was used as a refuge by the locals when Highland caterans or raiders descended on the glen to steal cattle and whatever else they could find. In 1659, when the laird bestowed a grant for the reader, or schoolmaster, he bound himself and his successors to pay the whole stipend in the event of "a general vastatione of the paroche by Highlanders or otherwise."

The castle was used by young David Lindsay, in 1607, after he had killed Lord Spynie in Edinburgh after a long-standing quarrel. James Carnegie, Lord Balnamoon was another who sought shelter in Invermark Castle. He hid from government troops there after Culloden.

The keep is around 65 feet high, 38 feet long and 27 feet broad. The basement walls are over 5 feet thick. The doorway is around 9 feet above the ground and although the wooden door is missing, the iron 'yett' is still in position.

The tower stands 50 feet high and 38 feet in diameter, and was largely rebuilt in 1887 after a slip. This work was done by Stewart Porter of Cuttlehaugh, who was an apprentice to Robert Dinnie. The Queen's Well is a crown shaped monument built over a spring well in Glenmark. It was built to commemorate a visit made to Invermark Lodge, in September 1861, by Queen Victoria and Prince Albert. They made the journey from Balmoral to Glenesk over Mount Keen on horseback, and stopped at the well to drink.

The outbuildings were removed circa 1803 to supply materials for building the Lochee Church and Manse.

**Location:** ●
From Edzell head west along the B966 to Tarfside. 4 miles on and you will come to a car park. From the car park you walk a few hundread metres up to the Castle en-route to Loch Lee.

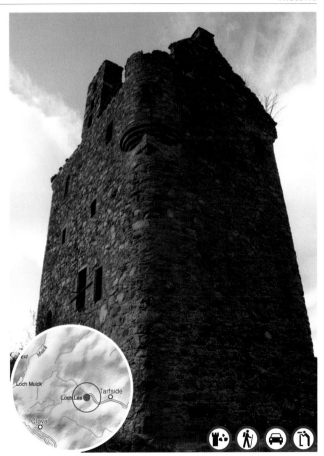

# Kindrochit Castle

● **Braemar**

Kindrochit Castle stands on a hill near Birkhall House on the South Deeside Road, in the centre of Braemar.

Originally built between 1057 and 1093 by King Malcolm III, Malcum Caen Mor, King of Scotland, the castle was then named Ceanndrochit meaning bridge head.

Today it's a ruin, but visitors can still make out many features, including the foundations and the original three-metre thick walls.

King Robert II spent time here, enjoying the hunting on the Braes of Mar. Later King Robert III gifted the castle to Sir Malcolm Drummond, his brother-in-law. Sir Malcolm proceeded to build the family tower in 1390, making it the fifth largest in Scotland.

Before the building could be finished, Sir Malcolm was attacked and killed by an unknown group. However, Alexander Stewart then stormed the castle and forced the widow, Isabella, Countess of Mar to marry him. Thus Alexander Stewart became the Earl of Mar. In 1435, Stewart died and the Earldom was annexed by the Crown.

By 1628, the castle was dilapidated, the Earls or Mar having moved out to take up residence in the newly-completed Braemar Castle.

The site of the castle commanded the important routes from the south and north into Glen Dee and in 1371 and 1388 King Robert 11 used it as a hunting base.

Although Kindrochit Castle was built mainly as a base for royal hunts, it took over from Doldencha the function of a strategic power-base. Braemar in medieval days was at the crossroads of two important routes - the link between Aberdeenshire and Perthshire via the Cairnwell Pass, now the A93, and the route from the north across the Mount to Angus via Glen Callater and Jock's road.

Excavations of the site began in 1925 and one of the most significant finds was an ancient prison as well as a brooch with some 16th century French Gothic writing. It read "I am here in place of a friend".

**Location:** ●
The ruins are located in the centre of Braemar opposite the car park next to the police station.

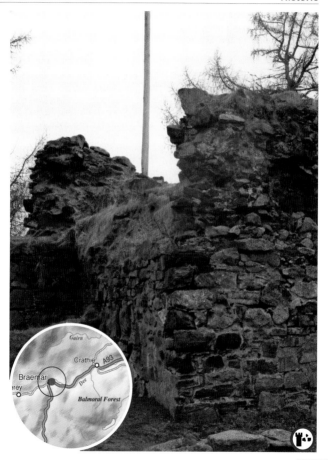

# Knock Earth House

• Glenlivet

Knock Earth House dates back to late Bronze Age of 1200 BC and is a protected ancient monument.

What you see here is an underground chamber which, reputedly, was used an illicit whisky still having been "made-over" as a corn-drying kiln.

However, the original purpose of the building was probably as a souterrain - which was a type of underground food store.

The site can be reached very easily via a track which branches off the marked-out West Avonside Walk, numbered as 11 on the

Glenlivet walk trails. The walk is posted on information boards around Glenlivet.

**Location**: •

From the Bridge of Avon, travel along the B9136 towards Glenlivet. After 1/2 a mile past Tomintoul Distillery, you will see a turn to the left over a short bridge. After the bridge you turn right and park in the Balcorach car park. From here you walk along the track for 1/2 a mile and then turn left at the sign for Knock House. From here the site is a further 1/2 mile along the track past an old farm and past the set of buildings with a tower. The fenced off ruins are close the buildings wall.

# Lecht Mine

Located near the Well of Lecht is this abandoned stone-built mine dating back to 1730. Iron was mined in these parts for many years.

The Lecht Mine closed in 1737 but was re-opened in 1841 and began producing manganese ore, which was processed in a crushing plant driven by a water-wheel in the building, and which can still be seen near the picnic area cleared nearby.

The building is devoid of any machinery today, but you are free to explore inside and there is an information board with diagrams and descriptions showing just how the mine would have looked.

You can reach the mine from the car park located a few yards of the main A939 road between Tomintoul and The Lecht Ski Centre. The walk to the building, beside the stream, takes about 10 minutes.

**Location**: ●
Look out for the sign for the Well of Lecht and car park, which is on the left as you approach form Tomintoul. The turn off is about 5 miles from on from Tomintoul on the bend just before the steep hill up to the ski area.

# Muckrach Castle

● **Dulnain Bridge**

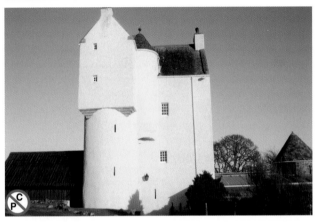

Muckrach Castle lies a mile out side Dulnain Bridge and 3 miles from Grantown-on-Spey. Located on a steep bank in the valley of the River Dulnain, Muckrach Castle is a typical Scottish tower house built to a very simple L-plan, with a main block of three storeys, a garret and a circular stairway.

John Grant of Freuchie (4th Laird of Grant) gave Muckrach to his second son, Patrick, in 1583 and the castle was built soon afterwards. Patrick was knighted by James VI and lived until 1626.

The building lay in ruins for centuries until it was restored between 1978-85 by architect Ian Begg, who also worked on the St Mungo Museum in Glasgow.

The castle, which is set in an acre of garden with views over the Spey, is not open to the public as it is a self-catering holiday home.

**Location:** ●
Muckrach Castle is located 1 mile east of Dulnain Bridge along the A938 back road, 3 miles from Grantown-on-Spey, 7 miles from Carrbridge and 12 miles from Aviemore.

# Old Spey Bridge

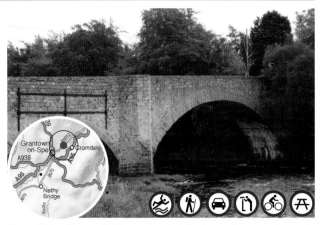

The Old Spey Bridge at Grantown-on-Spey, is a listed building a mile downstream from the current bridge.

It was built in 1754 to support the military road that ran between Blairgowrie, Lecht, Inverness Nairn and Fort George. It was originally constructed by a detachment of men from Lord Charles Hay's Regiment, under the direction of Major William Caulfield, a former assistant of General Wade.

At one time the Old Spey Bridge was the only permanent bridge over the river. However, today the bridge is not just an historic site,

but it also acts as a home to numerous species of wildlife, such as Daubentons bats, which live in the bridge's many cracks. You will also be able to spot various forms of plant-life, for instance the purple flowered ivy-leaved toadflax clings profusely to the bridge's lime mortar and stone brickwork.

### Location ●
The bridge is located 1/2 a mile north of Grantown off the A95, or by walking down the road that leads off the north end round-about.

# Packhorse Bridge The Old Bridge of Livet

**• Glenlivet**

In its original form the Packhorse Bridge, also known as the 'The Old Bridge of Livet', spanned the river with three stone arches. However, the left arch was washed away during severe weather in 1829.

The bridge has often been linked to General Wade, who built numerous bridges and military roads throughout the Highlands, however it's thought that the Packhorse Bridge is more likely to have been associated with Blairfindy Castle, which is close by.

The bridge spans the river at section with a rock and banks lined with wild plants, flowers and mixed woodland.

Next to the bridge you'll find an information plaque, picnic area and small car park.

With the age of the bridge in mind, visitors are asked not to walk over the arches, even though they are not fenced off.

**Location:** •
The bridge is located on a sharp bend of the B9008 in Bridgend of Glenlivet. If travelling via Tomnavoulin, follow signs for the Glenlivet Distillery, the bridge is on the left just as you go around the bend.

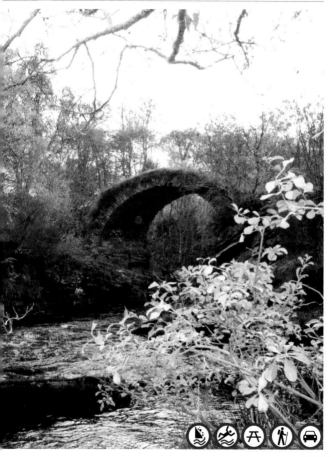

# Rothiemurchus

Rothiemurchus is a privately owned Highland Estate situated to the northeast of the River Spey just outside Aviemore. The estate has been owned and run by the Grant family since the 16th Century, and as one of the most treasured areas of the Cairngorms National Park boasts a vast number of historical gems.

People have lived in Rothiemurchus for over 5,000 years and have had quite dramatic effects on the flora and fauna, however, people and nature have long co-existed here and the indigenous people still feel very close to the land. The Parish of Rothiemurchus belonged to the Crown until 1226 when Alexander II gave it to Andrew Bishop of Moray as a hereditary thanage.

In 1787 the 8th Laird of Rothiemurchus, passed a deed of entail over Rothiemurchus, which meant that it was impossible to sell the estate and so subsequent Grant heirs became life tenants of their land. The entail proved a bonus in the 1790s when John Peter, inherited the estate. John Peter, who spent a few years as an MP in the House of Commons, had run up huge debts and finally became bankrupt in 1824 but because of the entail, creditors could take only his personal possessions to pay back his debts. John Peter and his family, which included his daughter, Elizabeth Grant, The Highland Lady, fled to India to escape this hardship. Rothiemurchus stayed under the control of trustees until 1842 when William Patrick, 10th Laird, regained control of the estate and settled the debts through the sale of timber from tress grown in one of the estates many forests.

Johnnie Grant 17th Laird currently owns and manages Rothiemurchus, supported by his mother the 12th Countess of Dysart, wife Philippa, son James Patrick and a dedicated staff.

The Highland Lady, Elizabeth Grant, was born in 1797 to the 9th Laird, she was the eldest of five children and is remembered largely for journals, which were published after her death. She began to write her memoirs on her birthday in 1845 whilst she was on holiday in France and in 1898, three years after her death her writings were first published as Memoirs of a Highland Lady.

The Doune of Rothiemurchus, which dates back to the 16th

Century, is the Laird's home and is situated on the original hill fort or 'Dun' a few miles south of Aviemore. This fascinating building was nearly lost as a ruin until an ambitious repair programme began in 1975. It was the home of Elizabeth Grant and it was here she wrote her celebrated 'Memoirs detailing life a century and a half ago.

Drumintoul Lodge is another historic building on Rothiemurchus. The Lodge was built in 1877 with one year's shooting income and was let to shooting and stalking tenants until 1960, when the parents of the present Johnnie Grant of Rothiemurchus moved here from Inverdruie House. During the Second World War the Lodge was used by Kompani Linge as a training base for their commando raids into Norway. The King of Norway often stayed in the lodge during his frequent visits to his troops.

Of all the historic buildings to be found on the estate, none have more intrigue and myth about them than the Loch an Eilein Castle, which translates from Gaelic as 'Loch of the island'. The castle origins are not clear

however it is believed that the structure was first built between 1222 and 1298 by the Bishop of Moray on the south of the island.

In the 1380s, it is thought that the notorious Wolf of Badenoch (Alexander Stewart, Robert the Bruce's grandson) built a tower house, which was used as a fortified, hunting lodge on the north end of the island. The castle, which is a small building, has a barrel-vaulted cellar, first floor hall and upper chamber. In 1600 a connecting curtain wall between the hall house and the lower tower was added to increase security. Years of highland storms has reduced the building to a ruin and despite some minor repairs the castle reduced in size in the 1770s when a sluice built to enable felled timber to be floated down the Spey, raised the water level.

**Visitor Information**:
For details relating to all aspects about Rothiemurchus check the website or call (01479) 812345 . www.rothiemurchus.net

# Ruthven Barracks

● **Kingussie**

Ruthven Barracks wasn't the first building to sit on this strategic hill-top near Kingussie. The first castle recorded here appeared in 1229. The second built at Ruthven was fought over during the Civil Wars of the 17th century and was badly damaged by John Graham, 1st Viscount of Dundee.

During the 18th century, after the 1715 Jacobite uprisings, the British Government decided to tighten its grip on the Scottish Highlands by building four fortified barracks in strategic locations. Ruthven Barracks was one of them. All of the remains of the earlier castles were removed to make way for the structure you see today. Building was completed in 1721.

The base was designed to house 120 troops, split between two blocks. The officers lived separately from the troops. The stables, which stood slightly to the west, were built in 1734 to house 28 horses for dragoons. By this time the strategic importance of the site had been enhanced by the building of military roads from Perth, Fort Augustus and Inverness, all converging on Fort Ruthven.

In August 1745 some 200 Jacobites tried to capture Ruthven Barracks. A force of just 12 British redcoats, commanded by a Sergeant Molloy, fought them off with the loss of just one man. By February 1746 Sergeant Molloy had been promoted to Lieutenant. He was still in charge when a larger force of Jacobites arrived, this time equipped with artillery. As a result the government garrison surrendered. On the day after the Battle of Culloden as many as 3000 Jacobites assembled at the fort with the intention of fighting on. The Bonnie Prince, however, instructed each man to save himself.

The Jacobites set fire to the barracks and dispersed, in an effort to evade the government forces who were now set on suppressing the cause once and for all. What remains is pretty much what was left by the departing Jacobites in 1746. Most of the exterior walls remain but little of the interior structure or roofing survives.

**Location**: ●
1 mile east of Kingussie along the B970 back road to Kincraig and Insh.

**Facilities**: The ruins are open to the public all year and are free to enter.

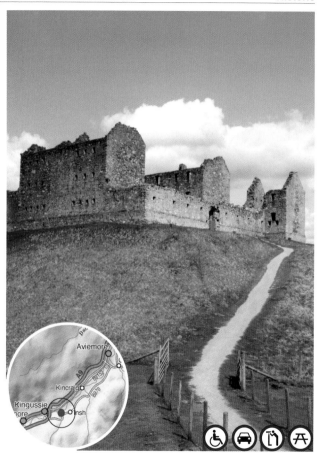

pic - Louise McGilliviray

# Sluggan Bridge

## ● Carrbridge

Up river via Station Road in Carrbridge towards Dalnahaitnach, Sluggan Bridge, which is category A listed and a scheduled monument was the second bridge to be built at this point on the river.

The bridge was built in 1729 and crosses the Dulnain River on the old General Wade Military road which is an ancient right of way.

Wade originally crossed the Dulnain with a ford which was later replaced in the 1760s with a two-arch bridge. This was swept away during the great flood of the 3rd of August 1829, to be replaced by the current large single span bridge in the 1830s.

In 2001 the bridge underwent major repairs by Sustrans the transport charity, as part of the National Cycle Network.

### Location ●

The bridge is located about 2 miles west of Carrbridge. To reach the bridge, travel along the road that runs past the famous Pack Horse Bridge and following the signs for the railway station. Continue along the track through the tunnel under the railwayline and A9 main road for two miles. You will see a gate and a sign for the cycle route 7. Pass through the gate and walk down the track through the birch trees for about 15 minutes until you come to the river just after a small cottage.

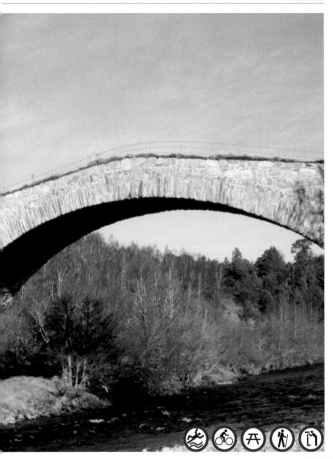

# The Auld Brig of Dee

● Ballater

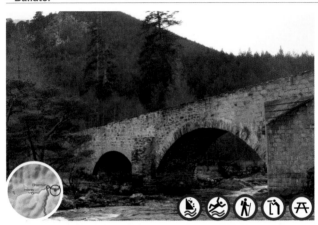

Back in 1746 after Bonnie Prince Charlie's army was finally defeated by King George II's, the government decided to build various forts to house Redcoats in order to quash any further Jacobite uprisings.

The new strongholds required good communications with lowland garrisons, so between 1749 and 1754 a new military road was built linking Fort George with Blairgowrie. Much of that road is still in use as the A93 and A939.

The Auld Brig of Dee, or Old Invercauld Bridge, which spans the River Dee, was originally built in 1753 by Major Caulfield and four companies of Holm's Regiment of Foot. The bridge was later lengthened at each end before it was finally superseded in 1859 by a new structure commissioned by Prince Albert to a design by J F Beattie and is still in use today.

Set before the stunning backdrop of the Lochnagar peak which rises to 3,786 feet, this triple-arched stone bridge is said to be one of the most photographed and painted bridges in Scotland. The bridge is looked after by Historic Scotland

Location: ● 3 miles east of Braemar of the A93 close to the current bridge.

# The Clan Grant Centre • Duthil

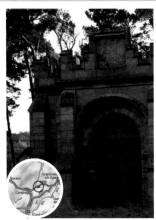

The Grant clan is one of Scotland's oldest clans and the Clan Grant Centre at Duthil, near Carrbridge, is a testament to the clan. On site is a former church with two mausolea in its grounds where some of the past Clan Chiefs are buried.

Duthil Church is owned and managed by the Clan Grant Society and is set in the midst of the Clan territories. It is planned to develop it into a resource centre to hold a collection of objects relating to Clan history and to be open to the public at certain times of the year.

**Location**: •
Duthil is reached along the A938.

# The Graves of Pets • Glenmore - Aviemore

This is a small burial site with stone marked graves of horses and tombstones for dogs. The stones are very small, but if you look closely you can read some of the inscriptions with names and dates.

**Location**: •
The burial site is located behind Glenmore Lodge opposite the rifle range sign. Access is possible from the car park a few hundred metres south of the snow gates opposite the area known as the Hay Field.

# The Martineau Monument • Aviemore

Located at the Loch an Eilein junction, this carved 16ft stone pillar was unveiled back in 1913 in memory of Dr James Martineau and his family who lived on Rothiemurchus.

**Location** - Situated in the fork in the road along the B970 2 miles south of Aviemore.

**135**

# The Old Bridge of Avon

● **Glenlivet**

The Old Bridge of Avon was built in 1754 in conjunction with a military road, and for a number of centuries provided the main access across this stretch of the Avon.

The stone structure has one main large arch and one smaller arch covering a wide stretch of water with a riverbed of granite rocks and steep banks on the south side.

The bridge was replaced in 1991 with a new one, a short distance down stream. The modern bridge carries the A939 road between Grantown-on-Spey and Tomintoul.

Access to the old brig is extremely easy, by taking the B9136 after Tomintoul and turning off just before the new bridge. A short distance on you come to a picnic site on the left. This is an excellent viewpoint and you may well see salmon in the pools below.

The bridge also gives access to Glenbrown and Kylnadrochit walk, which is a four-mile complete circuit.

**Location**: ●
From Grantown-on-Spey along the A939, turn left over the new bridge on to the B9136. Drive for 200 yards and park on the left.

# The Bridge of Carr

## ● Carrbridge

Dating back to around 1717, The Bridge of Carr - also known as the "coffin bridge" - is an ancient packhorse bridge crossing the River Dulnain and is said to be the oldest stone bridge in Scotland.

The bridge, in the centre of its namesake village, was erected by Brigadier-General Sir Alexander Grant of Grant, with the stonemasonry completed by John Nicholson of Pluscarden. Costing £100 to build and taking around six months, the building contract specified "and reasonable breath and height as will receive the water when in the greatest spear".

In 1829 the bridge suffered severe damage after exceptional flooding, but only the parapets were washed away in the "muckle spate".

A toll bridge for wheeled traffic was constructed in 1791 where the present bridge stands now. However, today the bridge is not safe to use and is closed off - but it does make for a great picture and, weather permitting, it's a great spot for a picnic.

**Location**: ●
The bridge is situated in the centre of the village directly across the road from the post office.

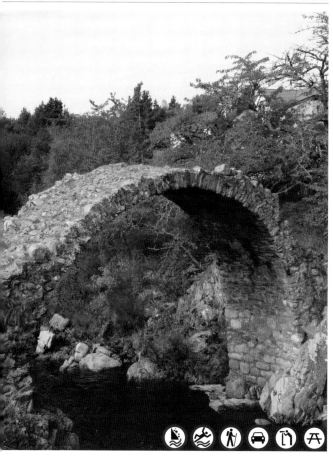

# The Doune of Invernochty

● **Strathdon**

Located at Bellabeg near Strathdon, The Doune of Invernochty is a Norman earthwork castle from the 12th or early 13th century. The name is a corruption of Dùn Inbhir Nochdaidh which means the "Fort of Invernochty (confluence of River Nochty)".

Dating from around 800AD it is a moated motte, once the stronghold of the Mormaer of Mar and is thus sometimes described

as the 'Citadel of Mar'. The nearest villages are Bellabeg and Strathdon, the latter once going by the name of Invernochty.

The Doune, which was an important stronghold, is an oval-shaped mound of residual mass of fluvial gravel. Surrounded by a deep ditch, the summit has remains of a curtain-shaped wall 1.8m thick with an entrance to the south. In the wall are remains of a Norman chapel which served as a parish church until the mid-17th Century, a unique piece of Norman military engineering.

**Location:** ●
The Doune of Invernochty is accessed off the A944 road which runs through Bellabeg and Strathdon. You will find the settlement in the centre of the village near the bridge. There is parking close to the mound.

# The Duke's Monument

The Duke's Monument, which is a 90ft column, was built to commemorate the 5th Duke of Gordon, who was also known as the "Cock of the North" and who died in 1836.

The tower resembles Nelson's Column in London, but without a statue. The base walls carry inscriptions in Gaelic, English and Latin with the words: "He was a generous landlord, a patriotic Highlander and a brave soldier.

It is said that the Duke's mother, Duchess Jane, was so taken by the location that she wanted to be buried here. After her death in 1812 her funeral cortege, a hearse drawn by six jet black Belgian horses, was brought all the way from London. It was one of the wonders of that time in Badenoch. With the arrival of her body, it caused great excitement in the area and the Duchess lay in state for two days until her final resting place on her beloved Kinrara. Robert Burns wrote of the duchess as a "charming, witty, kind and sensible lady".

**Location**: ●
If you drive south out of Aviemore, you will find access to the monument about 2 miles on the left just past the Rowantree Hotel. The trek up takes about 40 minutes from the road.

141

# The Stone Circle

## ● Aviemore

The Stone Circle in Aviemore is a Clava type cairn which, it's thought, was constructed some 4000 years ago.

Most of the material has been removed, leaving the two kerbs exposed with the almost-complete outer kerb measuring about 8 miles in diameter. The inner kerb, which is no longer visible, is enclosed in an area of around 8 metres in diameter. The cairn was surrounded by a stone circle, now comprising of only four uprights.

This ceremonial gathering place once consisted of a circular rubble bank edged by kerbs inside and out, all surrounded by a ring of standing stones. It has been covered with soil for its protection and the inner kerb is not now visible. The momument was probably built by farmers and herdsmen, and may have had cremated human bones placed in it. The site is looked after by Badenoch and Strathspey District Council.

**Location**: ●
The stones are situated at north end of Aviemore and lie within a small housing estate opposite the medical centre just past the fire station.

142

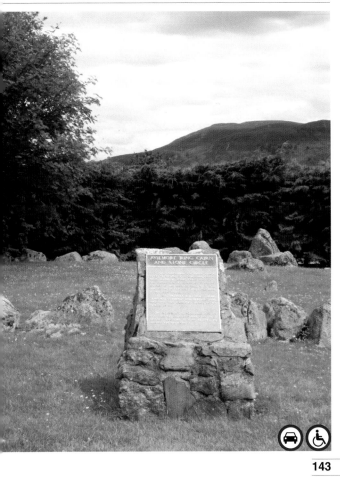

# Natural Attractions

The Cairngorms National Park (Scottish Gaelic Pàirc Nàiseanta a'Mhoinhaid Ruaidh) was established in 2003. It covers the Cairngorms range of mountains, and some surrounding hills. It is the largest national park in the UK, with an area of 1,467 sq miles (3,800 km).

It's the second of the two national parks so far established by the Scottish Parliament, the first being the Loch Lomond and Trossachs National, established in 2002.

One of the most outstanding features of the Cairngorms is the diversity of the landscape, with a range of mountains, glens, lochs and moorlands. The area also features a primeval forest, one of the last in the British Isles, known as the Caledonian Forest. Much of its remains are found within the national park. The Cairngorms also provide a unique alpine semi-tundra moorland home to many rare plants.

There's a huge range of wildlife species, many of which are dangerously close to extinction. Birds include ptarmigan, dotterel, snow bunting, golden eagle, ring ouzel, ospreys. Red squires, wildcats, otters and pine martens also live in the park, some more common than others.

# Abernethy Forest & Loch Garten

**National Nature Reserve** • Boat of Garten

Just a few miles outside Nethy Bridge, Abernethy Forest and Dell Wood make up the largest native Scots pinewood in Britain.

The combination of thick woodland and bog enables an abundance of wildlife to thrive in this reserve managed by the RSPB and SNH.

The forest is home to many breeding birds such as capercaillie, crossbills, crested tits and goldeneyes, as well as osprey, which can be seen fishing in nearby Loch Garten.

The Abernethy Forest is also home to a large number of rare northern insects and forest plants.

The information centre is a treasure house of information, where you can get advice regarding everything to do with the forest and Loch Garten, including full details on how to see the osprey and capercaillie.

**Location** ●
The forest can be reached via the B970 road that runs between Nethy Bridge and the Boat of Garten. There is a shop with amenities.

**Information:**
Explore Abernethy Visitor Centre.
tel: (01479) 821565. (April - Oct).
RSPB Abernethy/Loch Garten Osprey Centre.
tel (01479) 831476 (May - end August only)
www.rspb.org.uk/scotland. tel: 01479 810477.

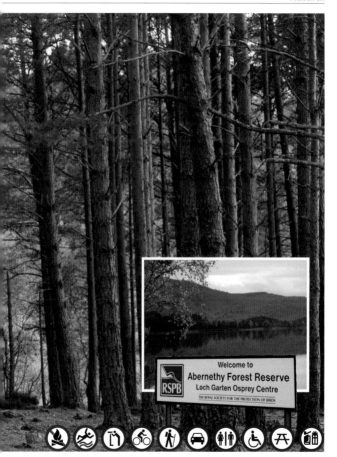

Welcome to
**Abernethy Forest Reserve**
Loch Garten Osprey Centre
THE ROYAL SOCIETY FOR THE PROTECTION OF BIRDS

# An Lochan Uaine The Green Loch

● **Glenmore Forest**

The Green Loch, as it's locally known is a small loch located in the Pass of Ryvoan, once a busy cattle droving route through Glenmore Forest.

As the name suggests, the loch's bright green and while some will give you a more scientific explanation for its colour, the real reason is, of course, that the local faeries wash their green clothes in.

The loch's easy to reach from the Glenmore Visitor Centre or the Allt Mor car park. There's a good path which, with the exception of the steps down to the loch, is suitable for accompanied wheelchair users starting from the visitor centre. Staff there will be able to give you all the information you need.

You can return the same way, or take a steeper waymarked route back to the visitor centre (not suitable for wheelchairs or buggies) and enjoy spectacular views of the Cairngorms along the way.

**Location** ●
Start from Glenmore Visitor Centre, on the ski road 7 miles east of Aviemore, or from Allt Mor car park, 1.5 miles further along, just past the Hayfield.

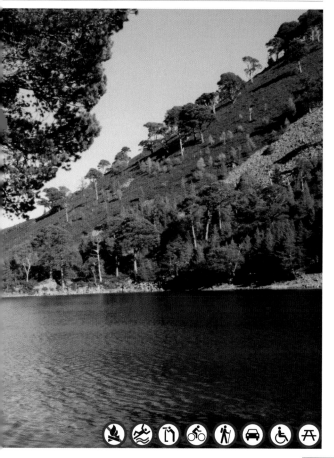

# Burn O'Vat

● Dinnet

The Burn O'Vat is situated within the Muir of Dinnet National Nature Reserve and lies 3 miles north of the village of Dinnet.

The hidden Vat, or cave, which is a ten minute walk from the car park, is an interesting and spectacular geological feature famed for concealing the 18th Century outlaw, Gilderoy Macgregor. There are numerous circular walks throughout the nature reserve that will take you pass abandoned settlements and an ancient Celtic cross.

The Muir of Dinnet National Nature Reserve is an area with extensive Birchwoods, wetlands and heather moor. Located in the reserve are two large and spectacular lochs, Davan and Kinord, that attract many thousands of geese during the winter.

At the Burn O'Vat, there is a visitor centre with displays relating to the natural history, geology and archaeology. The centre has toilets, a picnic site and free parking and is open throughout the year. However, the marked walks are not suitable to wheelchairs.

**Location** ● Close to the village of Dinnet between the A97, B9119 of the A93.

Visitor Centre. tel: (013398) 81667

# Cambus O'May Forest

● Dinnet / Ballater

Cambus O'May, which is managed by Forest Enterprise, is a wonderful pinewood with a host of facilities for visitors of all ages. The forest offers four easy to follow way-marked routes with interesting interpretation about the area's history and ecology, and openings in the forest give great views of Lochnagar. There are also trails for disabled visitors leading to view points and past shallow lochans with picnic benches, as well as narrow "natural" paths twisting between Scots pines and boulders for the more active. A permanent orienteering course offers visitors the chance to explore the forest more fully. The area has been designated a SSSI for its geological features, and recent timber work is improving the structure of the wood, thinning the Scots pine and removing some of the small stands of spruce.

The woods are also home to an abundance of wildlife where red squirrels leave their tell-tale chewed cones (crossbills also enjoy this source of food too). Secretive roe and red deer can often be spotted

**Location ● & facilities:**
Cambus O'May Wood lies on the north side of the A93 between Ballater and Dinnet. Car parking, information boards and picnic sites.
www.forestry.gov.uk

152

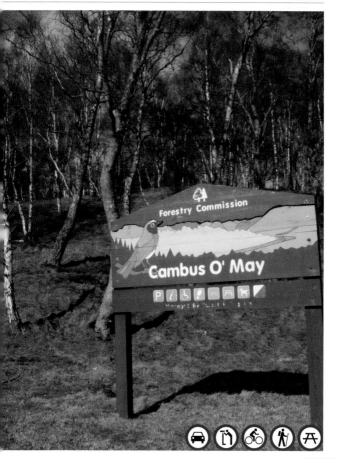

# Corrie Fee / Glen Doll National Nature Reserve

● Glen Clova - *Angus Glens*

Corrie Fee nature reserve, which is managed by Scottish Natural Heritage, is located in the Angus Glens at the head of Glen Clova.

The reserve was formed thousands of years ago as and was sculpted by ice which left behind corries, cliffs, moraines and a meandering river.

This is a wild and barren location with breathtaking landscape that is a haven for scarce arctic-alpine plants, birds and animals able to cope with the challenges of mountain life.

Corrie Fee's newly-upgraded path is popular all year round with hill walkers and its rich mountain flora includes some of Britain's rarest plants and lots of wildlife. Watch out for beautiful alpine flowers, rare mountain willows that clinging to the crags and golden eagles and peregrines flying high above.

There is a Visitor Information shelter and toilets at Glen Doll car park. While nearby the Angus Glens Ranger Service provides guided walks.

**Location ●**
You access the area via a road out of the hamlet of Clova which is 3 miles from the Glen Doll car park, which is pay and display costing £1.50.

# Craigellachie National Nature Reserve

● Aviemore

Just a stone's throw from the Aviemore Centre is Craigellachie National Nature Reserve, which is looked after by Scottish Natural Heritage.

The reserve, which sits at a height of 495 metres, is easily reached on foot via a short walk that takes you through a tunnel under the A9 bypass. The lower section of Craigellachie has a thin blanket of mature birch trees which are home to a wide variety of birds, between April and July you can often spot peregrines falcons which nests higher up on the cliff faces here.

Craigellachie includes several woodland trails, a viewpoint balcony and a couple of picturesque lochans. It's a fair bet that few of Aviemore's visitors are even aware that Craigellachie exists, but those who are curious and who wander through the sinister corrugated iron tunnel under the A9 find a quiet world of natural forest with rewarding views across Aviemore towards the Cairngorms. The best time to visit to see woodland flowers is around springtime.

**Location** ●
Located alongside the A9 to the west of Aviemore and only a 5 minute walk from the Aviemore centre via the play park and A9 tunnel. You can park in Aviemore centre.
SNH tel (01479 810477

# Creag Meagaidh National Nature Reserve

● **Creag Meagaidh** *(near Moy and Laggan)*

Creag Meagaidh is a mountain on the northern side of Glen Spean and to the west of Laggan. It is a complex mountain - a flat summit plateau from which five ridges radiate - and is most famed for the cliffs surrounding the corrie of Coire Ardair on the north-eastern face.

The name Creag Meagaidh is sometimes anglicised (in a somewhat tongue-in-cheek manner) to "Craig Maggie". The name is also applied to refer to the neighbouring peaks of Stob Poite Coire Ardair and Carn Liath, which together may be termed the Creag Meagaidh range.

Creag Meagaidh is designated as both a Special Protection Area and a National Nature Reserve, as the number of grazing animals is controlled. This has led to a regrowth of the native woodland of birch, alder, willow, rowan and oak. The site is also an important breeding ground for many species of birds, in particular the dotterel.

The car park at main entrance has interpretative panels and a bike rack. An all-abilities trail from the main entrance leads towards Coire Ardair.

**Location** ●

On the A86 road between Newtonmore and Spean Bridge, 10 miles west of Laggan.
SNH tel: (01528) 544265.

# Eidart Falls

- Glen Feshie

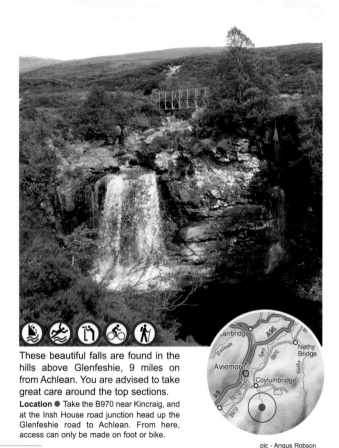

These beautiful falls are found in the hills above Glenfeshie, 9 miles on from Achlean. You are advised to take great care around the top sections.

**Location** ● Take the B970 near Kincraig, and at the Insh House road junction head up the Glenfeshie road to Achlean. From here, access can only be made on foot or bike.

pic - Angus Robson

# Falls of Pattack & Strathmashie Forest

● **West of Laggan**                                                    Natural

The Falls of Pattack and its cascading river lie within the Strathmashie Forest to the west of Laggan. This impressive gorge was used as a film location in the BBC's series, 'Monarch of the Glen'.

Strathmashie Forest is a community-led project comprising three very different woodlands. There are numerous stunning walks around the woods, some complete with handy directions. The Pattack Walk is a nice, easy, flat 500-metre walk, which will take about 30 minutes to complete.

You can reach the falls via a very short walk from the car park, which lies just of the A86. There is marked path up to the viewing point. From the falls walk uphill along the main path (ignoring the faint path next to the river). The path winds uphill to a way-marked junction; turn left here to follow a loop path through the attractive pinewoods. Note that there are some dangerous waterside drops - be careful!

### Location ●

From Newtonmore, travel west along the A86 6 miles past Laggan. On the left is the Druim an Aird Car Park. There is no wheel chair access up to the falls viewing point.

# Falls of Truim

## • South of Newtonmore

The Falls of Truim form part of the River Truim, which joins the River Spey south of Newtonmore.

Located in Glen Truim, this is a great spot in order to see leaping salmon as they try to reach their spawning grounds further up river. The best time to spot them is between September and October.

The falls are fairly tame but you do need to take care when getting down to the water. Watch out for steep waterside drops onto rocky slabs.

There is no official car park, but there is some parking space close to the stone bridge, which is also a good viewing platform.

Walkers will be able to explore numerous walks from this spot with mapped trails taking you across the hills to places such as Cruban Beag.

**Location** ● Along the A9, 7 miles south of Newtonmore, take old Dalwhinnie road and then follow signs for Crubenbeg Holiday Cottages.

# Feshiebridge

● **KIncraig**

Feshiebridge is a stunning part of the National Park located to the west of the Cairngorms.

Locals know this area more for the stone bridge spanning the River Feshie, which flows north through Glen Feshie down to the point where it joins the River Spey, near Kincraig.

In the summer, high fliers flock here to cheer their dare-devil mates as they jump from the bridge into the water pools below (Note: this is dangerous! The water depth is actually quite shallow in places).

Apart from bridge-jumping, this is a very popular spot for leisurely pursuits - bird and wildlife watchers find this an especially interesting area. The woods are also home to numerous rare butterfly species.

There are lots of excellent walks, through thick birch and pine woodland or across heather moorland - a notable new experience is the Frank Bruce Sculpture Trail, featuring stone and wood sculptures.

**Location** ●
You can reach Feshiebridge via Kincraig or Aviemore along the B970. The bridge is a mile from Kincraig, or about 7 miles from Aviemore.

# Glen Einich

Glen Einich is a large, glacially-carved rock on the western side of the Cairngorm Mountains, standing above 1650 feet. The glen leads to Loch Einich in the most dramatic of settings beneath steep corrie walls.

The loch supplies Aviemore and much of Strathspey with its fresh water.

There is a good mountain path, which is also suitable for bikes, following the whole length of the glen - some seven and half miles in all, starting out near Coylumbridge and Tullochgrue.

In the lower regions, the path snakes through areas with remnants of ancient Scots Pine, but as you travel up, the landscape becomes open and barren, offering breath-taking views. Several river crossings have to be made before you get to Loch Einich.

As well as various rare mountain plants to look out for, you will also come across large herds of deer and, if you're lucky, may well see golden eagles soaring high above in search of prey.

**Location** ●
Glen Einich is located in the centre of the Cairngoms and can be reached via several points. You can access the glen via Loch an Eilein on foot or by mountain bike, the distance being around seven miles. You can also access the glen via Tullochgrue

**166**

pic - © George Gordon

# Glenlivet Estate

● Glenlivet

Glenlivet Estate, which covers almost 600 acres, sits on the northern border of the park between Ladder and the Cromdale Hills.

It's a Crown Estate - owned and run by the sovereign of the United Kingdom "in right of the Crown" - with origins dating back a thousand years.

Glenlivet is surrounded by high moors and rolling hills with limited access points, the landscape ranging from low-lying woodlands to pine forests and wetlands, which offer sanctuary to numerous species of birds.

Much of Glenlivet lies over schist and limestone, which break down into more fertile soil than the granites found elsewhere in the Cairngorms. Around the estate there are various disused quarries which once produced slates for roofing (Cnoc Fergan Schist), limestone and coarse aggregate.

For outdoor enthusiasts, Glenlivet offers a host of attractions with some stunning and well sign-posted walks. You will find excellent information boards giving exact details.

**Location** ●
Glenlivet is 12 miles east of Grantown-on-Spey via the A95 and B9008.

www.glenlivetestate.co.uk

# Glenmore Forest Park

● **Glenmore**

With lochs, mountains and one of the best ancient pine forests in Scotland, Glenmore Forest Park really is a must-see place to visit within the National Park.

Managed by Forestry Commission Scotland, the ancient forest is an attractive mixture of massive 'granny' pine trees (some more than 500 years old!) and new saplings. The forest is being steadily expanded too, with non-native trees being replaced by native pine, birch and rowan.

You can enjoy Glenmore's peace and quiet at your own pace by taking a wander along the extensive network of paths. If you're lucky, you might spot some of Glenmore's permanent residents too, like the red squirrel, crested tit or the wood ant whose large, pine needle nests come alive on a summer's day.

There's a visitor centre on site, with a shop, café, displays and, in the summer months, information about ranger-led activities.

**Location** ●
7 miles east of Aviemore, either side of the ski road.

tel: (01479) 861 220
www.forestry.gov.uk/glenmoreforestpark

# Glen Tanar National Nature Reserve

## ● Glen Tanar

The Glen Tanar nature reserve lies a few miles south east of Ballater and is one of the finest remnants of Scotland's native pinewoods.

The glen is home to a host of pinewood plants and numerous species of wildlife, such as the rare Scottish crossbill, capercaillie and red squirrels.

You will also be able to find some wonderful plants, such as heather, blaeberry and twinflower.

The ideal time to visit is between May and September, when the weather's at its friendliest and the wildlife most abundant.

The visitor centre offers a Ranger service during summer, with a reduced service in winter.

A network of tracks encourages walking, biking, cross country skiing and pony trekking.

**Location ●**
You can reach Glen Tanar via Aboyne off the A93 and then south along the B968 and left-left along the B976. The road leads down to a car park just after Home Farm. There is a car park with pay and display charges. There is alos a visitor centre just over the bridge from the car park.

Glen Tanar Estate. tel: (013398) 8645
www.glentanar.co.uk

# Insh Marshes

• **Kingussie**

The Insh Marshes, more than three miles in length, lie either side of the River Spey upstream of Loch Insh between Kingussie and Kincraig.

They are owned by the RSPB and became a nature reserve in 2003, now treasured as one of the most important wetlands in Europe.

After heavy rainfalls and when the snow melts on the Cairngorms, the Spey will often flood its banks and spill over into the wetlands at various times of the year.

The marshes are home for hundreds of plant species, including orchids and various grasses. But the area is most popular for its wildlife, especially the birds. Large populations of goldeneyes nest here, as do curlews, snipes, wigeons, pintails, spotted crakes, redshanks, lapwings and whooper swans.

The marshes are freely open to the public with parking, picnic areas, information points, bird-watching hides and nature trails.

**Location** •
From Kingussie drive along the B970 towards Insh. You will find the marshes about a half a mile past Ruthven Barracks along on the left.

tel: 01540 661518
www.rspb.org.uk/reserves/guide/i/inshmarshes

**174**

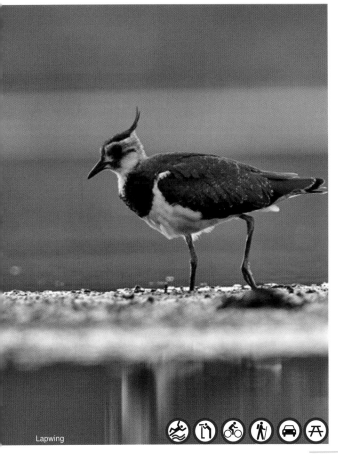

Lapwing

# Linn O'Dee

**• Angus Glens**

Narrow chasm on the River Dee west of Braemar.

# Loch Alvie

**• Aviemore**

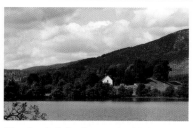

Stunning loch 2 miles south of Aviemore of the B970 with the Monadhliath Mountains providing the backdrop.

# Linn of Quoich

**• Braemar**

Located on thr River Quoich north of Braemar. This is a good start point for lots of walks.

## Loch Avon **• Cairngorms**

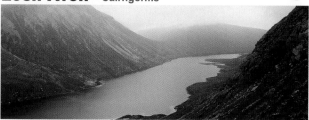

Loch Avon sits at a height of around 2200ft and is located in a deep cleft between Cairngorm to the north and Beinn Mheadhoin to the east. There are various mountain tracks but this is not a place for those who are not well - equipped.

# Loch Brandy

● Glen Clova - *Angus Glens*                              Natural

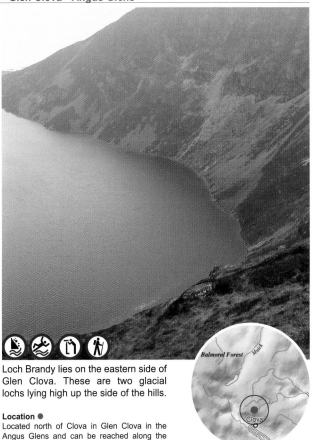

Loch Brandy lies on the eastern side of Glen Clova. These are two glacial lochs lying high up the side of the hills.

**Location** ●
Located north of Clova in Glen Clova in the Angus Glens and can be reached along the B95 and B955.

# Loch an Eilein

● Aviemore

Loch an Eilein is a small loch on the Rothiemurchus Estate and is said by many to be one of the most beautiful Lochs in the Highlands. The name Loch an Eilein comes from the Gaelic 'loch of the island' as there is a ruined castle on an island in the middle of the loch, estimated to be over 600 years old.

Used as a refuge in troubled times it was attacked by Jacobite MacDonalds after the Battle of Cromdale in 1960, but the Grant defenders successfully beat off the assault. The castle was used in the 1700's to hold Jacobite prisoners, but later fell into disuse as Scotland became a more peaceful country.

There is a really stunning walk all the way around the loch allowing you to view the castle from all angles. For the more adventurous and those whowould like to inspect the castle at closer quarters, Rothiemurchus offers canoeing trips on the loch itself - fabulous!

There are lots of picnic sites and a small visitor centre that stocks gifts and refreshments. The car park is good and a small fee is required which goes towards caring for and protecting this stunning place.

**Location** ●
3 miles south of Aviemore along the B970.
tel: (01479) 812 345 www.rothiemurchus.net

# Loch Insh

## ● Kincraig

Loch Insh is a large loch by the small village of Kincraig, which is one of the most attractive villages in the park, so it's no wonder the place has such a beautiful feature at its heart and this majestic loch has it all: breathtaking mountains views, an exquisite island covered in a thick blanket of trees. The loch is also a popular spot for walkers, with plenty of easy wooded trails snaking around the shoreline.

Wildlife enthusiasts are in for a real treat, as the loch is home to numerous species. It's not uncommon to see an osprey fishing for trout or salmon. At the southern end, the loch runs into the Insh Marshes, which is an RSPB nature reserve where you may see goldeneyes, wigeons, teals and so many other species.

At the Loch Insh visitor centre you can embark on a wildlife boat tour and get even closer to species you would normally miss. The centre also has a cafe, and picnic sites. You can take it easy on the loch-side balcony and enjoy the view, all the way south from Suie Hill to the atmospheric Craig Dubh.

**Location ●**
From Kingussie drive north along the B9152 and turn of east and drive down through Kincraig, and you will come to the loch at the bridge.

# Loch Laggan

## ● Glen Spean

Loch Laggan is a freshwater loch situated west of Laggan en route to Spean Bridge and Fort William and is located on the very border of the park. The loch also boasts the largest fresh water beach in the UK. The A86 road between Spean Bridge and Newtonmore follows along its north bank with lots of places where you can pull over and view the loch.

Since 1934 Loch Laggan has been a reservoir, retained behind the Laggan Dam, forming part of the Lochaber hydro-electric scheme. The dam is located south west of Loch Laggan and is 700 feet (213 metres) long and rises 170 feet (52 metres) above its foundations.

In recent years the loch has been made famous by the BBC who filmed the long - running TV series Monarch of the Glen at the lodge house that over looks the loch from the south side. Queen Victoria spent her first long highland holiday here in1847 but (allegedly) was driven to distraction by the midges.

**Location ●**
From Newtonmore along the A86 for around 14 miles via Laggan and following signs for Spean Bridge and Fort William. The loch begins on the parks, very boundary.

# Loch Lee

## ● Glen Esk - *Angus Glens*

Loch Lee is rather impressive reservoir situated at the head of Glen Esk in the Angus Glens and in the foot of Monawee, which rises to over 2000 feet. The loch lies west of the area known as Auchronie and is just inside the park boundary.

Glen Esk, which is split into three privately-owned estates and mainly lies outside the park boundary, is a rather barren place, yet stunning with wide open hillside moorlands and woodland, which comprises mainly birch trees. The area has a number of high cliffs and corries which provide excellent breeding grounds for a number of wildlife species, including grouse and golden eagles. It's not uncommon to see herds of deer roaming moors which also support a wide range of plant life.

The glen stretches for around 15 miles with Loch Lee at the northern end. The only access is via the B966 road from Edzell and there is no through road. This is a popular area for both walkers and climbers with plenty of interesting trails for all abilities to try out.

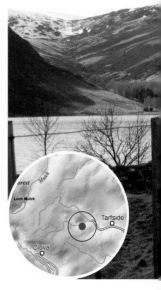

### Location ●
From Edzell head west along the B966 to Tarfside. 4 miles on and you will come to a car park. From the car park you walk for about a mile to the loch passing by Invermark Castle on the left.

# Lochan Mor The Lily Loch

## ● Cairngorms

Lochan Mor, known locally as the Lily Loch, is located in a remote part of the Rothiemurchus Forest and a wonderful spot to visit for a stroll, or simply to view the hundreds of lillies which adorn the water's surface and lend the loch its name.

The loch is a popular spot for visitors and locals alike - it's not uncommon to see a wedding taking place on the shores, the Cairngorm Mountains providing a majestic backdrop.

The loch, though under a mile long, is a haven for wildlife and home to a fascinating variety of wild plants. This is also a popular walking spot and a great place to have a picnic, but note: it's not just people who enjoy the place!  Midges also love it and sometimes there are millions of 'em!

This also a popular loch for fishing, its 12 acres of water very much a des res for brown trout.

You can reach the loch with ease via Inverdruie or off the road leading to Loch an Eilein, and along a wooded track.

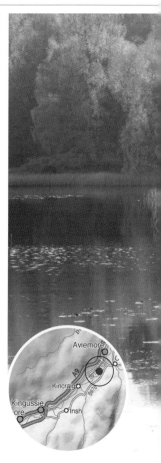

**Location ●**
Take the Loch an Eilein road off the B970 and after about a 1/3 of a mile you will come to on the left. From here you turn left and follow the track for about a mile. The Loch is on the right through a clearing in the trees.

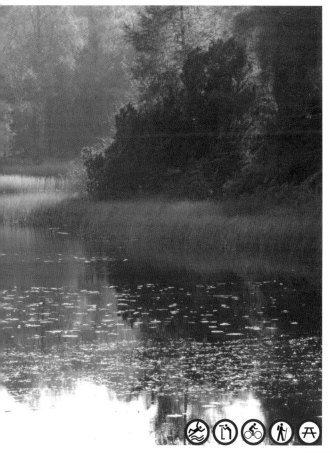

# Loch Morlich

Loch Morlich, nestling at the base of the Cairngorms, not only boasts fantastic views, but also lays claim to having the highest beach in Britain.

On a hot summer's day, this place is ideal for watersports enthusiasts. Kayaking, sailing and windsurfing are just some of what's on offer from the watersports centre, or you can simply relax under one of the ancient pine trees surrounding the beach.

Summer's not the only time to visit this loch - it's just as attractive in autumn and winter. The greens of summer make way for rich russets right up to the top of the mountains and the loch becomes home to a number of migratory birds. With most visitors gone, you'll also get the feeling that the forest is there for your enjoyment alone!

There are plenty of waymarked forest walks to enjoy, including a circular route around the loch and one accessible for wheelchairs. They start from different points, but you can pick up a walks leaflet from Glenmore visitor centre.

**Location** ● At the roundabout south of Aviemore, take the ski road towards the Cairngorms. Loch Morlich is 6 miles along. There are three car parks along the lochside, with the largest - adjacent to the watersports centre and beach - situated at the far end.

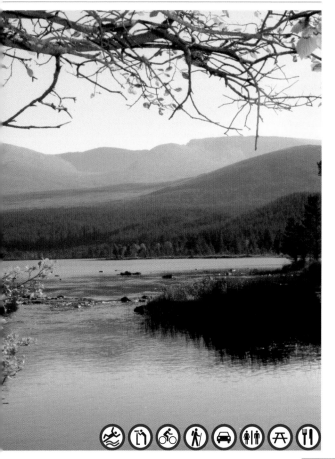

# Loch Muick & Lochnagar Nature Reserve

● **Glen Muick** - *south of Ballater*

Loch Muick and the Lochnagar Nature Reserve, which is located at the southern end of Glen Muick, is a nature reserve managed by the Balmoral Estates and despite its remoteness is surprisingly easy to reach with a single track approach road with passing places.

At the shore line is the Glas-Allt Shiel, a royal lodge built by Prince Albert for Queen Victoria. It's still used by the royal family. This is also the location of the Glas Alt Shiel Waterfall, a spectacular water cascade which flows down a rocky path into the north-eastern shores of Loch Muick. This dramatic feature sources from a steep rock section before levelling out through a thick wooded area, ultimately running into Loch Muick.

The distance around the loch is 7½ miles and would take around 4 hours to walk. But take note: it can be quite rugged in places, so a good pair of walking boots is required. The walk is rated as moderate. The area is also popular with mountain bikers, offering some some great trails to explore.

**Location** ● Travel south from the centre of Ballater along the B976 follwoing signs for Glen Muick and the Spittal of Glenmucik.

**Facilities.**
There is a car park (£2 for cars) toilets and a visitor centre with leaflets and displays.

**190**

# Mar Lodge Estate

● Inverery - *near  Braemar*

The Mar Lodge Estate is owned by the National Trust and is located west of Braemar near Inverey. It covers 29,340 hectares of wild land.

Throughout the estate you will find remnants of the ancient Caledonian pine forest, heather moorland and juniper scrubs. The estate includes land which has a number of national and international natural heritage designations; a wealth of important archaeological sites and five listed buildings, including the lodge itself.

Mar Lodge Estate has three areas of native Caledonian woodland covering almost 800 hectares, supporting various wildlife populations of red squirrels, black grouse, capercaillies, Scottish crossbills and parrot crossbills. The estate manages large stretches of the headwaters of the river Dee, an important spawning ground for spring-run salmon.

The estate is open all year round, and there are guided walks and events and special open days for access to the Lodge and the Ballroom.

### Location ●
Mar Lodge Estate can be reached by road by following the A93 north from Perth or West from Aberdeen. It lies three miles west off Braemar. Visitors arriving by car can make use of the car park at Linn of Dee.

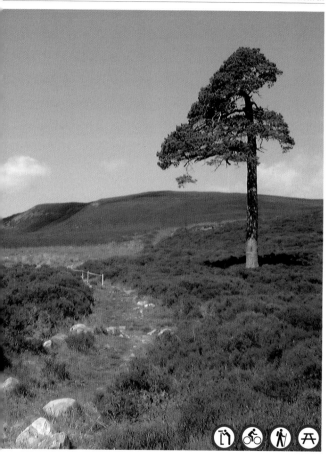

# Morrone Birchwood Nature Reserve

## ● Braemar

Morrone Birchwood Nature Reserve is set in a beautiful location above the village on the side of Morrone Hill, which is southwest of Braemar. The woods are one of finest example of upland birchwood in Britain covering 225 hectares. These woodlands aslo provide an important habitat for a number of plant, invertebrate, bird and mammal species, including a number of priority species. You will find numerous woodland birds nesting in the trees, such as siskins and tits. You will also see red deer grazing and red squirrels searching for nuts. There is an abundance of plants to enjoy which include various orchid species, globeflower and wood cranesbill.

It is said by scientists that the woodlands here closely resemble some woodland areas in Norway and is a reminder of how large tracts of upland Scotland would have looked in earlier times.

Around the area there a plenty of walks. The duck pond near the top of Chapel Brae is a good starting point for walks up Morrone or around the Morrone birchwood.

### Location ●

Morrone Birchwood Nature Reserve is located south west just outside of the of Braemar and can be reached from the car park at the top of Chapel Brae.

# Muir of Dinnet National Nature Reserve

## • Dinnet

Dinnet Oakwood is a designated special area of conservation located six miles from Ballater and is owned by Scottish Natural Heritage.

The area is alive with an array of wildlife and is home to otters and a number of breeding bird species and wintering wildfowl, in particular greylag geese and wigeon. You can discover lots of insects among the reedbeds, bogs and thick woodlands. As well as wildlife, there is evidence of prehistoric habitation.

The area has two lochs, Davan and Kinord where you will find lots of interesting plants. Loch Kinord is an important site for aquatic beetles.

In the summer, the mires and bogs are carpeted with red and green Sphagnum mosses and alive with dragonflies. You can visit the 'Vat' a giant pothole carved by a huge melt-water stream during the last Ice Age.

There is a visitor centre at Burn O' Vat with parking and toilets.

### Location •

Via Ballater along the B9119 at Milton of Logie. From here the reserve can be accessed via the footpath from the village car park. Main car parks are located at the visitor centre and just east of New Kinord. Smaller car parks are situated on the A97, west of Lochs Kinord and Davan.

# Roches Moutonnées

● **Dulnain Bridge**

The Roches Moutonnées rocks are located on the outskirts on the edge of Dulnain Bridge. Theses are glaciated rocks, which although close by, are totally different form the Ballintomb Standing Stones.

The name Roches Mountonnées, which means actually "rock sheep" was given to the rocks by French geologists who felt that they looked like the backs of sheep.

These distinctive glacial features are formed when the moving ice sheet passes over exposed lumpy bedrock. The ice is forced up the rock and smoothes and scores as it goes, giving a gently sloping profile on the leading edge. However at the rear of the rock there is little support for the bedrock and it tends to get plucked off bit-by-bit, leaving a sharp edge and a steeper face. From above the roches look like an arrowhead in plan and they point into the direction in which the ice sheet passed over them. In this area it is estimated that the ice sheet was up to around 700m thick. Roches Mountonnées are common all around the Cairngorms.

**Location** ●
Located at the layby just outside of the village en-route to Grantown-on-Spey.

Those
ice-smoothed rocks
are frequently ovoid in plan
view with their longer axes parallel
to the direction of ice flow. Here the
long axes of the Roches Moutonnées are
aligned from south west to north east
so giving the direction of the
ice flow

SW                    NE

# Rothiemurchus

- Aviemore

Rothiemurchus is one of the most treasured areas of the Cairngorms National Park. This extraordinary Highland estate stretches from the tops of the sub-arctic mountain plateau to the River Spey with splendid forests, lochs, heather clad hills, moorland and glens.

This living and working estate has been cared for by the Grants of Rothiemurchus for over 450 years and presents a unique blend of stunning landscapes, wonderful wildlife and exciting outdoor activities. Its incredibly varied environment includes habitats for many rare species, with some of the most important wildlife in Europe residing here, including osprey, Scottish crossbill, capercaillie and crested tit. With over 125 species of birds, 27 species of mammal and 400 species of flowers there are so many exciting discoveries to be made.

Rothiemurchus also has one of the largest surviving areas of ancient Caledonian Pine Forest in Europe. The forest covers an area of about 30 square kilometres and is believed to comprise of over 10 million trees where the average age of the Scots Pine exceeds 100 years, with some more than 300 years old. Rothiemurchus' forestry plan ensures the woodland's rich biodiversity is maintained and sustained for all to enjoy.

There are lots of fantastic walks and other activities which take place in this superb environment. You can find out more at the Rothiemurchus Centre or by visiting the website .

**Location** ●
3 miles south of
Aviemore along the B970.
tel (01479) 812345
www.rothiemurchus.net

pic - © Rothiemurchus Estate

# Uath Lochans

## • Glen Feshie

Uath Lochans are located within the Inshriach Forest in Glenfeshie on the western side of the Cairngorms.

Inshriach Forest is owned and managed by the Forestry Commission after it was purchased from the Duke of Gordon's estate back in 1935.

The forest is made up of rare Caledonian pine trees, small lochans, heather clad moorlands and bogland.

This is a remote location with an abundance of wildlife and plants to seek out. There is a small hide that overlooks the largest lochan where goldeneye ducks and flocks gees may be seen.

There are some spectacular views of the Cairngorms along with a host of interesting walks. The Uath Lochan walk is around a mile long and will take around 30 minutes to do. The Farleitter Crag walk is 2 miles and will take 3 hours. The Farleitter Ridge walk is 1.3 miles long and takes 2 hours, while the Uath Lochan walk down to Feshiebridge is 4-1/2 miles long and will take around 4 hours.

**Location** •
From the B970 between Kingussie and Kincraig, turn up the narrow road at Insh House. Drive for 1-1/2 miles then turn right at the signpost. There is a car park and picnic site.

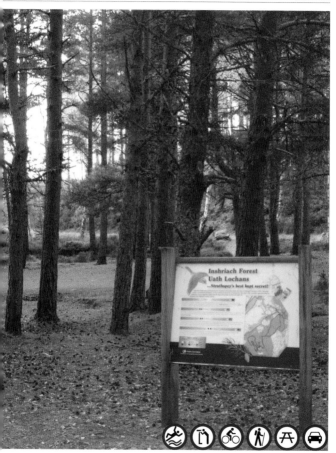

# The Lairig Ghru

● Cairngorms

The Lairig Ghru has a long history, and was for many years used as a drovers road for taking cattle between Deeside and Speyside. The full route from Aviemore to Braemar is about 26 miles, though many walkers cut the walk short by starting or finishing at Linn of Dee.

The highest point of the Lairig Ghru is 838m - higher than many British mountain summits. It occurs at a point known as the Pools of Dee (the source of the River Dee), in a narrow glaciated trough between the Braeriach and Ben Macdhui massifs.

One of the many features along the Lairig Ghru is a large stone known as Clach nan Taillear (the "tailors' stone"). According to legend three tailors agreed to meet here one Hogmanay in order to celebrate the new year. A violent storm ensued, and the three drunken men perished.

An alternative route at the north end of the Lairig Ghru is known as the Chalamain Gap. The path, which links the main route to Glen More at the foot of Cairngorm, passes through the gap, which is narrow rocky defile between two small peaks.

**Location** ●
You access the Larig Ghru at various points from either side of the park, via Aviemore and Braemar.

204

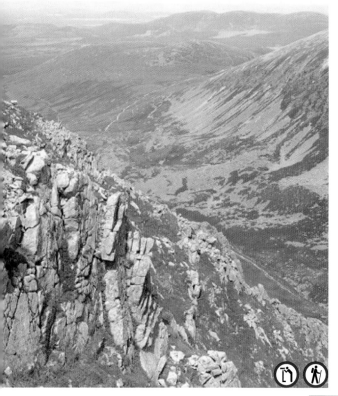

# Visitor Centres

Cara & Bruce

Whether it's history, leisure, wildlife, culture, sports, or nature, there is a visitor centre somewhere in the Cairngorms National Park that will be able to help you find just what you need to know.

Some centres are open all year, while others are seasonal and only open during the summer months, however all the centres in the park are packed with information and knowledgeable staff.

Tourist offices are also a great place to get information about where to go or what to do and most stay open all year round.

Some centres offer ticket sales for attractions while others double up as a shop or cafe.

Highland Wildlife Park - Kingussie

Highland Folk Museum Newtonmore

# Balmoral Estate

STB ★★★★★ Visitor Attraction

Balmoral Estate is open to the public for most of the year with seasonal variations depending on the activity or when the Royal Family is in residence.

Visitors are invited to view the castle, the grounds with guide tours available.

The estate has a number of interesting art exhibitions and each year The Upper Deeside Art Society has a display of their work in the coffee shop and in the stables.

Within the castle you can view exhibitions in the Ballroom and with further exhibitions on display in the Carriage Hall Courtyard.

Of particular interest are the displays of Christmas cards from the Queen and the Duke of Edinburgh, which date back from 1950.

The Ballroom, which is the only room in the castle open to the public. The hall has lots of wonderful paintings to view and numerous display cabinets containing silver statues and precious porcelain.

There is also a fine collection of Royal ball-gowns on display including gowns worn by the Queen and the late Queen Mother.

### Activities at a Glance

**Art Exhibitions**

**Carriage Hall Exhibitions**

**Car Rallies**

**Coffee Shop**

**Digital Photography Course**

**Garden Cottage**

**Gift Shop**

**Grounds & Gardens**

**Guided Tours**

**Guided Walks**

**Luxury Land Rover Safaris**

**Marked Walks**

**Painting Holidays**

**Pony Trekking**

**Salmon Fishing**

**School Visits**

**Tractor Rides**

**Wildlife Watch Holidays**

**Wildlife Watching**

**Self-Catering Cottages**

There are various ways to learn about the castle and its grounds including audio tours in various languages that detail all aspects of the estate. Audio tours are available English, French, German and Italian. A £5 deposit is required with each hand set and you also get a map, which can be obtained, in the Carriage Hall Exhibition. Hearing aid loops are available.

You can also visit the Talking Guides website and download the Balmoral Audio Tour as an MP3 file. The tour, which includes music by the Queen's Piper, was recorded at Balmoral.

Balmoral's formal gardens, which extend to around three acres, were designed with help and advice from Prince Albert. There are numerous Victorian glasshouses and a conservatory. The gardens are constantly being improved and expanded. The Duke of Edinburgh built a sizable kitchen garden, which is usually harvested for its vegetable when the Royal family are at the castle on holiday between August and October.

pic - © Balmoral Estate

# Balmoral Estate

Located amid the Garden Cottage and the main gate, is a wonderful water garden, while on the front lawn there is a stone marker showing the location of the front door of the original house, which was knocked down back in 1856.

The Garden Cottage, which overlooks the water garden is delightful cottage built back in 1863 was often used by Queen Victoria as a place to do important state work. The cottage has had numerous alterations, but in the main it is much as it was originally and you are free to view the rooms through the windows.

Around the estate there are various walks with ranger led services. On Wednesday afternoons from April to July who can join a guide on a woodland walk which sets out from the Carriage Exhibition at 2pm. The walk takes in the gardens and castle grounds and you will learn all about Balmoral history and visit numerous monuments. Your guide will also be able to point out and explain the estate's woodlands, wildlife, flora and fauna.

The walk, which last for around 2 hours and covers around 3 miles, is free of charge, but you do have to have paid the standard estate entrance fee.

The Ranger service also hosts a large number of themed guided walks between spring, summer and autumn. To find out what walks are on, with the times and dates, visit the estate's web site.

If you are not up to walking, then you can take a free tractor-trailer ride, run daily between the main gate and the carriage exhibition.

Pony Trekking costs from £30 for 2-hour treks or £70 for day treks. Luxury Land Rover safaris are also possible at certain times of the year costing from £45 per person for a 3 hour tour.

## Coffee Shop
There is a self-service licensed coffee shop in the grounds offering snacks and meals. Tables are also available outside. Toilets include baby changing facilities and disabled access.

## Gift Shop
The gift shop stocks a range of souvenirs, many of which are produced exclusively for Balmoral. On display are china, crystal, jewellery, and giftware produced by The Royal Collection. You can also buy gifts on-line.

**Facilities, opening and contact:**
Gardens, coffee shop and souvenir shop. Open times: the grounds, gardens and exhibitions are generally open from March to the end of July but are closed to the public during August, September and October when The Royal Family are in residence, however guided tours are also available during November and December. Daily hours 10am to 5.00pm Entry costs: from £7 adults, £3 child. Family ticket (2 adults 2 children) £15. The estate operates an access for all policy with excellent facilities for the disabled visitor.

**Location:** ●
Located 9 miles west of Ballater along the A93 opposite Crathie Church.

www.balmoralcastle.com
tel: (013397) 42534

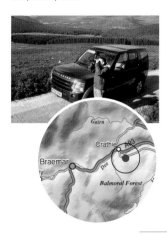

pic - © Balmoral Estate

# Cairngorm Mountain Railway

The CairnGorm Mountain Funicular Railway was opened back in May 2002, having replaced the old chairlift system. The train takes visitors from the bottom car park up to the Top Station at 3600ft, which is located a short distance below the summit of Cairngorm.

The mountain is open all year round and rose to fame - literally - as the UK's largest winter snow sports destination, however in recent years a lot of time, money and effort has seen the area transform itself into an all-year-round visitor destination. Since the new train was built, along with the exhibition centre, restaurant and shop opened, summer visitors have risen dramatically.

To get to the train, drive up the mountain road to the top car park, from where there is a short walk to the ticket office. Trains run every 15 or 20 minutes, one going up and one coming down. The journey takes around 8 minutes to the top station. On a clear day you are rewarded with some awesome panoramas.

At the top you exit the train at the mountain exhibition centre, which tells the story of the mountain and the area. However, to help protect the environment, a visitor management programme operates from April to December, with visitors not permitted to exit the top station onto the mountain. Walking is possible from the car park level.

## Prices at a Glance
(Based on 2007 prices so
call for latest rates).

**Daily Train Tickets**
(unlimited travel on day
of purchase)

| | |
|---|---|
| Adult | £9.25 |
| Junior (16 and under) | £5.85 |
| Senior (over 65) | £8.00 |
| Family | £27.55 |
| Children 5 and under free | |

**Ski Tickets**

| | |
|---|---|
| Adult Half Day | £21.50 |
| Junior Half Day | £15.00 |
| Adult 1 Day | £28.00 |
| Junior1 Day | £17.00 |

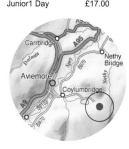

The mountain has numerous walking opportunities for all levels of ability and for those who require assistance, there is a ranger service offering guided walks.

Also at the top is the UK's highest restaurant: the Ptarmigan is open all year round as a self-service facility. In the summer it offers a spectacular evening dining experience. There's also a licensed bar, a shop and a cafeteria at the Day lodge.

**Facilities, opening and contact:**
Spring/Summer/Autumn - trains run every 15, or 20 minutes daily First train up 10.00am (10.20am on Wednesdays). Last train up 4.20pm. Last train down 5.00pm (times vary throughout the seasons).
Winter - train and other snowsports uplift open from 9am daily, subject to weather conditions.
The mountain railway and all other facilities are accessible to wheelchair users.
Guided Walk Booking Line tel: (01479) 861 341
Cairngorm Ranger Service tel (01479) 861 703
General information tel: (01479) 861261
www.cairngormmountain.co.uk

**Location: ●**
From Aviemore, take the Cairngorm road form the round about at the south of Aviemore, and travel for 10 miles. The road runs out at the top car park.

**213**

# Cairngorm Reindeer Centre

● **Glenmore** - *Aviemore*

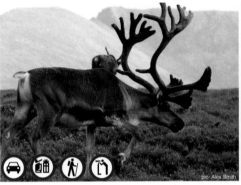

pic- Alex Smith

The Cairngorm Reindeer Centre is just off the road at Glenmore, 5 miles from Aviemore.

Reindeer were re-introduced into Scotland in 1952 by Swedish reindeer herder Mikel Utsi - the herds on the Cairngorms and over in Glenlivet are the only ones to roam freely in the UK.

The reindeer centre is open all year and acts as information point and meeting place for those signing up for a reindeer tour.

However, you don't need to go on a tour in order to see the reindeer, as a small number are available to see in the paddocks between Easter and New Year.

The centre has lots of relevant information on the animals, with wall displays explaining just what the animals eat, detailing their history and specifying which countries they now inhabit.

There is, naturally, a special section dedicated to the reindeer's association with Father Christmas!

Guided daily tours, for which a fee is payable, are arranged from the centre. The tour begins after a short car drive (5 minutes away) to where the reindeer herd is. Wear good weatherproof clothing and a decent pair of boots, as you will be tracking over open ground. Wellington boots are available to hire at Reindeer House.

pic- Alex Smith

**Prices at a Glance**
(Based on 2007 prices so call for latest rates).

**Paddock prices:**
Children and concessions (Senior citizens & students) are £1.50.

Under 6 are free.
Family ticket £7.50
(2 adults and 3 children)

**Guided tour:**
Adults £8
Children (over 6) £4
Concession £6
Family £24

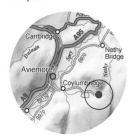

As well as guiding you to the reindeer's grazing ground (a 30-minute walk) your guide gives a talk before heading back.

Reindeer are very friendly, and will come up to you and let you to feed them by hand.

Tours are suitable for all ages, even toddlers, and leave daily at 11.00 am from the centre. From May to September, a second trip goes out in the afternoon at 2.30 pm. Between October and April only morning visits are available, weather permitting.

**Facilities, opening and contact:**
Next to the Reindeer Centre is the Glenmore Visitor Centre with toilets, a shop, a cafe and a car park.

**Location**: ●
6 miles from Aviemore on the left 50 metres from the Forestry Commission centre.

tel: (01479) 861228
www.reindeer-company.demon.co.uk

# Glenmore Forest Park
# Visitor Centre

If you want to get out and about in the National Park, then Glenmore Forest Park is the place to visit. Located a few miles east of Aviemore, it's easy to find and has an activity to suit everyone.

If you're looking for a peaceful time, then you may enjoy a walk along one of the many waymarked trails. Weaving in and out of some of the most attractive areas in the forest, these paths will take you by quiet lochs, ancient, gnarled pines, and will frequently open out to give stunning views of the Cairngorm mountains. Snippets of information about local nature and culture along some of the routes will enhance your visit, too.

You don't have to explore the area on foot, either - almost all the trails are suitable for bikes or, of there's enough snow, cross-country skis.

Loch Morlich with its sandy beaches is the perfect place to spend a hot afternoon. Surrounded by pine forest and a beautiful backdrop of the high Cairngorms, a day here spent out on a canoe or sailing dinghy is sure to be a memorable one. Fishing permits are available too, or you can simply relax on the beach and watch the world go by.

Active visitors might want to take advantage of some of the higher walking routes, like the one up to the top of Meall a Bhuachaille which offers some of the best views in the area.

**Activities at a Glance**

Cycling
Fishing
Reindeer Tours
Walking
Water Sports
Wildlife Watching

Two other paths through the Chalamain gap and up the Allt Mor to CairnGorm Mountain's base station also allow you to access the more remote parts of the Cairngorms from your forest base.

There's a ranger service based at Glenmore Visitor Centre and during the summer months a whole variety of events are held in the forest park. Everything from children's events to dog's days out, art sessions and big re-enactment events mean that there's something for everyone to enjoy.

**Facilities, opening and contact:**
Visitor centre open daily except Christmas Day, Boxing Day and New Year's Day.

tel: 01479 861 220 for more information

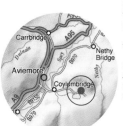

**Location**: ●
At the roundabout south of Aviemore, take the ski road towards the Cairngorms. The visitor centre is 7 miles along, opposite the Glenmore campsite.

# Highland Wildlife Park

• Kincraig                    STB ★★★★ Visitor Attraction

The Highland Wildlife Park is a unique safari-style park located in a spectacular setting between Kincraig and Kingussie. Visitors can drive through the Main Reserve in their own vehicle through herds of European bison, red deer, reindeer and one of the world's rarest mammals, the Przewalski horse. They can then explore the rest of the Park on foot, looking out for beaver, wolves, otters, wildcats, lynx and, coming summer 2008, Amur tigers.

The Park was first opened in 1972 and specialized in the variety of animals found in present day Scotland as well as the animals that were once found here, hundreds, even thousands of years ago.

The Park is now part of the Royal Zoological Society of Scotland who also run Edinburgh Zoo and in 2006, the Park's remit changed to include endangered species of the world's mountain and tundra regions.

The first new animals to arrive in 2007 were bharals, or Himalayan blue sheep, closely followed by the very rare Turkmenian markhor, a small goat-antelope with huge spiraling horns. They were joined later in the year by yaks, kiang (Tibetan wild ass) and snow monkeys. The monkeys can be seen in a wonderful new enclosure around the lochan.

The Park is also home to a pack of European grey wolves. Their enclosure won an award for leading the way in its design, offering plenty of space and extensive views to the Cairngorms where wild wolves would have roamed until the 17th century.

Japanese Snow Monkeys

pic - © Highland Wildlife Park

pic - © Gary Kramer

# Highland Wildlife Park

### ● Kincraig

The Park is split into two main sections. Visitors drive around the Main Reserve and then park and continue on foot through the walk-round area.

**Guided Walks**
Talks take place every day, usually including feeding. Times vary and are displayed on notice-boards around the Park. Whilst learning some interesting facts, take the opportunity to find out more about our animals from our expert keepers.

**Tours**
The Park offers guided group tours throughout the year for 10 or more individuals and covering all topics relating to our animals and conservation. Group rates apply and bookings should be made at least two weeks in advance.

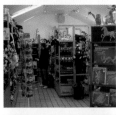

**Café**
Antlers café is found in the Visitor Centre and is open all year round, offering a range of hot and cold dishes and snacks. Disabled access is via the path and ramp around the Visitor Centre building.

**Shop**
Wildthings giftshop is also located in the Visitor Centre and stocks a selection of gifts and souvenirs that reflect the ethos and character of the Highland Wildlife Park and the surrounding Highland of Scotland.

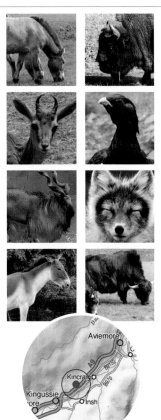

## Opening, prices & contact:

The Park is open every day of the year, weather permitting*, apart from Christmas Day. *Please note, on days with deep snow and ice, please call ahead to avoid disappointment as the Park may have to close.

April to October 10am to 5pm (last entry 4pm). November to March 10am to 4pm (last entry 3pm). July and August 10am to 6pm (last entry 5pm)

Dog owners can bring their dog to the Park but must ensure that the dog remains in the vehicle for the duration of the visit. Free kennels and an exercise area are situated outside the exit gate if required.

Prices: April 2208-March 2009

| | |
|---|---|
| Adults | £10.50 |
| Senior citizens / students | £8.50 |
| Children | £8.00 |
| Registered disabled | £8.50 |
| Family 2 adults + 2 kids | £34.00 |
| Family 2 adults + 3 kids | £38.00 |

## Location ●

The Park is 7 miles south of Aviemore. Travelling north on the A9 towards Inverness, turn off for Kingussie and Kincraig and then follow the B9152 north to the Park. Travelling south on the A9 towards Perth, take the second exit for Aviemore and Kincraig and follow the B9152 south through Kincraig to the Park.

tel: 01540 651270
www.highlandwildlifepark.org

# Jack Drake's Nursery

● **Aviemore**                STB ★★★ Visitor Attraction

Jack Drake's Nursery is an informal garden where you may peruse an interesting range of hardy plants growing robustly in the rockery, herbaceous borders, alpine house and around the margins of the pond and stream. There are also plenty of familiar hardy plants to be found alongside more unusual varieties in the sales beds that are arranged alphabetically, more or less.. Helpful staff are always available to assist.

As well as plants, Inshriach is also renowned for its Potting Shed Tearoom, overlooking a feeding station that is well attended by birds and red squirrels. Treat yourself to a slice of Norwegian inspired, freshly home-baked cream cakes as you watch the action outside. "One of Britain's Top Ten Cakeshops", the Observer Good Food Guide 2007 voted "Favourite Bird Feeding Station in Scotland 2007" by RSPB members.

The gardens and tearoom are open daily, 1st March - 31st October.

### Location & facilities ●
Jack Drake's Nursery is 4 miles south of Aviemore on the B970, near Inverdruie. Free parking, free admission, tea room and unisex toilet. No dogs except guide dogs.

tel: (01540) 651287. www.drakesalpines.com

pic - © Drakes Nursery

# Loch Garten Osprey Centre

• Boat of Garten                    STB ★★★★ Visitor Attraction

The Loch Garten Osprey Centre is a nature reserve located in the Abernethy Forest near Boat of Garten and managed by the RSPB.

The centre, which is open daily from 10 am to 6 pm from April to the end of August, is set amongst rare native caledonian pinewoods and you can view the nest of these spectacular fish-eating birds of prey via a combination of binoculars, telescopes, CCTV cameras, with expert advice on hand. There is a small entry fee of around £3 for an adult to 50p for Kids tel (01479) 831476 for further details or visit the RSPB web site: www.rspb.org.uk/reserves

### Location ●
The centre can be reached via the B970 road that runs between Nethy Bridge and the Boat of Garten. The forest is sign posted from whichevery direction you come: south you will turn left down to the forest and if north, then look out on the right for the turning.

### Facilities
Car park and coaches. No height restrictions or barriers. Bicycle stands, toilets, disabled toilets, baby-changing facilities, guided walks available and pushchair friendly.

Picture is an illustration - © Matt Edmonds

# Revack Estate

● Grantown-on-Spey                STB ★ ★ ★ Visitor Attraction

The Revack Estate, a mile from Grantown-on-Spey off the B970 to Nethy Bridge, makes for the perfect afternoon.

Revack was built as a shooting lodge back in 1860. The estate is rich in history, and over the years many famous individuals have been associated with Revack, namily the Countess Dowager of Seafield, the then second wealthiest woman in the UK, and Sir James Grant of Grant, also known as 'The Good Sir James', who in 1766 announced his plan to create Grantown-on-Spey as a new town. He included in his plans, schools, factories and roads making this one of Scotland's foremost planned towns.

The lodge is set amongst superb landscaped gardens with water features and mature woodlands, which are rich in wonderful flowers and abundant with wildlife.

Walkers will find the 10 miles of marked trails an ideal place to try and spot various wildlife species which are indigenous to this part of the Highlands. Lapwings, oyster catchers, red squirrels skylark's and curlew to name a few as well as rare butterflies which can often be found in areas of the estates wetlands which includes abundant bog myrtle.

The mature Scots Pines on the estate, also provide habitat for the rare and declining capercaillie.

**At a Glance**

**Plant Centre & Gardens**
**Adventure Playground**
**Licensed Restaurant**
**Wildlife**
**Walks**

For the children, there is an adventure playground with climbing frames, an aerial cableway, swing suspension bridge, assault wall, stepping logs a mini log cabin and a rope orienteering course.

After a long walk around the estate, you are invited to the visitor centre which houses an excellent selection gifts, cratfs, books and souvenirs.

The visitor centre also has a licensed restaurant and self service cafeteria. You can opt for a light snack to a full meal served in a very relaxed setting. You can enjoy some tasty home-cooking, served indoors or outside on the patio.

**Facilities:**
Shop, restaurant, car park with disabled access.

**Location** ●
Revack can be reached via the B970 road that runs between Nethy Bridge and Grantown-on-Spey.

tel: (01479) 872234

# Rothiemurchus Centre

The Rothiemurchus Centre is your starting point for all the estate's activities, and as well as being able to to sign up for a host of activities, you can also savour the restaurant café and some fantastic shops. At Ord Ban restaurant café they believe in delicious, locally sourced, sustainable produce, prepared simply and reflecting the character of the estate. With fresh home baking, rustic lunches and great coffee served in a warm café atmosphere during the day and an intimate dining experience rich with local flavour at night, it's a great place to eat.

The Rothiemurchus gift shop, card shop and farm shop & deli are also located in the Rothiemurchus Centre and are open all year. There is a superb selection of cards for all occasions and the gift shop has some truly delightful presents for all ages. The farm shop & deli offers mouth-watering Rothiemurchus Highland beef, velvety forest Venison and fresh rainbow trout, all 'home reared' on the estate. There is also a large selection of farmhouse cheeses, home cooked products, chutneys, preserves, honeys and a locally brewed beers and wines - and of course Norma's famous fudge!

One thing that's good to know is that the money you spend on activities and shopping at Rothiemurchus contributes to caring for and protecting this amazing place for future generations to enjoy.

**Facilities:**
Rothiemurchus welcomes visitors to the Estate all year.

The Rothiemurchus Centre, including the farm shop & deli, card and gift shops are open daily (except Christmas Day):

Rothiemurchus Centre
tel: 01479 812345
Book Online
www.rothiemurchus.net

**Location:**
The visitor centre is located 1 mile east of Aviemore along the Cairngorm road.

# Speyside Heather Garden

## & Visitor Centre • Dulnain Bridge                    STB ★★★★

The Speyside Heather Centre is a uniquely interesting stop on the outskirts of Dulnain Bridge, just off the A95 between Aviemore and Grantown-on-Spey.

It's a family-run, multi-award winning visitor attraction, where over 300 varieties of heather are grown for sale.

This is also the only place in Scotland offering an insight into to the use of heather throughout history. An exhibition details how heather is used in thatching and the weaving of ropes, and you will learn how heather is used in tattie baskets, doormats and wool dyeing - heather is even used to flavour tea, wine and, yes, whisky!

Heather was worn by soldiers, as they went into battle. And for good luck, an ancient custom dictated that the dead were buried with heather.

This versatile, evocative plant can be found over vast areas of moorland and is said to be one of Scotland's most prolific, with a million acres of Scottish land covered in it. And it's here, at the centre, that you can find out exactly what heather is.

As well as man using heather, it's also an important food source for sheep and deer, which can graze the tips of the plants when snow covers low growing vegetation. Red grouse also feed on young shoots and seeds.

### At a Glance
- **Boutique**
- **Gallery & Antiques**
- **Garden & Plant Shop**
- **Garden trail**
- **Heritage Centre**
- **Restaurant**
- **Shop**

**Facilities:** Shop, restaurant, car park and disabled access.

**Location**: ● Off the A95 on the outskirts of Dulnain Bridge.

**Contact**: tel: (01479) 851359
www.heathercentre.com

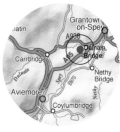

While heather is the main theme here, there are lots of other interests such as the Antiques and Collectables shop as well as The Gallery, with wildlife and landscape paintings on view. The boutique and gift shop has a wide range of goods from jewellery and cosmetics to malt whiskies.

Outside the main building you can take a stroll around the show garden, which has displays, water features and 300 varieties of heather, conifers and shrubs all posted with useful information.

Surrounded by Scots pine and Birch, the new sheltered wildlife viewing areas attract an abundance of birds and red squirrels while butterflies are attracted to the wild flower garden.

And to finish off your visit, a trip to the Clootie Dumpling restaurant is a must: sample dumplings served in 21 different ways, or lap up the home-made soup and baking.

**231**

# Strathspey Steam Railway

The Strathspey Steam Railway is a popular attraction based in Aviemore running restored steam trains between Aviemore, Boat of Garten and Broomhill - the fictional location for Glen Bogle Station from the television series Monarch of the Glen, near Nethy Bridge.

The line is 10 miles long, and passes through some wonderful countryside with views of the Cairngorms. Visitors can also see one of the country's most impressive Victorian engine sheds still in use today - it was constructed back in 1898.

The Strathspey Railway is pure nostalgia recreating pre-60s travel with visitors loving the chance to experience just what it was like being pulled along by a steam engine. Train services are run between April and September with special Christmas trips in December.

There are a number of fare options with first and third class tickets available. On board there is a restaurant car where you can enjoy a full meal or a simple snack. There is a shop at the Aviemore ticket office.

**Location** •
Ticket office at Aviemore train station.

tel: (01479) 810 725
www.strathspeyrailway.co.uk

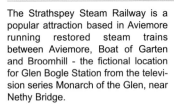

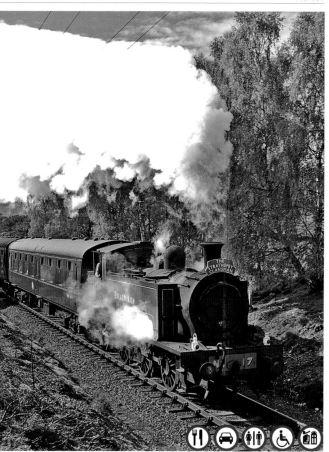

pic - © Hendy Pollock

# The Auchgourish Gardens

STB ★★★★ Visitor Attraction

Auchgourish Gardens, on the outskirts of Boat of Garten, makes an interesting centre with an unusual and pleasing collection of plants covering some 10 acres - indeed, there are a number of plants grown from seeds collected from botanists working in the former Soviet Union, and some of the plants have never actually been grown in the West previously. Some have yet to be given a name, such as some of the lilies from Tibet.

The themed layout of the Botanic Garden reflects plant species found in the Northern Hemisphere and countries such as Korea, China and Japan, which are set out mainly in bio-geographic areas.

There are a number of rockeries, including a Scottish Alpine rockery and a garden called St Andrews, celebrating the Scottish flag: all the plants are blue or white.

Auchgourish boasts several thousand different species of plant, including important collections of Alnus, Arisaema, Betula, Clematis, Iris, Lilium, Malus, Paeone, Prunus, Pyrus, Rosa, Rubus, dwarf Salix & Sorbus. There are also some rarely seen species of Rhododendron.

Also to be seen for the first time is the small herd of White Highland Cattle, and an interesting nesting colony of Sand Martins.

**Facilities, opening and contact:**
The gardens are open 7 days a week from April to the end of October and by arrangement at other times.

**Location:** ●

Located on the B970 between Coylumbridge and Boat of Garten.

tel: (01479) 831 464
www.auchgourishgardens.org

# The Cairngorm Brewery

The Cairngorm Brewery has won a host of awards for its speciality beers, which are all brewed cask conditioned and bottled.

The brewery has produced eighteen different beers with some only available at certain times of the year. Along with distinctive tastes, all the beers have a strong identity and come with some interesting names such as Sheepshagger, Witches Cauldron, Howler or the festive named Santa's Sledgehammer.

Tours are available to individuals or parties but you are asked to phone in advance. They are free of charge.

The brewery has a shop offering bottle packs that you select as singles, 4-bottle or 12-bottle packs. The shop is open Monday to Friday, 9.00am - 5.00pm. Beers are also available in either 5ltr, 10ltr and 20ltr poly pins (beer in a box) but only direct from the shop and not through mail order.

**Location**: ●
The brewery is located in the Dalfaber Industrial Estate at the northern end of the Aviemore.

tel: (01479) 812222
www.cairngormbrewery.com

# Waltzing Waters

Waltzing Waters is one of the park's most popular and unusual attractions. Visitors enjoy comfortable indoor seating as they witness spectacular, live performances on stage, regardless of outdoor weather.

Gallons of water explode into the air, in a dazzling rainbow of colours synchronised with music, leaving audiences spellbound. The 40 minute shows are presented in five acts, each featuring a different musical style. The show's immense popularity has made it a must-see for both tour groups and individuals on holiday.

Light snacks are available in the coffee lounge and the gift shop features quality items from around the world at reasonable prices.

Performances are on the hour from 10 am through 4 pm inclusive - 7 days a week. Additional evening shows are presented in July and August at 8:30 pm. Open year round from 26 January - 12 December. Admission: £4.25 Adults, £2.50 Children, £3.75 Concession

**Location** •
Main Street in Newtonmore; 15 miles south of Aviemore just off the A9 on A86.
SatNav: PH20 1DR

tel: (01540) 673 752
www.waltzingwaters.co.uk

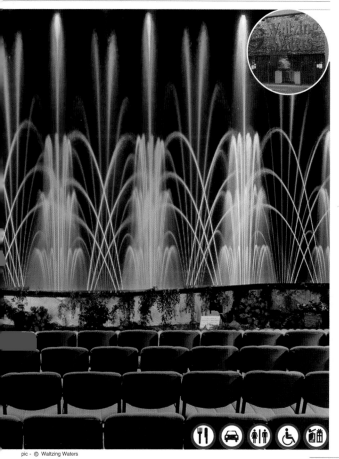

pic - © Waltzing Waters

# Whisky

Around The Park

Scotland is renowned for so many things, from thistle-hopping bagpipers to heather-hacking haggis-hoggers, but there's never been anything quite as Scottish as malt whisky, and the Highlands have always played a leading role in the production of this liquid gold - the earliest documented records of distilling in Scotland going back as far as 1494.

There are dozens of distilleries throughout these glens, thanks largely to the purest burns in the world. Today there are eight distilleries nestling within the national park's boundaries.

### Balmenach Distillery

Built in 1824 by James McGregor, Balmenach was one of the first in the Highlands to become legitimate. Located in a stretch of land known as the Haughs of Cromdale and in an area once notorious for illicit distilling, the distillery uses water from the Creagan a' Chaise, part of the Cromdale hills, via the Resmuden and Cordon burns to produce its single malt, notably the Balmenach Deerstalker, which is available in local shops. Visitors are welcome by appointment only.
tel: (01479) 872 569

### Braes of Glenlivet Braeval

Braeval is one of only three distilleries in the glen of the Livet. Built in 1973 under the name "Braes of Glenlivet", the distillery was intended to produce malt exclusively for the needs of the blenders, especially for its owners, the Chivas and Glenlivet group. This is a small distillery and there are no visitor centre facilities here.

### Dalwhinnie Distillery
see page 240

### Glenlivet Distillery
see page 242

### Royal Lochnagar Distillery
see page 244

### Speyside Distillery

The Speyside Distillery is located  on the banks of the River Tromie in Kingussie and is one of Scotland's newest distilleries, dating back to just 1990.

The distillery draws water from the old mill lade which originally ran the waterwheel powering the old mill. The water is also used in cooling the distillery. This is not a large distillery, nor is it a mass whisky producer but, despite there

not being a visitor centre, you can buy their whisky in local shops, notably Drumguish which is a single malt with a medium-dry, minty taste.

tel: (01540) 661 060

### Tamnavulin Distillery

Built in 1966 by Invergordon Distillers, this is a small distillery now owned by Whyte and Mackay. You'll find it next to the river Livet in Tomnavoulin, near Glenlivet. The whisky produced here is used in Whyte & Mackay, Mackinlay and Crawfords Blends.

tel: (0141) 248 5771

### Tomintoul Distillery

 Tomintoul Distillery was built in 1964 by W&S Strong and Hay & MacLeod, who were whisky brokers from Glasgow. Regarded as a young and modern distillery, it's located 5 miles north of Tomintoul, en route to Glenlivet along the B9136. The location was chosen due to the quality of the water from the Ballantruan Spring. The malts produced here have long been associated with Whyte & Mackay blends. Visitors are welcome by appointment only

tel: (01807) 590 274

# Dalwhinnie Distillery

• Dalwhinnie

Dalwhinnie distillery stands proud at the northern end of Dalwhinnie, producing a renowned single Highland malt.

It's the highest distillery in Scotland and was founded in the late 1890s on a site with good access to the clear spring waters of Lochan-Doire-Uaine and because of the large amounts of peat from the surrounding bogs.

In 1897, John Grant, George Sellar and Alexander Mackenzie founded the Strathspey distillery and began production in 1898, but it soon went bankrupt and was sold to A.P. Blyth in the same year. The distillery was then re-launched as Dalwhinnie. However, in 1905, the operation fell into American hands and was taken over by Cook & Bernheimer of New York, who paid £1250 for the distillery - this was the first American investment in the Scotch whisky industry.

The American adventure continued until the prohibition in the United States in 1920, after which the business reverted to Scottish ownership, when Lord James Calder bought the distillery. He was finally to sell it to the Distillers Company in 1916.

During the early 1930s Dalwhinnie was still very much undeveloped and, like other parts of the country, there was no telephone and no electricity in the village - the distillery was lit by paraffin lamps with equipment powered by steam engines.

A fire in 1934 stopped production for three years, and the re-opening in 1938 was short-lived because the Second World War brought restrictions on the supply of barley. Since reopening in 1947, the distillery has continued to operate through to the present day, although on-site malting ceased in 1968.

Over the years Dalwhinnie has gone through numerous refurbishments and in 1979 the malt barns were converted to warehousing.

Dalwhinnie is a famous brand due to the astute marketing of United Distillers under their Classic Malts brand, launched in 1988. Despite this, only 10% of the production is actually marketed as single malt.

After a £3.2m make-over in 1992, the distillery reopened 1995 to produce the 'Gentle Spirit' brand.

.

**Facilities, opening and contact:**
The distillery has a visitor centre with a shop and is open as follows:
**January to Easter:**
Monday - Friday: 11am - 2pm
Tours at 11.15am, 12.15pm & 1.15pm
**Easter to May:**
Mon - Fri: 9.30am - 5pm
**June to September:**
Mon - Sat: 9.30am - 5pm
July & August:
Also Sun: 12.30pm - 4pm
**October**:
Mon - Sat: 11am - 4pm
November & December:
Mon - Fri: 11am - 2pm
Tours at 11.15am, 12.15pm & 1.15pm
Last Tour:
1 hour before above closing times.
Admission Charges; Adults: £5.00
Children: £2.50 (8 yrs to 17 yrs inclusive)
Children under the age of 8 years old are welcome but are not permitted on the distillery tour.

**Location**: ●
The distillery is located at the north end of Dalwhinnie half a mile from the A9 turn off.

Dalwhinnie Distillery
tel: (01540) 672219

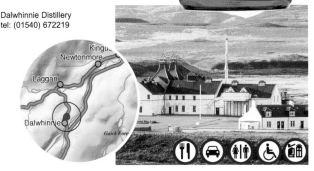

# The Glenlivet Distillery

The Glenlivet Distillery, situated in the secluded glens of the Scottish Highlands, produces single malt Scotch whisky, bottled at 12 years, 15 years and 18 years as well as more limited releases, which include 21 years and 25 years.

The Glenlivet is the oldest legal distillery in Scotland, having been established at Upper Drumin in 1824 by George Smith and his youngest son, James Gordon Smith. Crucially, the three fundamental elements in the whisky-making process – spring water, copper stills and oak casks – have remained unchanged since the distillery was established.

Today, as in George Smith's time, the distillery draws water from Josie's Well, a natural spring that yields mineral rich, pure mountain water. The stills used are lantern-shaped with long, narrow necks, producing perfectly balanced spirit.

The distillery has 4 wash stills, each with a capacity of 15,000 litres each and 4 spirit stills with a capacity of 10,000 litres. A selection of oak casks is central to the development and style of the spirit. A variety of casks are used in creating the different expressions of The Glenlivet; European, American, Traditional oak and new French oak.

If you want to learn more about the distillery a visit to the visitor centre is a must, indeed even if you are not a whisky buff, you should visit what is one of the finest visitor centres in Scotland, depicting 200 years of Glenlivet history.

Keen walkers can follow in the footsteps of famous whisky smugglers like the legendary Robbie MacPherson, who distilled whisky in the remote climate and terrain of Glenlivet away from the prying eyes of excise men, before smuggling it out of the glen. The whisky produced by the illicit distillers of Glenlivet became the most sought after in the land. Visitors can choose from three walks in the Glenlivet valley of varying length, from a family walk, to a one day hike to explore the secret smuggling paths of days gone by.

In addition, there is a superb exhibition which gives a fascinating insight into the story of The Glenlivet. There's also a wonderful shop and a very relaxing restaurant.

**Facilities, opening and contact:**
Guided tours with audio translation phones available in French, German, Italian, Spanish and Swedish. The restaurant is located in the main building offering snacks, light meals and a choice of beverages. Toilets, information counter and seating area are all provided in the main building. Admission is free of charge, but please note, children under eight are not allowed in the production areas - they are welcome in the visitor centre.

Glenlivet has excellent disabled access to the visitor centre and still house.

The distillery is open to visitors from March to October. Daily hours are: Monday to Saturday 9.30am to 4pm Sundays 12 noon to 4pm.

**Location**: •
The distillery is located of the B9008, 10 miles north of Tomintoul.

tel:(01340) 821 720
www.maltwhiskydistilleries.com

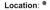

# Royal Lochnagar Distillery

● Ballater

The Royal Lochnagar Distillery which stands today dates back to 1845, but the distilling of whisky in Lochnagar goes back to the early 1800's, when local man James Robertson started distilling illegal whisky around the area.

The legitimised distillery, on the North side of the Dee close to Balmoral Castle, was burnt down in 1841, possibly by competitors, but it was rebuilt and Robertson continued distilling in this area until 1860.

In 1845 John Begg of Aberdeen built a new distillery known as "New Lochnagar" on a 120-acre site which serviced an annual ground rent of £12.

The Warrant of Appointment as supplier to the Queen didn't bring the "Royal" to the name until 1861, quite some time after Queen Victoria and Prince Albert's 1848 visit.

This whisky was distilled by hand and soon became commonly popular (not just with Royals!) and by 1870 Begg's Royal Lochnagar was leading the market for blended whiskies. However, Begg died in 1880 and his son Henry, took over. He in turn died in 1902.

After being completely rebuilt in 1906, the Lochnagar distillery was sold to John Dewar & Sons in 1916, but it wasn't long before the distillery was forced to close by the first world war.

In 1925, seven years after the war had ended, the distillery became part of the Distillers Company Ltd and continued producing whisky until the 1940's when it had to close again - this time due to (you've guessed it) the second world war.

After the war the distillery was extensively rebuilt in 1963 and the only structures remaining from the earlier days were the long-disused malting barns and kiln. Throughout its history, the distillery has been owned by various companies, and it still produces a quality whisky. In 1998 Prince Charles visited, to commemorate the distillery's 150th anniversary, and today you are invited to take a tour to watch the distillers tending to the traditional mash tun and gleaming copper stills.

**Facilities, opening and contact:**
The Distillery Visitor Centre was refurbished in 1998 to incorporate a shop, which stocks a large range of single malt whiskies. There are also knowledgeable guides on hand to help with enquiries. Disabled visitors are given a good ground-floor tour and can see most of what is available.

Foreign visitors information sheets available in six different languages, but guides indicate that they do not cater to non-English speaking visitors.

January to March: Tours Monday to Friday 11am, 12.30pm, 2pm and 3pm. April to October: Tours 7 days a week, at 30 minute intervals, with the last tour leaving 1 hour before closing. November and December: Tours at 11am, 12.30pm, 2pm and 3pm. Children under 8 are welcome, but not encouraged to take the tour. Tours cost £5.00 per person, which is redeemable in the gift shop.

**Location**: ●
Via Ballater along the A93 Deeside road, at Crathie take the B976 signposted for Balmoral. After a short distance you will see the distillery sign on the right.

tel: 01339 742700

# Been There

Stick your own
picture here

Stick your own
picture here

Stick your own
picture here

Stick your own
picture here

**Forestry Commission**
Scotland

Cairngorms National Park

## Explore your forests!

*Come in and enjoy!*

Wildlife, views, biking, events &
picnic sites to enjoy in and around
the Cairngorms National Park.

Glenmore Forest Park A mecca for
outdoor enthusiasts offering walks,
cycle & ski trails. Or just relax on
Loch Morlich's sandy beaches.

Glenmore Visitor Centre Browse in
the shop, relax in the café and see
the audio-visual show and displays.

Inshriach Forest Amble along the
River Feshie or cycle up to Uath
Lochans, where a walk up to
Farleitter Crag gives stunning views.

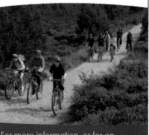

For more information, or for an
'Events Guide', visit our website
or call 01479 861220
www.forestry.gov.uk/scotland

# Been There

**Visitors Notes**

Stick your own
picture here

Stick your own
picture here

Stick your own
picture here

Stick your own
picture here

# Wild and Art

## Creative Adventures

### Art Holidays
### Workshops
### Accommodation

Art courses based in Newtonmore,
for all ages and abilities capturing
the wildness and dramatic light of
the landscape of the Highlands, its
wildlife and its people.

tel: (01540) 670191

www.wildandart.co.uk

# Been There

**Visitors Notes**

Stick your own
picture here

Stick your own
picture here

Stick your own
picture here

Stick your own
picture here

# GO WILD
## IN THE
## HIGHLANDS

Experience endangered mountain
wildlife and tundra species at the
Highland Wildlife Park in Kincraig.

- Antlers Cafe
- Gift shop
- Free parking
- Children's trail
- Play area
- Daily animal talks
- Picnic Area
- Free guidebook
- Binocular hire

**Highland Wildlife Park**
Kincraig, Kingussie.
Open daily from 10am.

**tel: 01540 651 270**
www.highlandwildlifepark.org

# Been There

**Visitors Notes**

Stick your own
picture here

Stick your own
picture here

Stick your own
picture here

Stick your own
picture here

## the lost gallery

painting
indoor sculpture
outdoor sculpture
photography
exhibitions

The Lost Gallery is one
of the most interesting
and unusual venues in
Northern Scotland, with
an excitingly eclectic
selection of paintings,
sculpture and
photography.

The Gallery is based in
Bellabeg, Strathdon
which is approximately
40 miles West of
Aberdeen on the A944.
The Gallery is open 6
days a week 11am to
5pm. Closed Tuesdays.
By appointment only
between January 2nd
and March 31st.

**tel: 019756 51287**

**www.lostgallery.co.uk**

# Been There

Stick your own
picture here

Stick your own
picture here

Stick your own
picture here

Stick your own
picture here

**Forestry Commission**
Scotland

Cairngorms National Park

## Explore your forests!

### Come in and enjoy!

The reputation of Laggan Wolftrax
as a premier mountain bike centre
just keeps growing.

Set in a magical mixture of mature
forest and open country - with
fantastic mountain views - there are
trails here to suit everyone from
the novice to expert.

Basecamp bike hire & shop,
café and toilets open daily.

On the A86, 1 mile
past Laggan heading
to Spean Bridge

Laggan
**wolftrax**

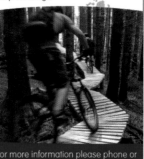

For more information please phone or
check our website. Tel: 01528 544 786
www.forestry.gov.uk/wolftrax
or www.basecampmtb.com

# Been There

✏️ **Visitors Notes**

Stick your own
picture here

Stick your own
picture here

Stick your own
picture here

Stick your own
picture here

# Waltzing Waters ®

## Watershow Spectacular!

**SEE WHAT MILLIONS HAVE SEEN...
AND NEVER FORGOTTEN!
THE WORLD'S MOST ELABORATE
WATER, LIGHT & MUSIC SHOW!**

INDOOR SHOWS • RAIN OR SHINE!
7 DAYS A WEEK • 40 MIN. SHOWS
HOURLY 10AM – 4PM INCLUSIVE

• MAIN STREET IN NEWTONMORE •
15 MILES SOUTH OF AVIEMORE

ADULTS £4.25  CHILD £2.50
TEL:01540 673 752 • SATNAV: PH20 1DR
www.waltzingwaters.co.uk

# Been There

**Visitors Notes**

Stick your own
picture here

Stick your own
picture here

Stick your own
picture here

Stick your own
picture here

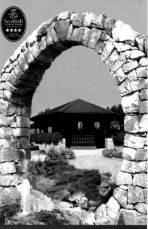

# SPEYSIDE HEATHER
## Visitor & Garden Centre

**Award winning visitor attraction
in Dulnain Bridge**

- Garden & Plant Shop
- Display Garden & Trail
- Wildlife Viewing Stations
- Gift Shop & Boutique
- Restaurant
- Art & Antiques Galleries
- Heather Exhibition

**T: 01479 851359**
**www.heathercentre.com**

# Been There

**Visitors Notes**

Stick your own
picture here

Stick your own
picture here

Stick your own
picture here

Stick your own
picture here

# Alvie Estate

Traditional Highland Estate over-looking the Cairngorm mountains located 4 miles south of Aviemore.

Alvie provides an ideal centre from which to explore and participate in one of the many activities available on or around the Estate.

* Hill Walking
* Skiing
* Golf
* Falconry
* Horse Riding
* Fishing
* Clay Pigeon Shooting
* Archery
* Quad Bike Treks
* Deer Stalking
* Grouse and Hare Shooting
* Gliding
* Watersports

**Alvie Estate**
Kincraig, Kingussie
(01540) 651 255
Dalraddy Holiday Park
*(Chalets, Caravans & Tents)*
(01479) 810 330

# Been There

**Visitors Notes**

Stick your own
picture here

Stick your own
picture here

Stick your own
picture here

Stick your own
picture here

# Dalfaber Golf & Country Club *Aviemore*

*Accommodation, Leisure, Restaurant & Bar*

Dalfaber Golf & Country Club
**Aviemore**
**Tel: (01479) 811 244**

www.aviemorehighlandresort.com

**263**

# Been There

## Visitors Notes

Stick your own
picture here

Stick your own
picture here

Stick your own
picture here

Stick your own
picture here

# Been There

**Visitors Notes**

Stick your own
picture here

Stick your own
picture here

Stick your own
picture here

Stick your own
picture here

*Travel is more
than just A to B.
Travel should bring
your family together.*

### The Funhouse at Hilton Coylumbridge

- Soft play tree house
- Funhouse Party Pods
- Family games
- 10-pin bowlingo
- Crèche and day care centre
- Video-game arcade
- Adventure mini-golf
- 50's style American Diner

For information and opening times
please call 01479 813081.

© 2007 Hilton Hospitality, Inc.

 **Hilton**
Coylumbridge

Travel should take you places™

# Been There

## Visitors Notes

Stick your own picture here

Stick your own picture here

Stick your own picture here

Stick your own picture here

# Pinebank Chalets

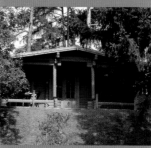

Pinebank Chalets in Avimore offers quality self catering chalets, apartments, and log cabin accommodation in the heart of the Cairngorms National Park, making this the perfect location for enjoying outdoor activities including wildlife tours, fishing, walking, mountain biking.

Open all year round, we have 5 Log cabins, 6 Chalets & 2 Apartments which can sleep 2-6 people for weekly, weekend and short break stays.

**Contact**
**tel (01479) 810000**
**www.pinebankchalets.co.uk**

# Index

## Balmoral Castle & Estate

**Location - Ballater**
Balmoral Estate is open to the public for most of the year with seasonal variations depending on the activity or when the Royal Family is in residence. Visitors are invited to view the castle, the grounds with guide tours available. See the landscape, wildlife and learn all about the castle history.

**Contact**
tel (013397) 42534
www.balmoralcastle.com

## WalkDeeside Ltd

**Location - Deeside**
We offer guided walking holidays, mountain navigation courses, Lochnagar, East Cairngorm Munros, weekend breaks, individual or group programmes. We utilise the rich natural heritage of Deeside with qualified local guides offering quality wildlife sightings.

**Contact**
tel (01339) 880081
www.walkdeeside.com
info@walkdeeside.com

# Index